Frank Stella
1970-1987

Frank Stella
1970–1987

William Rubin

The Museum of Modern Art, New York

Published in conjunction with an exhibition of the same title shown at
the following museums:
The Museum of Modern Art, New York
Stedelijk Museum, Amsterdam
Musée National d'Art Moderne, Centre Georges Pompidou, Paris
Walker Art Center, Minneapolis
Contemporary Arts Museum, Houston
Los Angeles County Museum of Art

The exhibition and its accompanying publication were made possible
by a generous grant from PaineWebber Group Inc.

Edited by James Leggio
Designed by Joseph del Gaudio
Production by Tim McDonough
Type set by Concept Typographic Services, New York
Color separation by Spectra II Separations, New York
Printed by Franklin Graphics, Providence, Rhode Island
Bound by Sendor Bindery, New York

Distributed outside the United States and Canada by
Thames and Hudson Ltd., London

The Museum of Modern Art
11 West 53 Street
New York, New York 10019

Printed in the United States of America

Contents

Text by William Rubin 7

Notes 151

Chronology 153

Selected Bibliography 160

List of Illustrations 164

Acknowledgments 170

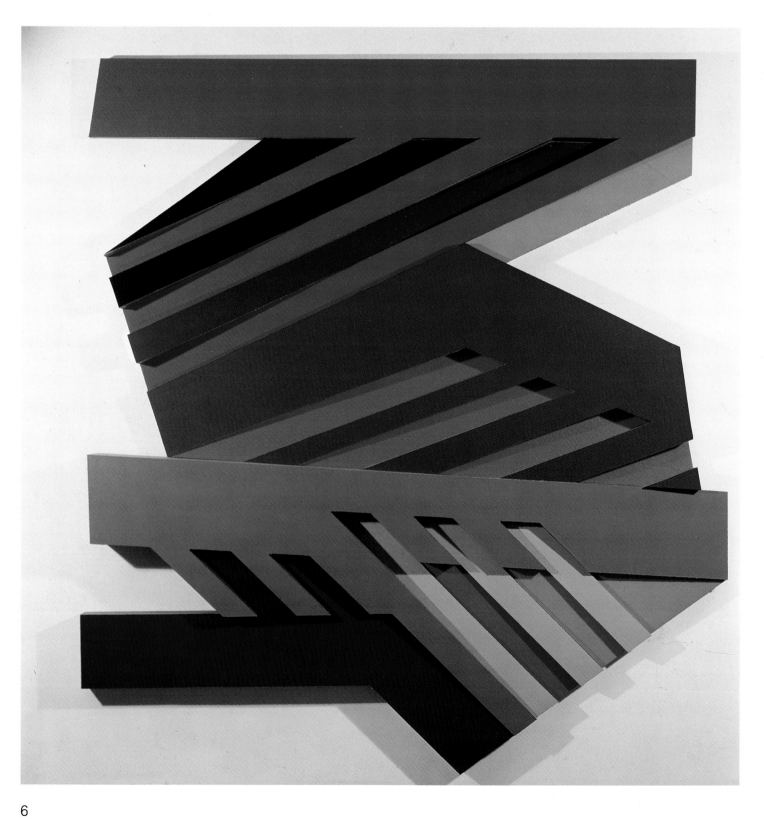

Jones: You still call these paintings?
Stella: Yes. They are, in fact, paintings.

.

Jones: Where do you stand on "purity"?
Stella: I don't know. Wherever I happen to be.[1]

NON-FIGURATIVE PAINTING has traditionally presented itself as the highest of the plastic arts—the most spiritual, most philosophical, most absolute, most pure. Kandinsky, Mondrian, and Rothko related this noumenal loftiness in part to the elimination from the picture of references to the things of this world. Frank Stella has shown that total abstraction need not be thus. He has aimed lower, but wider. While Mondrian proved that great non-figurative painting was not doomed to short-windedness, Stella has shown that it could also have the range and variety of the most inventive figurative art; the pluralism of his vernacular encompasses a stylistic polarity as antipodean as were Picasso's Cubism and neoclassicism.

Stella's diversity has been propelled by an urgency to "make it better," which has also generated the relentless pressure he has maintained in his work for almost thirty years. His production has required not only a profound inner commitment, but an enormous expenditure of physical energy. Stella insists upon the importance of this physicality, describing his picture-making as "more physical than visual."[2] This has nothing to do with the supposedly autobiographical theatrics of so-called Action Painting; the bodily contortions necessitated by executing the tightly controlled stripe paintings, Stella observes, taxed him physically even more than does the highly gestural recent work. I take Stella's singular emphasis on physical activity not only as his way of stressing the animated, workshop nature of his enterprise, but of signalling the literalness of its product: an art of a resolute and unabashed materialism, directly at odds with the "purity," absolutism, and Platonism of most pioneer non-figurative painting.

There has been something insistently palpable about Stella's work since its beginnings, something almost vulgar, in the etymological sense of the word. Nor is there anything visible in the man of his elitist Andover/Princeton schooling; though he profited from it enormously, it fit him like the two-piece suit he dusts off for official functions. Despite the rhetoric in which he sometimes drapes his aesthetic choices, they have always been instinctive; his methods have been artisanal, his career decisions street-wise. Had Stella not been born with a genius for painting, one could imagine him a ball player, construction engineer, or high-stakes gambler. There are in Stella's art—and it is an aspect of its relative accessibility—the vestiges of a certain banality. Yet it is precisely when life's commonplaces are amplified by the spirit of genius that the truly universal work of art is born. At least I take this to be among the lessons of Dante, Shakespeare, and Picasso. This "popular" side of Stella's work is not, however, a matter of image sources and allusions, as in Pop Art.

Piaski III. (1973)
Mixed media on board,
7'8" × 7' (233.7 × 213.4 cm)

It is bred into the very fabric—the morphology, syntax, and material substance—of the work. It is also consonant with Stella's matter-of-fact self-image:

I like to make paintings, and I work at that: it's my job. I don't consider myself that different from anybody else. So I live in the real world and while I'm living in it, I'll be more or less like other people. At some points I'm going to cross common experiences. Some of them are going to stick and become a little bit peculiarly mine.... I don't worry about that. I worry about the paintings ... the drive to make the art.[3]

Like all great painters, Stella has the gift of recognizing not only what painting is but what it can be. In his early years, he distilled a pared-down definition of its conventions by using simple geometrical patterns as images. Nothing would distinguish his paintings from mere diagrams but their convincing pictoriality, rightness of scale, material "presence," and profound emotive power. These "minimalist"-related explorations tended to isolate the ineluctable conventions of painting—what most distinguishes it from the other plastic arts. During his later, "maximalist" years, however, he has, so to say, posed the question in reverse: How much could he subsume from the neighboring plastic arts of sculpture and architecture and still be making paintings? And how many of the lapsed conventions of painting itself—in the realm of configuration, spatial structure, and even narrative form—could be redeployed in an art that still remained wholly abstract?

IN THE CONTEXT of postwar art, the change in Stella's work in the early seventies, which initiated what appears in retrospect almost a "second career," framed the question of stylistic identity in unexpected terms. During the decade that followed the end of World War II, when American painting was imposing itself as a world force, it was widely agreed that the surest way to define one's artistic personality and open a path to success was to create a personal "image" and, above all, to persist in it. To be sure, many major Europeans of the previous generation—Jean Arp and Joan Miró, for example—had remained within "signature" styles. But one sensed in their cases a less conscious imperative to do so; they seemed simply to have discovered their own pictorial identities and to have worked comfortably within them. Exceptionally, a few Europeans of the interwar generation, notably Max Ernst and André Masson, worked in a variety of dissimilar manners. But they were widely regarded as lacking conviction, and it was not lost on the younger Americans that their reputations suffered accordingly. Only Picasso seemed to have the force to make a career virtue of such diversity—and even he did not escape criticism for it.

As virtual outsiders to the history of modern art in their early years, the future Abstract Expressionists had ample opportunity to study the unfolding of modern art and to make judgments about the way its history seemed to operate. From these

judgments, they also tended to deduce strategies: the fixing and maintaining of one's pictorial identity, one's personal image, was one of the "solutions" most frequently discussed in artists' studios in the early 1950s. Insofar, however, as this strategy was based on perceptions and judgments about the historical processes at work in modern art, it posited a new and—as subsequent history would suggest—a potentially hazardous degree of self-consciousness for painters. Jackson Pollock was among the few Abstract Expressionists who possessed both the authenticity not to second-guess their instincts and the daring to risk their own success. But it was not lost on Pollock's colleagues that soon after he sacrificed his ongoing "all-over" style for his black stained imagery, Pollock began to falter. For all that one might attribute Pollock's fate in his last years to extra-pictorial problems, it was said more than once by his contemporaries that in veering from his classic poured style at the end of 1950, Pollock had made a "strategic" error.

That was, in any case, the opinion Mark Rothko held in the late fifties regarding Pollock's development; moreover, he considered Pollock's reintroduction of figuration in the 1951 black paintings as somehow "ahistorical." Just how much Rothko's opinions here reflected his judgments about the nature of art history is difficult to state precisely.[4] His view was symptomatic, however, of a then increasing tendency among painters to think in terms of presumed historical imperatives, and to situate their own and others' enterprises as functions of these beliefs. By the early sixties, the younger artists in particular were drawing heavily on critical analysis in their studio talk, and had an eye cocked on art history as they worked. Some of them appeared to be trying to decipher the direction in which art history was moving and to identify their work with what they conceived to be that history's leading edge. With the advent of Conceptual art, the process of artistic decision-making became almost a parody of art-historically oriented criticism.

Rothko's commitment to a signature style after 1950 may be said to characterize the thinking of the Abstract Expressionist generation as a whole. The next waves of New York artists, the Color Field painters and Minimalists, who matured in the late fifties and early sixties, were to take this kind of thinking even further, being (or at least seeming to be) for the most part intellectually more rigorous and self-aware in regard to their strategies. These strategies reflected not simply perceptions about the unfolding of art history, but the then prevailing critique of the dialectics of that history. The latter was a function of the larger and more sophisticated critical apparatus that had arisen, and suggested an increasingly symbiotic relationship between the younger artists and the critics writing about them. A substantial number of Abstract Expressionists—Pollock, Willem de Kooning, Arshile Gorky, Adolph Gottlieb, and Franz Kline among them—had had only art-school or artisanal backgrounds; and those who did attend universities did so at a time when, with rare exceptions, the discipline of art history stopped with Cézanne. The artists of the sixties and seventies, however, constituted almost entirely a university-bred group.

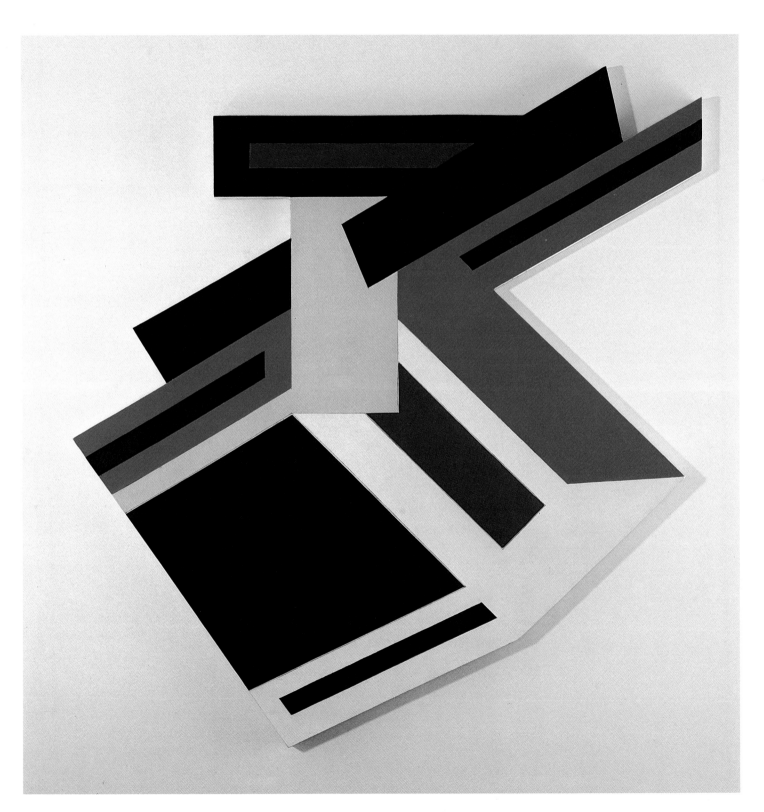

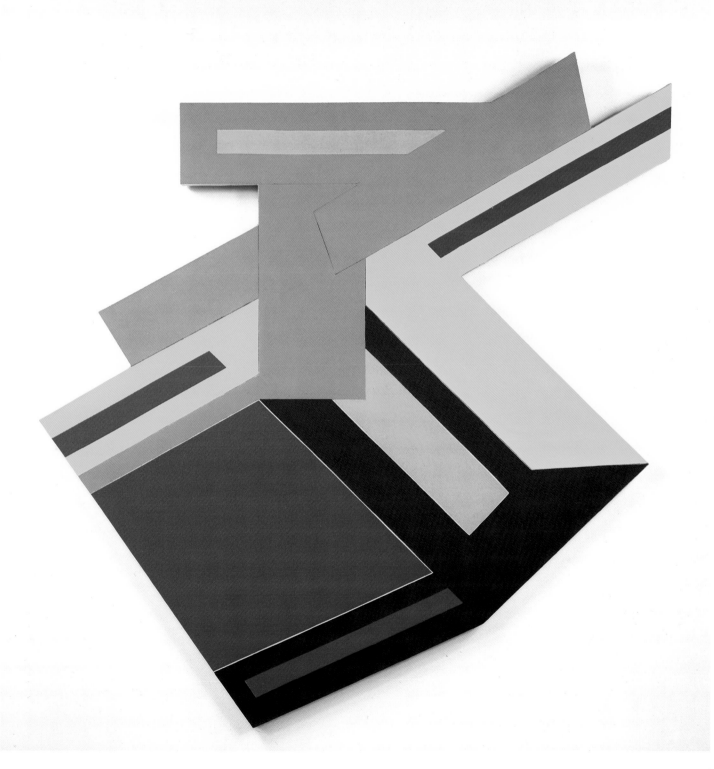

They studied at a time when modern art had become an accepted part of the university curriculum, and when the early history of that art had become far more visible than ever before in museums and commercial galleries. Moreover, while even the most successful of the Abstract Expressionists had spent a good part of their lives in the wilderness, during a time when the infrequent champions of vanguard art directed their interest almost exclusively toward the European product, the generation of the sixties enjoyed a new atmosphere marked by the "triumph," both critical and commercial, of American painting. Doubts about the ultimate meaning of this success—and a certain equivocation, even guilt, associated with its material aspects—were still only rumblings. (Though implicit in some aspects of Minimal art, the critique of art as "commodity" would fully jell only in Conceptualism, where the network of money and power within which art circulated became an explicit subject.)

Odelsk I. (1971)
Mixed media on canvas,
7'6" × 11' (228.6 × 335.3 cm)

The sixties were a decade more strongly marked than any before by the notion of a signature style. For every Robert Morris that roamed the map of possibilities, there were many more artists who kept within narrow and consistent limits. In this context, the painting of Stella distinguished itself by its range. The twelve years of his work shown in The Museum of Modern Art retrospective of 1970 demonstrated a richness of ideas and a willingness to take risks unmatched by any other painter during the preceding decade. To be sure, among Stella's pre-1970 works, the various series of stripe paintings could be considered as extensions of a single pictorial concept, despite all their differences. But both the Irregular Polygons and the Protractor paintings constituted major breaks within that development.

Yet those redirections in Stella's development were as nothing compared to the break that would lead, toward the mid-seventies, to the painterly metal reliefs called Exotic Birds. The reliefs appeared, in both spirit and concept, to be not merely different from but opposed to the whole body of his earlier work. In the face of the insistent, rationalist rigor of the stripe paintings, they proposed a certain fantasy and a sense of playful improvisation; against "tight" execution, they proposed loose, painterly handling. And against what had earlier appeared an absolute suppression of illusionism, the metal reliefs made room, at least by implication, for an exploration of certain visual ambiguities of a spatial order. To many, it seemed as if these highly colored reliefs could hardly have been made by the painter of the stripes. One thought of those Japanese artists who changed their names in mid-career and started over. "How do we explain," asked Robert Rosenblum, "that the artist who first defined himself in 1959 by scraping his painting to the flattest, leanest, most minimal bones is the same one who, less than twenty years later, embraces a vocabulary so maximal that the very plane of the painting's surface has to burst forward in ever-multiplying layers to accommodate this teeming profusion?"[5] The surprise these relief paintings produced in the world of critics and collectors equalled that of late 1946, when Pollock began his all-over poured pictures.

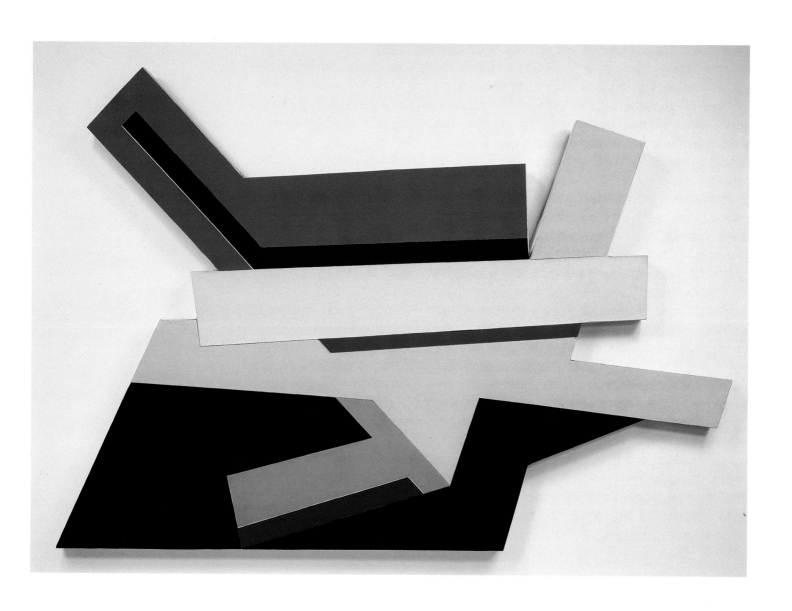

Not all Stella's admirers were enchanted by the change. Indeed, some of the most important of his critical supporters felt he had sacrificed what they considered the principal goals of abstract painting, goals they saw as being more properly explored in the continuing efforts of medium-oriented painters as different as Robert Ryman, Jules Olitski, and Kenneth Noland. Stella himself was not beyond a certain anxiety about how the new work would be received, but his conviction about it overcame his concerns. He remembers "what you might call a sort of mid-life crisis":

Nothing much had changed in the externals of my life. But while I was painting the Protractor pictures, I felt I was coming to the end of something in my work. I really did want a change, and wanted to do things that went beyond the methods and system that underlay my painting until then. I just had to start all over again. That the new work could be contradictory and good is what makes the life of an artist exciting. Anyway, by the early seventies I had more or less "had it" with the art world, and with my relation to other artists. I had paid my dues and earned the right to do whatever I wanted, to just let it happen. I felt loose—sort of beyond the point of criticism. As long as I myself felt confident about the new work, why not just do as I pleased? And the new things really were different. There's a power in the stripe paintings that the newer ones will never have; on the other hand there is an energy—and a kind of florid excitement—in the newer work that the stripe paintings didn't have. I don't think you can do it all at once. That's why you're lucky to have a lifetime.

What Stella defined as a "new beginning" did not, of course, mean a total and instantaneous change, either in his way of working or the results it produced. Even the Exotic Birds and the many series of metal reliefs that succeeded them contained, as we shall see, some common denominators with the early work (though these lay more in the area of methods than in what those methods produced).

FRANK STELLA, LIKE MOST of his Abstract Expressionist predecessors and Color Field coevals, maintained (and maintains) an absolute conviction about the viability of painting in general and abstract (i.e., non-figurative) painting in particular. He is the youngest and last of those abstract painters who developed before the crisis in painting that marked the later sixties and seventies. That crisis had been signalled by the Minimalist emphasis on sculpture as against painting, and was made fully manifest in the vogue of Conceptual art. The rhetoric of the Abstract Expressionists, with a few notable exceptions, had been of a Romantic and, at times, almost apocalyptic order. Against their poetic emphasis on an elusive "Sublime," the abstract artists of the late fifties and early sixties mounted a campaign of rationalist literalism. "What you see," said Stella—in what came to be a slogan of his generation—"is what you see."

This literalism dictated an absolute eschewal of illusionism in Stella's early painting. In the opinion of some Minimalists, however, even Stella's suppression of all modelling or perspective and his application of serial repetition (his "one thing after another") left the art of painting fatally tainted with illusion, as Don Judd implied in a now famous dual interview with Stella.[6] The "evolution" of Judd (and of Carl Andre and others) out of painting and into new forms of non-pictorial sculpture appeared to many at the time as a function of historical deduction and theorizing as well as of creative intuition. "They made a negative reading of the possibilities of painting at that moment," Stella recalls. "It is ironic that painting had a lot to say to Minimalism while Minimalism had little to say to painting, at least at the beginning; it didn't feed back until later."

Most artists of Stella's generation who were to "remain behind" in painting—Robert Ryman, for example—were to find the path of style even narrower than had the Color Field painters; if this was somewhat less true for the sculptors, only a few of them, notably Richard Serra, were able to invest their work with a real structural and conceptual range. The flight in the 1960s from painting to sculpture (and, beyond that, into Conceptual art) on the part of artists then in their thirties left Stella feeling more than ever an obligation to prove the continuing viability of abstract painting. While not alone in this aim, he, more than any other painter of his generation, has provided the concrete proof of his contention.

Nor does Stella see the renewal of interest in painting during the last ten years on the part of young artists as a reversal of the crisis situation that had earlier developed. On the contrary, "the problem with the recent return to painting," says Stella,

is that it returned at such a low level. It has certainly loosened things up, but it's hard to get excited about this work. It represents a return of the mentality of the art school...the exaltation of student mannerisms. In the sixties and seventies, it was considered undignified to be an institutional art student. You were supposed to work at being an artist, and that implied that you had the intellectual agility, the integrity and coherence of character, to put yourself together without going to art school in order to learn a trade and acquire credentials....I feel very close still—and I obviously felt very close then—to artists of my own age, the generation of the sixties. It was a varied and talented generation. I sympathize with its tendency to want to make art that's not painting—or even sculpture—in any received sense, and I admire the attitude that led a Heizer or a Turrell elsewhere. I don't find the so-called return of painting in the late seventies and eighties an important alternative. At least not yet.

IT MUST BE KEPT in mind that Stella holds his metal reliefs to be *paintings*—although they contain some sculptural qualities of a literal order. Hilton Kramer

page 16
Lanckorona I. (1971)
Mixed media on canvas,
9' × 7'6" (274.4 × 228.6 cm)

page 17
Felsztyn III. (1971)
Mixed media on board,
8'10" × 7'6" (269.4 × 228.6 cm)

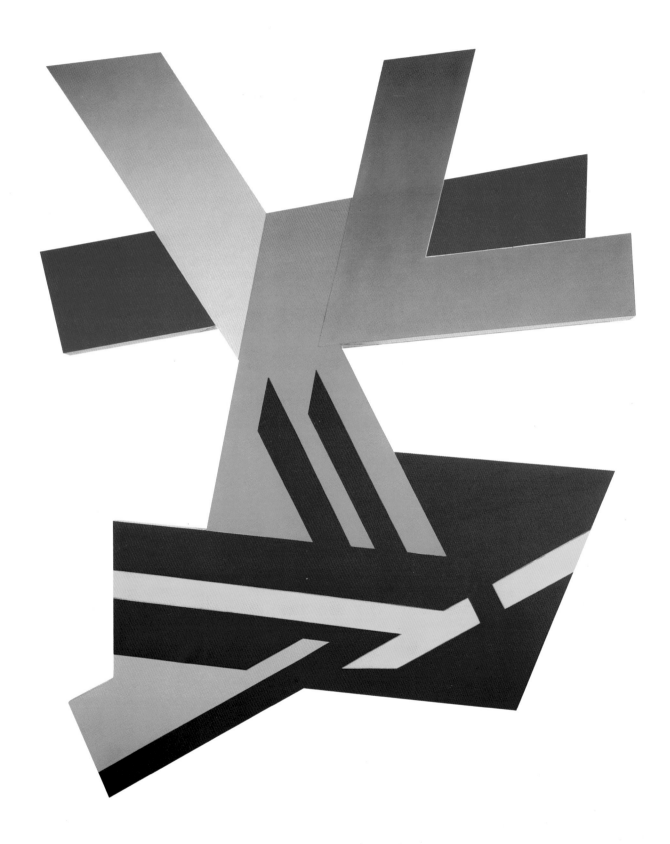

16

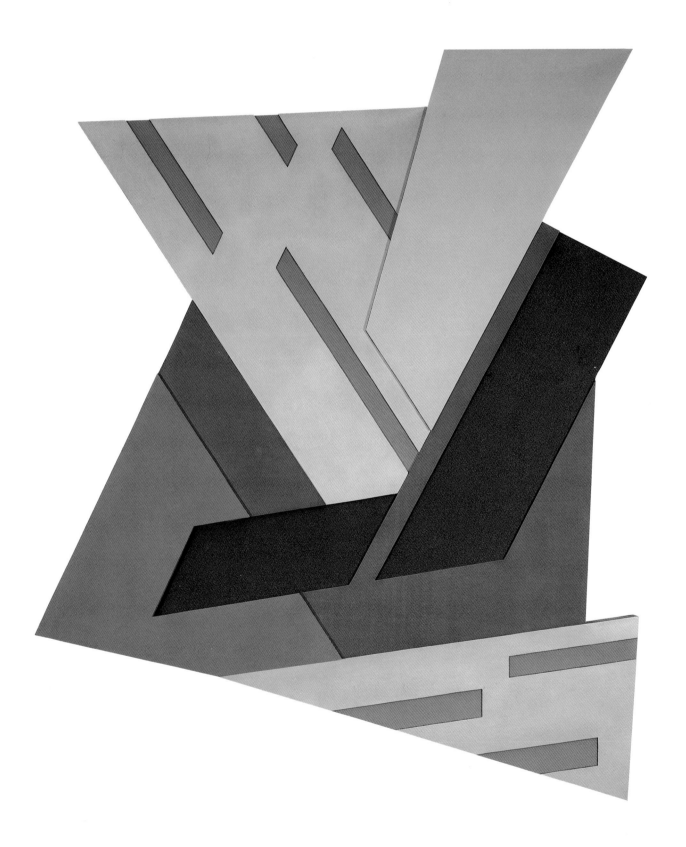

was following the conventional nomenclature—according to which bas-reliefs are referred to as sculptures—when he characterized Stella as having in the seventies "abandon[ed] painting in favor of sculpture." His later works "can often claim a high degree of pictorial drama," Kramer continued, "but they aren't paintings. They are a species of sculpture relief [sic] that incorporates, often very effectively, certain elements of pictorial illusionism within a three-dimensional structure."[7] As Stella considers, quite rightly I believe, that his whole career has been concerned with expanding the boundaries and possibilities of the pictorial, rather than of the sculptural, we need some clarity on the semantic side if we are going to be able to proceed.

First, it is essential that we distinguish between "the pictorial" and "the sculptural," rather than simply between "painting" and "sculpture," nouns too inflexible to contain modernist innovations and mutations developed long before Stella's. We would, I think, have no difficulty agreeing that a freestanding aesthetically structured object, supported by a ground plane, could be called a "sculpture," even if painted. But reliefs, beginning with those of the ancient world (especially those of the Hellenistic era but including, for that matter, those of the Parthenon), are primarily *pictorial*, for even when left unpainted they clearly share more with the nature of painting than with that of sculpture. They replace freestandingness with a wall-induced planarity expressed most completely in the rear plane of the relief, which establishes a delimited—and usually regular—field, whose function parallels that of the picture plane of painting. Aside from implicitly fixing the image's orientation to the viewer at a right angle, this planar structure permits the development of figure-ground relationships of a pictorial order. As in painting, the image is elevated from the floor, generally addressing the viewer at eye level or higher. This elevation eliminates the "totemic" analogy—the "I/thou" relationship—that normally obtains between a freestanding sculpture and the viewer's body and, with that elimination, any tendency on the part of the viewer to use his body as a measure of scale.

All this must be grasped in order to properly define the particular pictoriality of Stella's work, which derives in part from a Cubist/Constructivist tradition that is itself ultimately rooted in Cézanne. And it is *there*, in the mature work of Cézanne, that the issue of relief—still in its illusioned form—becomes crucial for modern painting. This becomes clear when we situate Cézanne's pictoriality in relation to earlier Western painting. We may describe the illusionist structure of Renaissance painting—a structure systematized in the early fifteenth century in such works as Masaccio's *Tribute Money*—as *a simulacrum of sculpture in the round* (i.e., the figures) *in a "stage" space.* The illusion of cylindricity of the figures is achieved through modelling; the illusion of the space they inhabit, through linear (and, later, aerial) perspective. Cézanne came of age in the wake of Manet's undermining of this spatial illusionism, and of the Impressionists' atomization of its modelled forms into discrete spots of color. He accepted this early modernism as his starting point, despite the

Narowla II. (1971)
Mixed media on canvas,
9′ × 8′8″ (274.4 × 264.2 cm)

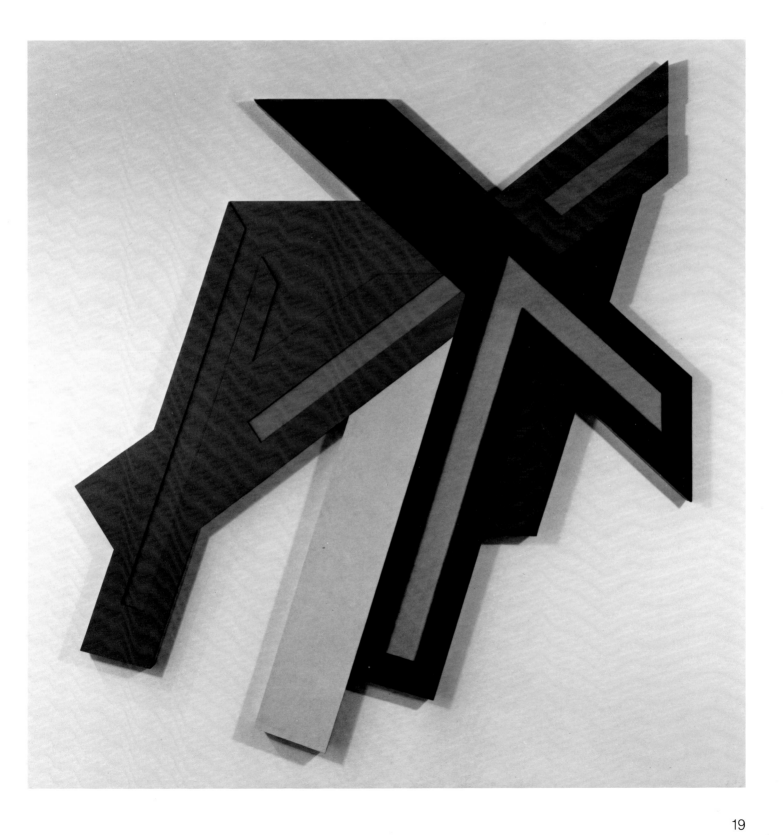

fact that it was ultimately alien to his temperament as a painter. Cézanne clearly aimed to re-endow modernism with a sense of solid forms, whose weight and density could serve as the metaphorical carriers of his pictures' *gravitas*. This seemed to mandate a return to some form of modelling. But Cézanne did not want simply to imitate the illusionism of the Old Masters, so he gradually developed out of Impressionism an entirely new method. In effect, Cézanne modelled only the *fronts* of forms, opening their contours so that they bled into neighboring forms (the earliest examples of what soon came to be called *passage*). Hence, Cézanne's picture might be said to be more like *a simulacrum of a bas-relief* than—as had been the case with the Old Masters—a simulacrum of sculpture in the round in a stage space.

Picasso and Braque produced in early Cubism a conceptualized, more abstract version of the structure that Cézanne had developed in a purely intuitive way. Braque himself clear-mindedly distinguished the structure of (early) Cubist pictures from that of Old Master painting by noting that his own pictures were not composed inward, away from the picture plane in the direction of a vanishing point, but outward from a back plane (the support) toward the viewer, in the manner of a relief.[8] Picasso was to literalize this formulation several years later in his early Cubist constructions, all of which are wall reliefs.[9] These constructions emerged directly from Picasso's pictorial strategies (though in certain respects they moved closer to the condition of sculpture than do most of Stella's painted reliefs). Such works as the *Guitar* of 1912— and, even more, the painted reliefs Picasso executed subsequently—never divest themselves of the pictoriality of the paintings and collages from which they sprang. Stella's fresh way of looking at older art is reflected in his perception that Picasso's constructions could speak as much to the possibilities of painting as to those of sculpture. Indeed, Stella's gloss on these constructions raises the question of whether we have not tended, in our view of the interior dynamics of Picasso's work, to view the early reliefs too much in terms of the freestanding sculpture to which they later led and too little as elaborations of the collages and paintings of their moment. In any case, Picasso's reliefs suggested something that became central for Stella, namely that *literal flatness*, heretofore always accepted as an irreducible common denominator of painting, *was not a sine qua non of pictoriality* as such. "Whether you call what I do painted reliefs or relief paintings," Stella has said, "doesn't seem to me to make much difference. The impulse that goes into them is pictorial, and they live or die on my pictorial abilities, not my abilities as a sculptor....They want to do everything that sculpture doesn't want to do."[10]

THE EXTENDED 1970–73 SERIES known as the Polish Village paintings (named after seventeenth-, eighteenth-, and nineteenth-century Polish synagogues that had been destroyed by Hitler) and the Brazilian reliefs of 1974–75 (whose titles recall Rio

de Janeiro neighborhoods Stella visited) can be considered stages in his transition toward the new pictorial language exemplified by the Exotic Birds. Yet even as that language was evolving, Stella continued to elaborate the series of Concentric Square pictures he had begun in 1961–62, bringing it to a brilliant level of authority in 1974 with the huge paintings named mostly after works by Diderot. By that year, Stella had completed all of the more than 130 full-scale versions of the Polish Village pictures.

Though one speaks of the Polish Village paintings as a series, they have none of the seriality, the tight sequential logic, that marks the various groups of stripe paintings. Among Stella's earlier works, only the Irregular Polygons anticipated them in being less sequences than sets of variations. The Polygons had been irregular not only in their forms, but in their eccentricity in relation to Stella's prior development. Given, however, the way some aspects of them were assimilated into the Polish Village series, the Irregular Polygons now look far less like "sports" in Stella's prior development than they had previously.

From our present vantage point, Stella's reference to these earlier works in the Polish Village pictures, combined with his simultaneous exploration of early modernism, both Cubism and its extension into Russian Constructivism, suggest that the Polish series constituted a classic example of *reculer pour mieux sauter.* It was the *reculer*—the aspects of what seemed stylistic back-pedalling, both personally and in historical terms—that bothered certain critics at the time; moreover, the *mieux sauter,* the leap forward, became fully evident only in the Exotic Birds, a few years later. The dominant aspects of what some critics saw as a retreat in the Polish Village series were Stella's sacrifice of his earlier "non-relational," holistic configurations and his concomitant embrace of an insistent asymmetry. Rosalind Krauss summarized such reservations in a text that also criticized Stella's departure from serial ideas.[11] The relational character of the new configurations ("relating parts, balancing objects, opposing vectors") was described as "inauthentic," as nothing less than the loss of the true modernist "medium," which, she insisted, "demanded" seriality. "Demanded," said Krauss, "because insofar as the creation of the medium was tied to the nature of painting generally, it was tied to the need for painting itself to signify. And this would entail a kind of deepening of the meaning through reiteration that a single statement could not achieve."[12] That the Polish Village configurations contained "a type of illusionism" also distressed Krauss, for this "tends to disrupt a quality which has been central to modernist paintings until now: namely, the singleness- or wholeness-of-aspect of painting itself."[13] Not surprisingly, this "juncture in Stella's career" reminded her of "the occurrence in 1951 of Pollock's reorientation of his own medium." (Writing in 1971, however, she could not have known how differently the two "junctures" would work out.)

I take little exception to Krauss's description of the then new paintings, but disagree with the qualitative conclusions she drew from her analysis—judgments

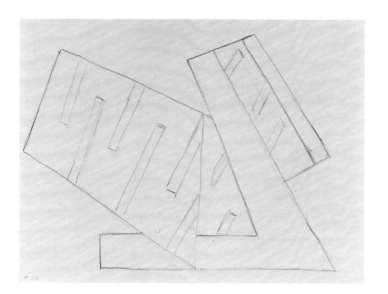 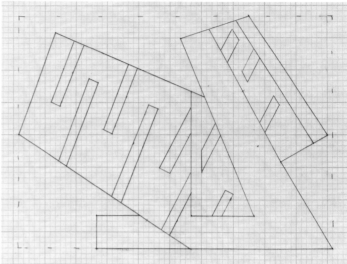

based less, it seems to me, on simply responding to the paintings than on situating them (or rather *not* being able to situate them) within the a priori historical continuum that constituted her vision of modernism. There is no question that the Polish Village series reintroduced a "relational" hierarchy within the parts. In fact, this kind of hierarchy had already been present in the Irregular Polygons, though less insistently so. There, the language had involved both the edge-to-edge touching and the interpenetration of different, hierarchically ordered parts. The Polish pictures carried the latter tendency much further in their jigsaw-like interlocking of parts (as in *Piaski* [page 6]). Krauss was largely right in describing what she called their "nascent illusionism": "...the way the gray T-form [in the lower center of *Odelsk I,* page 13] presents itself as the shaded side and cast shadow of the [yellow] triangle understood as a slab," she insists, "*forces an intermittent reading* of the triangle as turned away from the plane of the wall, and therefore oblique to the picture surface."[14] But it would have been more accurate, I think, to say that the way the gray T-form is presented *offers* (rather than "forces") *an alternative* (rather than "intermittent") *reading* that is potentially illusionistic. It is precisely the tension produced by the play of literal space against this ambiguous "alternative illusion"—and its various permutations—that would characterize Stella's work in the years to come.

The real question is whether such visual ambiguity—which permits a form to be read either in the picture plane or obliquely in space (as had already been the case with some of the color bands in the Irregular Polygons)—necessarily constitutes, as Krauss argues, the sacrifice of modernism. Though spatial cues of this type had disappeared for the most part in Abstract Expressionism, and were even more rigorously suppressed in some sixties styles—in Stella's stripe paintings especially—they nevertheless had been part and parcel of modernism throughout

above, left
Drawing for *Mogielnica.* (ca. 1972)
Pencil, 8½ × 11″ (21.6 × 28 cm)

above, right
Drawing for *Mogielnica.* (ca. 1972)
Pencil on graph paper,
11 × 16½″ (28 × 41.9 cm)

opposite, left
Maquette for *Mogielnica.* (ca. 1972)
Oak tag with pencil, 14⅜ × 20″
(36.5 × 50.8 cm)

opposite, right
Maquette for *Mogielnica.* (ca. 1972)
Corrugated cardboard with fabric and
paint, 18 × 24⅞″ (45.8 × 63.2 cm)

opposite, below
Maquette for *Mogielnica.* (ca. 1972)
Corrugated cardboard, 20 × 29⅞″
(50.8 × 75.9 cm)

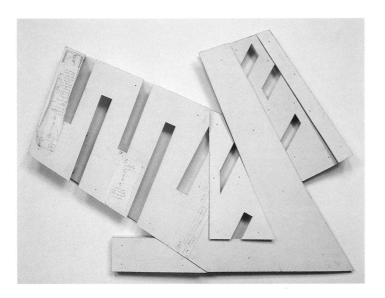 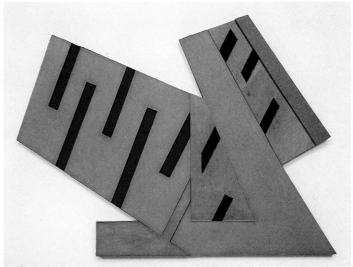

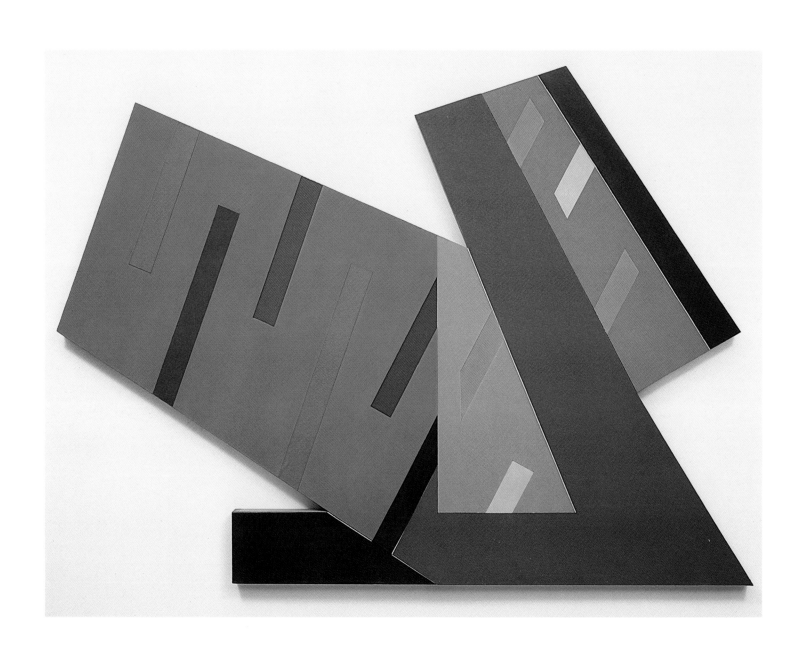

Mogielnica I. (ca. 1972)
Mixed media on board,
7'3″ × 10' (221 × 304.8 cm)

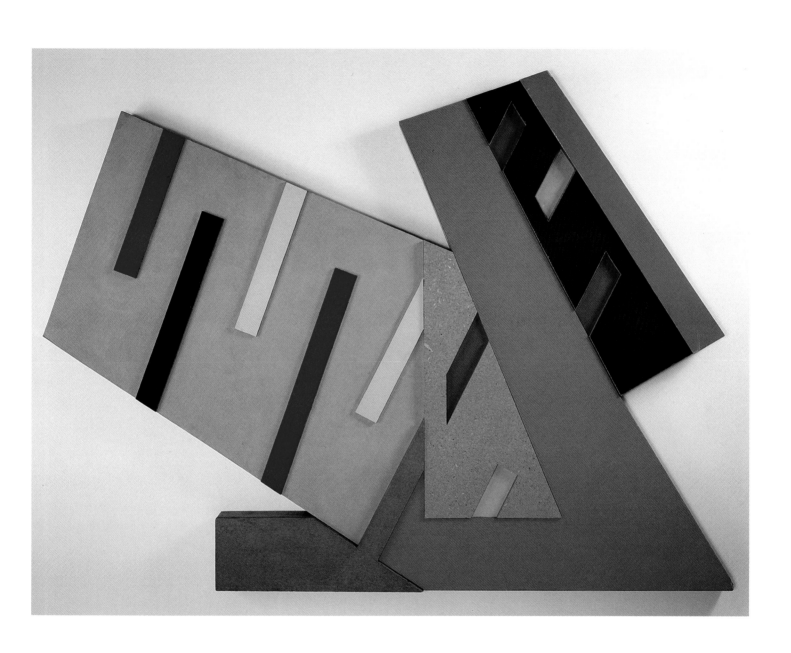

Mogielnica II. (1972)
Mixed media on board,
7'2½" × 10' (219.7 × 304.8 cm)

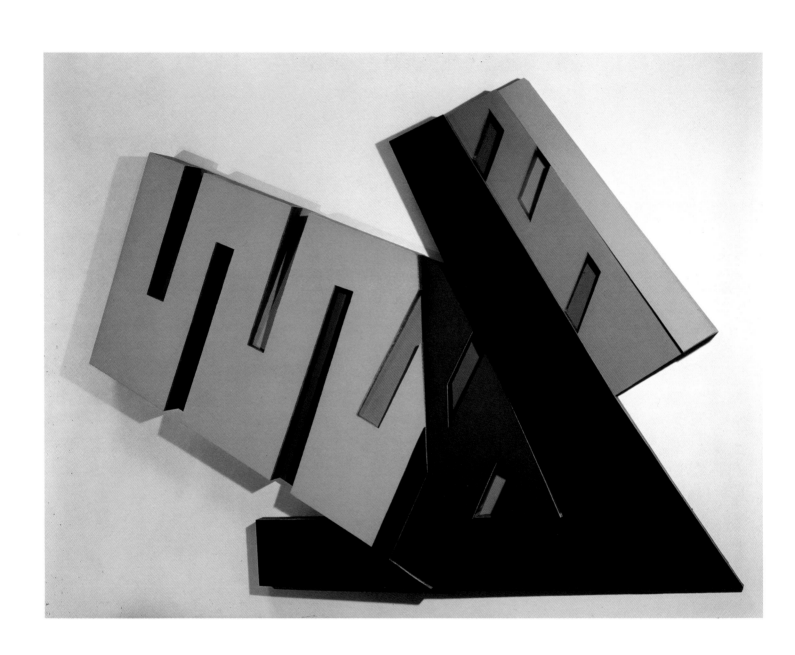

Mogielnica III. (1972)
Mixed media on board,
7′3″ × 10′5″ (221 × 317.5 cm)

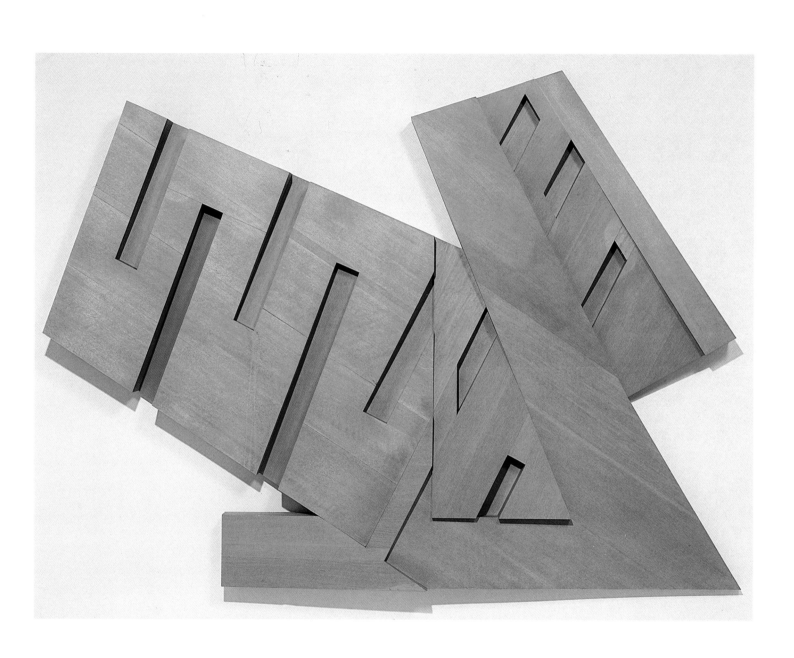

Mogielnica IV. (1972)
Unpainted wood,
7'2½" × 10' (219.7 × 304.8 cm)

Cubism and its various substyles. Hence, as with Stella's renewed use of internal compositional hierarchies, the Polish Village pictures constitute essentially a retrieval or recuperation of an option that had merely lapsed within modernism, a retrieval Stella obviously felt was necessary in order to "start all over again."

In 1971, it could not yet have been clear to critics why such a fresh start might be necessary; Krauss found Stella's shift as mysterious as she had found Pollock's. Nevertheless, the kind of abstract painting (if not sculpture) that Krauss preferred to these new Stellas, the kind that she and some other critics still found acceptable within their respective definitions of modernism, was, by the early seventies, wearing thin and becoming unproductively repetitious. In many of those abstract styles, configurational determination—not to say visual incident as a whole—had, literally, moved out to the edges of the canvas, where it seemingly got stuck. By the mid-seventies it was clear that many of the best abstract painters of the sixties were, in effect, milling about, with no idea in what direction to develop their art. Nor were any new young painters providing answers. Stella was speaking only for himself when he said he was "coming to the end of something" in 1970, but, in retrospect, that was a perception about vanguard painting as a whole. And its crisis soon became apparent—as witnessed by the widespread talk of "the death of painting."

In launching a new departure by retrieving possibilities that modernism had earlier jettisoned, Stella was treading a path well beaten by earlier major modernists. Nor was there anything new about the critics and collectors who could not follow him in it. One thinks of the confusion—indeed, consternation—of some *amateurs* of Cubism when, during World War I, Picasso recuperated figurative drawing and relief modelling.[15] It was, in fact, precisely that redirection of Picasso's which most struck Stella in viewing The Museum of Modern Art's 1980 Picasso retrospective. "I guess you always see things in personal terms," Stella observed. "The show was devastating. The step-by-step development of Cubism was so exciting.... And then, incredibly, it just seemed to stop...and Picasso's emphasis shifted to the more physical and sculptural—as in the classical figure paintings. He was sort of reborn. What hit me so hard was, in part, an analogy with the way I see myself....I mean it seems possible to do something really good, and then have a break, and to redevelop."

ALL FORTY-TWO SKETCHES from which the Polish Village pictures of 1971–73 derive were executed in 1970. That year, Stella was primarily engaged in completing the last (and largest) of the Protractor pictures he had planned. But the continuity of his work was interrupted by his Museum of Modern Art retrospective and, even more, by an extended hospital stay (a result of complications following what was supposed to have been a minor knee operation). The retrospective, by giving Stella an overview of his work, acted as a watershed, reinforcing his feeling of coming to

Kamionka Strumiłowa III. (1972)
Mixed media on board,
7′4″ × 10′4″ (223.5 × 315 cm)

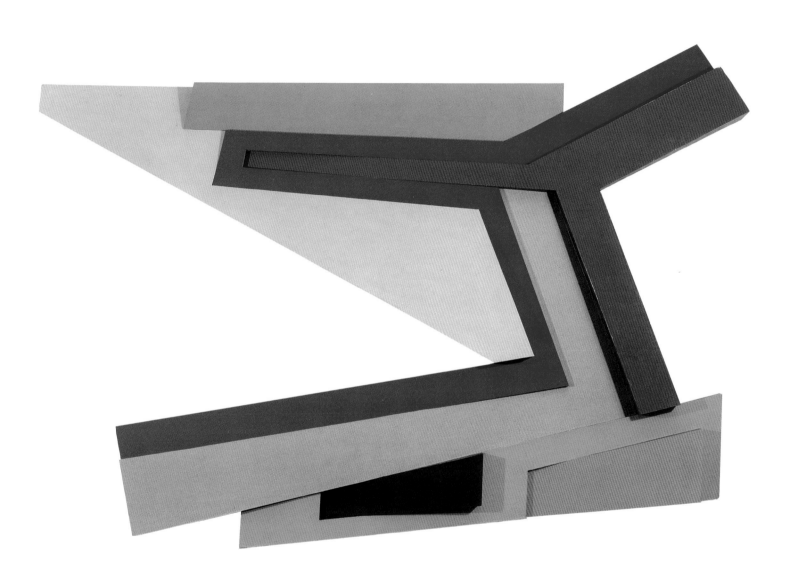

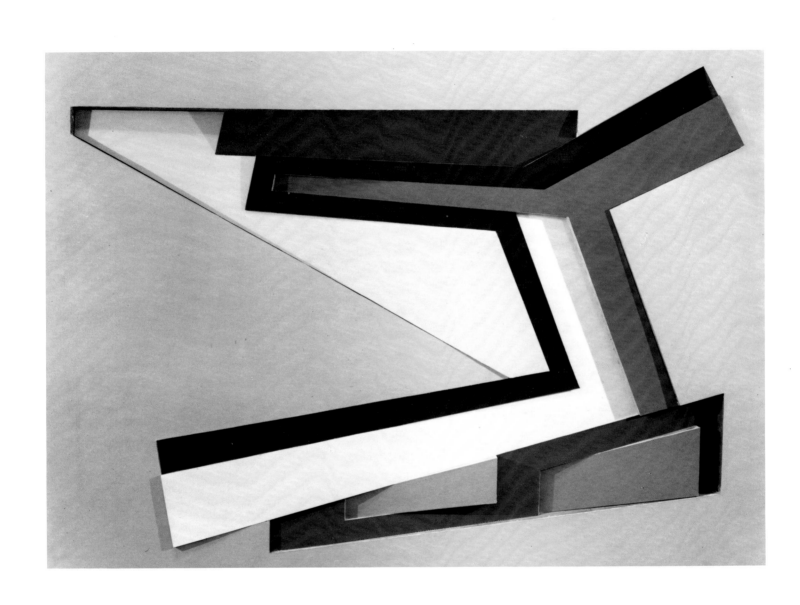

Kamionka Strumiłowa IV. (1972)
Mixed media on board,
8'2″ × 11'6″ (248.9 × 350.6 cm)

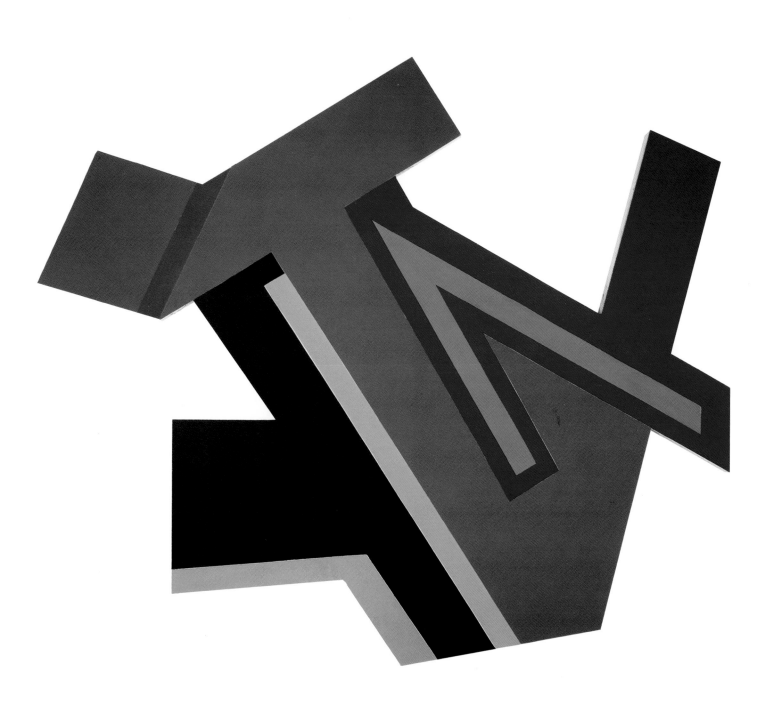

Jabłonów I. (1972)
Mixed media on canvas,
8′2″ × 9′8″ (248.9 × 294.7 cm)

the end of a cycle. If the group show organized by Henry Geldzahler some months earlier at the Metropolitan Museum had provided Stella with the occasion to "sum up" the way he saw himself in relation to his contemporaries, the retrospective reinforced his auto-critique. "I felt the retrospective was a good show," Stella recalls,

but I knew I didn't want to carry the work there to a "next step." When you're done with something you can't fool yourself.... I didn't see a way to improve what I had been doing over the previous decade, to make it better.... In starting all over again I didn't know where [the sketches of] the Polish pictures would lead, but I just had to follow them. In the Protractor pictures I had been as loose as I could get within a system that I'd kept to for over ten years. Imposing that discipline on myself endowed all the early work with both benefits and drawbacks. But I felt I wasn't free enough.

As had been the case with Stella's preparatory drawings all along, the first sketches for the Polish pictures were executed freehand (page 22, left). The forty-two sketches are marked by *pentimenti*—even those for pictures (such as *Mogielnica* [pages 24–27]) that seem in their finished versions to "come together" easily. In a second step, each sketch was realized on Stella's familiar graph paper, its edges trued and faired, and its lines fixed exactly to the vertical and horizontal axes of a rectangular field (page 22, right). The graph-paper versions then served as working drawings for anywhere from one to four small models.

The models for the first group of Polish Village pictures (page 23)—thirteen in all—were made of cardboard, and the full-size paintings were at first realized in two versions, both, in effect, giant shaped collages. In each First Version (designated by the Roman numeral I in the title), the different segments of the surface are distinguished not just by color but by texture: felt, paper, and second layers of painted canvas being laid on the canvas ground (page 24). That canvas support was at first stretched across conventional wooden stretcher bars, but shrinkage and warping of the collage elements led Stella to refine his "engineering," and stretchers gave way to KachinaBoard panels braced by rigid and reinforced strainers.

As the collage materials of the First Versions are all thin, their surfaces give the appearance of being flat. In the Second Versions (II), however, collage materials of significant thicknesses—plywood, pressboard, Masonite, and Homosote among them—were added to the earlier repertoire of felt, paper, and applied canvas, and the entire composition was laid down on a wooden board. This created what was, in effect, a shaped collage-relief (but one in which the planes were all still parallel to the wooden support). In these Second Versions (page 25), the varied materials endow the individual segments of the intricate compositions with a more particular character and also enhance the overall objectness of the pictures.

Varying projections of relief (as realized in the Second Versions) were as implicit in the original drawings for the Polish Village series as flatness had been in the

Nasielsk IV. (1972)
Unpainted wood,
9'2" × 7'5½" (279.4 × 227.4 cm)

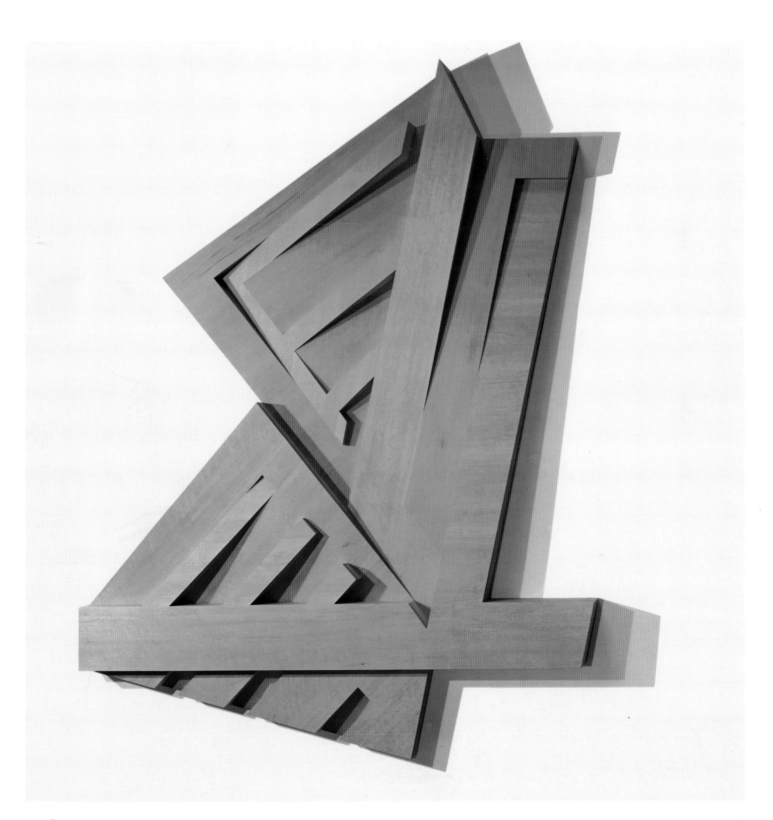

drawings for the stripe pictures. Every configuration in the Polish drawings proposed planes that seemed to pass over other shapes—or were truncated as still other planes passed over them. Hence, the relief structures in the Second Versions constituted a literalizing of certain of the schematic spatial cues in the drawings. But those drawings' overlapping and interlocking of planes also offered other cues: in many configurations, extended shapes gradually changed widths as if their contours were perspective orthogonals, which provided an alternative reading suggesting oblique planar movements through space. The kind of "schematic" illusionism, which had been central to Russian Suprematist and Constructivist drawing,[16] could also, however, be literalized. And beginning with the fourteenth work in the series, Stella constructed Third Versions (III) of each composition, this time with obliquely tilted planes (page 26). Here, the surface materials were applied not to a flat wooden support (as in the Second Versions) but to Tri-Wall cardboard constructions. Philip Leider aptly describes these Third Versions as "creating the effect less of elements affixed onto a support than of elements penetrating, or interlocking with themselves and the support."[17] In the end, only two of the forty-two original drawings for the series were left on the drawing board; most of the other forty had been executed in at least three full-size versions, different in the degree and character of their relief as well as in their color.[18]

Kasimir Malevich
Suprematist Drawing. (ca. 1916)
Pencil, 6½ × 4⅜" (16.5 × 11.2 cm)

In his superb catalogue of Stella's 1970–77 work, Leider stressed, in relation to the Polish Village series, both their formal and ideational links to Russian Constructivism and their continuity with the 1966 Irregular Polygons, to which "the drawings of 1970 are plainly linked." "The immediate meaning of the 1966 pictures was in their breakaway from Stella's own achievement," Leider observes.

[In those pictures] it appeared that he was no longer interested in pursuing a kind of painting that "forces illusionistic space out of painting at constant intervals by using a regulated pattern," or, rather, as if he were feeling that painting is not fulfilled in the too-rigid application of the demands of the strict style. Certain rules controlling all his previous work are relaxed, if not suspended, in the irregular polygons. It does not seem to matter as much whether there is this or that vestige of depictiveness, whether there appear here or there elements of incipient illusionism, whether the order of colors is as accountable in strict style as it was [in the Concentric Squares]. Shapes within the painting are less certainly derived from the overall shape of the picture; colors operate more independently, and frequently verge on metaphor; a certain amount of illusion, both spatial and figurative, is allowed to "come along," as it were.[19]

While the filiation of the Polish Village pictures from the Irregular Polygons must be accepted as the basis of any critical discussion of them, it is equally important to isolate those ways in which the Polish pictures went beyond the Irregular Polygons.

Moultonboro III. (1966)
Fluorescent alkyd and epoxy paint on canvas, 9′2″ × 10′1¼″ (279.4 × 305.5 cm)

The configurations of the Polygons were contained in simple silhouettes and had few constituent parts; most of them, such as *Moultonboro III,* consisted of only two large interpenetrating forms, partly framed by 8-inch bands; less frequently—and sometimes less successfully—three large geometrical forms were used. The large size of most of the color areas of the Irregular Polygons, the ¼-inch "breathing spaces" separating them, and the richness and intensity of their overall palette (which juxtaposes Day-Glo colors and epoxy enamels) had situated these Irregular Polygons somewhere between the geometrical concerns of Stella's own earlier (stripe) paintings and the concerns of contemporaneous Color Field painters such as Noland. In the Polish Village pictures, on the contrary, geometry regained the more dominant role it had played prior to the Irregular Polygons. Compared to the Polygons, the number of larger forms in the Polish pictures was doubled or trebled, and these large shapes were further complicated not simply by their own overlapping and interlocking, but by the profusion of narrow, vector-like bands of color darting through them. Color here seems less an expressive entity in itself than it had been in 1966, and more a tool for clarifying the complex configurations. In the Irregular Polygons, each format had been executed in three versions, but the only differences between these versions lay in their color. In the Polish Village pictures, as we have seen, the remaking of each configuration was motivated primarily by questions of relief and spatial obliquity. Though the color did change from version to version, such changes were prompted mainly by the desire to further individualize, clarify, heighten, or intensify planes which could collectively—at least in the high-relief versions—have constituted successful monochrome pictures (as was, indeed, the case with *Mogielnica IV* [page 27] and two other examples that were also executed simply as unpainted wood reliefs).

Despite the complexity of their overall silhouettes and the oblique relief of their internal forms, the Third Versions of the Polish pictures never passed into the sculptural. On the contrary, they marked another step in Stella's many years of probing and testing the outer edges of painting. The manner in which these oblique reliefs maintain their pictoriality is less a question of their color—even the unpainted wooden versions (page 33) are pictorial—than of their space: our awareness of an imaginary "picture plane" parallel to the wall, toward which recessed planes move forward through literal space and extruded planes resolve backward. That "picture plane" might be considered analogous to the actual plane of the drawing paper in the original sketches; from it, as a result of schematic overlapping and orthogonal narrowing, the component shapes of the drawings could be read as moving slightly backward or forward—or locating themselves at various distances parallel to the surface—within narrow, though obviously not measurable, confines. In all three types of large reliefs, the suggestion of this spatial movement would be either intensified or reduced by the color chosen to delineate each form.

Yet the drawings of the Polish Village compositions provided something more.

Insofar as the rectangle of the drawing sheet was to remain implicit in the final painting, it further guaranteed the pictoriality of the reliefs. So strongly was this pictorial rectangle implied in the large works that when Stella *literally* added it—as he did in the experimental *Kamionka Strumiłowa IV* (page 30)—it appeared redundant, even confining. Almost every Polish composition has at least one major form or edge that the viewer's eye can lock to the vertical, horizontal, or diagonal axes of the supporting wall, the way it locked to the drawing paper's edges and to the grids of the graph paper in the formalized sketches. In some compositions, this relationship is easy to grasp and, as a result, their equilibrium and stability are assured. The right angle of the upper right panel of *Dawidgródek*, for example, "fixes" the implicit rectangularity of the picture's field, as do the broken vertical rectangle in the upper center of *Chodorów* (pages 10, 11), the horizontal lower edges of the bottom planes in *Odelsk* (page 13) and *Mogielnica*, and the upper edges of the upper planes in *Piaski* (page 6) and *Kamionka Strumiłowa* (page 29). In *Brzozdowce* (page 38) the relation to the implicit rectangular plane is somewhat more perilous, as it is guaranteed rather by strong diagonals than by the minor verticals and horizontal of the "leg" in the lower right. The insistent axiality of all these pictures remains, however, only a quantitative aspect of their conceptions; indeed, among the best of the Polish pictures are a few, such as *Lanckorona* (page 16), whose axiality is left largely in doubt.

Stella's "pinning" of the large Polish compositions to the axiality of an implied rectangle followed from a perception about picture fields that had already played a role in his first shaped canvases, namely that one could express the pictorial rectangle not only in terms of its outer edges, but as an imaginary cross with diagonals traversing its center, and that a composition could visually be "built out" from that imaginary architecture as well as "built in" from a framing edge. "It's possible to build a painting from the axes," Stella insists. "To use the Christian metaphor, we'd be hanging the painting on the cross of structure.... When I'm executing a large painting, the rectangle that is given by the drawing paper begins to fade, and what I have before me are imaginary axes, floating in front of my face."

The most unexpected aspect of many of the Polish Village pictures—which clearly linked them to Constructivist composition and to the work of Kandinsky as well[20]—was their high center of gravity. They seem to "float" freely at a certain height on the wall rather than align themselves clearly and fairly closely to the wall's bottom edge, as had all Stella's large earlier works (including the Irregular Polygons). While a few Polish Village compositions, such as *Mogielnica,* do seem to support themselves from the bottom, and thus to exhibit a low center of gravity, many others, such as *Chodorów* and *Narowla* (page 19), appear to "hang" from a point high up in the configuration and—in the case of *Dawidgródek, Odelsk, Brzozdowce,* and *Zabludów*—to open upwards and outwards as well.

THE CONSTRUCTIVIST ASPECTS of the Polish Village series went beyond the formal affinities with Malevich, Popova, and Tatlin (which Leider describes as less an "influence" than "in the nature of an unpremeditated encounter with some earlier point in [the history of] abstraction"). The relationship to Constructivism has also to do with Stella's literal building up (or "engineering") of the pictorial object, an activity that now became a major preoccupation. Leider considers that these literalist concerns "correspond fraternally" with the conclusions Malevich himself drew from Picasso's Cubist relief constructions, and quotes Malevich as follows:

Thus we see that the expansion of forms of volume involves large spatial relations which already demand the technical and engineering efforts that lie in the constructive link of one element with another.

Thus we see now technical means penetrating into the purely painterly picture, and these means may already be called "engineering." At this moment the characteristics or functional qualities of the engineer begin to become linked with the artist, or with the artistic aspect of expressing the artist's painterly sensation.

Such an engineering method of constructing our artistic picture, as distinguished from other utilitarian constructions, we may call an "artistic construction." [21]

"Malevich is careful," Leider concludes, "to avoid confusing this 'painterly building of the picture in space' with 'the place of the art we call sculpture.'" As Malevich crucially insisted, "The entire material for building the picture is selected and developed on the basis of a painterly sensation or feeling."

The process of painterly construction that Malevich had envisioned—and, even more, its opening into large-scale work—was to remain a largely unfulfilled aspiration for the artists of the Russian painter's generation. Little had in fact been done in the direction of the kind of constructed painting that Stella was now undertaking. The "engineering" required by the literalization of pictorial forms, especially in the Third Versions of the Polish Village series, was to demand a great deal of Stella's time and energy. This despite the fact that the large-size reliefs were realized by others (assistants and manufacturers) from the artist's small maquettes. (As these maquettes were almost all destroyed in the course of their enlargement, a wooden model was made as a record.) "The Polish pictures were well designed and very tight in terms of engineering," Stella recalls. "We spent a tremendous amount of time with detail. Unlike the more recent metal reliefs, which are fabricated entirely in factories, they were partly handmade in the studio. I was around all the time, so that I could adjust and readjust things, deal with every decision about tilt, angle, or surface finish."

For Stella, the notion of structuring or "engineering" the surface of a picture prior to actually painting it came very naturally. Indeed, building the pictorial field in a literal, almost architectural, sense had always been a fundamental aspect of his

page 38
Brzozdowce II. (1973)
Mixed media on board,
10' × 7'6" (304.8 × 228.7 cm)

page 39
Targowica II. (ca. 1973)
Mixed media on board,
10'2" × 8' (309.9 × 243.9 cm)

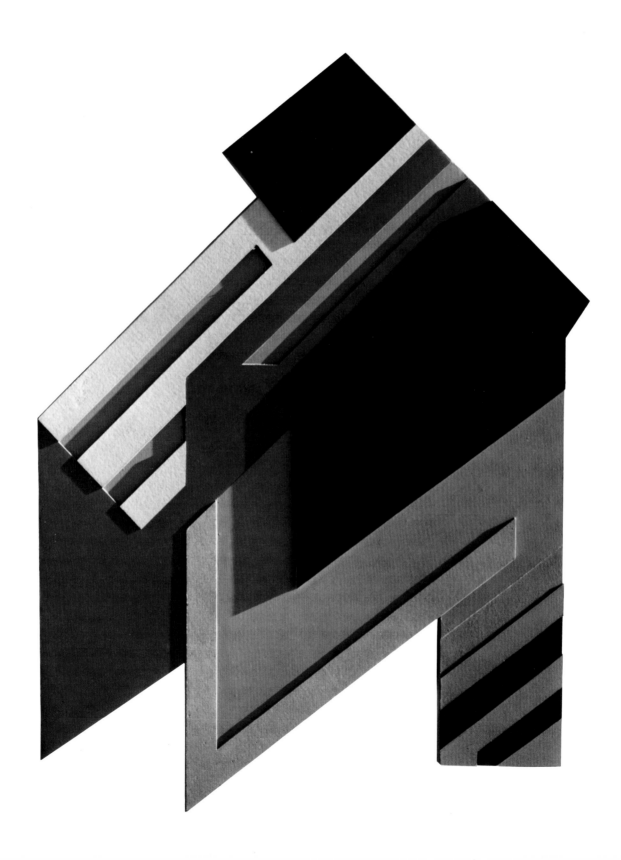

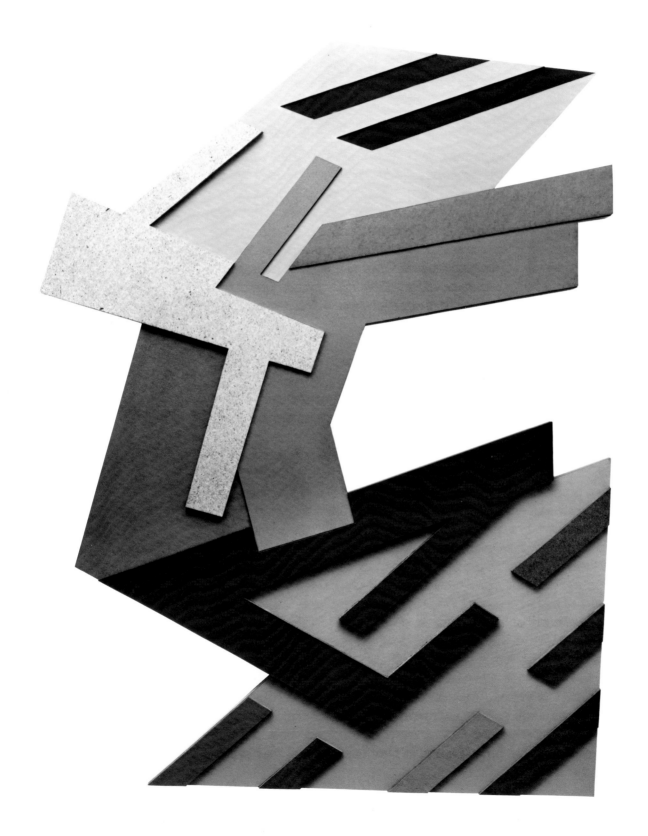

work. Even the conventionally rectangular fields of the Black pictures had been projected away from the wall through the use of very deep stretchers, which enhanced their object-like character. Beginning with the Aluminum pictures, the unpainted surface was further structured by being shaped. "I can't paint on just any surface, some neutral surface," Stella insists.

I need something that I feel is worth painting on, so I have to make it myself.... You can only take advantage of those gifts that you really have—that are part of your character, I guess—and you're lucky to be born with those gifts. I have a gift for structure, and the strength of all the paintings I made in the sixties lay in their organization, their sense of what pictorial structure could be. Struggling through the Polish pictures opened things up for me so that I was able to use my gift for structure with something that modernism hadn't really exploited before, the idea that paintings could be constructed, made by picture-building....Building a picture was something natural for me. Build it and then paint it. It was a job I was well suited for.

THE SYNAGOGUES AFTER WHICH Stella named the Polish Village series had been illustrated in Maria and Kazimierz Piechotka's *Wooden Synagogues*, published in Warsaw in 1959.[22] Carolyn Cohen notes that this book constituted "the last existing record of what were once numerous examples of an architecture highly original in form and construction" and marked by "innovative uses of materials and carpentry techniques."[23] Stella had always been deeply interested in architecture; aspects of architectural design had already served inspirationally in certain of the Black pictures, and architectural concerns were reflected in titles of that and some subsequent series. Nor was it pure chance that brought Stella to *Wooden Synagogues*, for his attention had been drawn to the book by his longtime friend the architect Richard Meier. Yet the Polish Village series was about more than "the synagogues that were destroyed," says Stella; it was "about the obliteration of an entire culture." This was the *shtetl* culture that fed into Constructivism through such artists as El Lissitzky, whose illustrations for the Haggadah song "Had Gadya" would a decade later inspire some of Stella's greatest prints. Cohen makes the unlikely suggestion that the architecture illustrated in *Wooden Synagogues* directly inspired particular pictures in the Polish Village series: "With these photographs as his visual reference, [Stella] transformed what he saw in these unique synagogues into works of art...."[24] But as Leider observes, "There is nothing Stella-like in the buildings."[25] And though Stella himself sees an analogy between the "interlockingness" of the carpentry style of the synagogues and the structure of the Polish compositions, it is, rather, in his *associations* to the buildings and to their locations that their significance for his work resides.

Leider further sees these as mapping out the "Munich-Moscow axis" of Con-

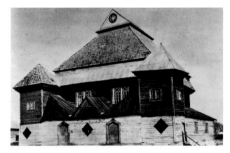

Synagogue, Piaski, Poland (destroyed 1939–45)

structivism. "At this point," he continues,

a certain political urgency enters, so to speak, the picture. One is reluctant, especially in this age of trashy neo-Marxism, to speak of the "political content" of these paintings. Imagine, however, the [Polish Village pictures] viewed through the eyes of a Russian dissident artist. Although Stella's work—for that matter the work of any American artist—has always spoken to such as him of freedom, a series of works evoking Russian Constructivism speaks to him instantly of an art, his own, which was once free and is free no more....He has, therefore, every right to see in them a message of freedom, and the point is that such a message would correctly reflect Stella's actual politics. It is not that political meanings were intended to be part of the immediate meanings of these works; it is that political meanings are one of the implications of the encounter with Constructivism that these works are about, and what Stella has done in the titles, along with whatever else yet to become clear, is to acknowledge that.[26]

As might be expected during a period of fundamental redirection, Stella's success with the Polish Village series was variable. Unlike the stripe paintings, in which the incremental change from picture to picture within a series was small and was controlled by a systemic idea, the Polish pictures reached out in many directions simultaneously. Each successive picture initiated not only major changes in configuration, but variations in texture, color, and relief. A few pictures failed right from the start, it seems to me, because the confusion in their spatial cues was beyond clarifying through color and/or relief; in other cases, such as *Targowica* (page 39), the composition failed sufficiently either to imply the necessary axiality that guaranteed stability or, if implied, to lock itself sufficiently to it. Even in many of the configurations that worked, Stella could run into problems: the color might not come out right, or it would not produce the desired effect because of the manner in which the felt, paper, and other materials took it. Add to this the previously mentioned difficulties of establishing a workable support for the earliest First Versions and you have a situation that might have led another painter to stop or reverse direction. But Stella was committed to a vision of how these paintings might be made to look and, as always, preferred to solve his problems by painting through them rather than by cerebration. Gradually, as he progressed through the more than 130 reliefs that make up the Polish series, the pictures—especially the oblique Third Versions—began functioning as he wanted. Although the Polish series has what is for Stella a relatively high incidence of near misses and outright failures, the bulk of the Polish paintings were nevertheless successful, and in ways that Stella had never brought off before. "After struggling through them," he recalls with a sigh, "I came out on the good side."

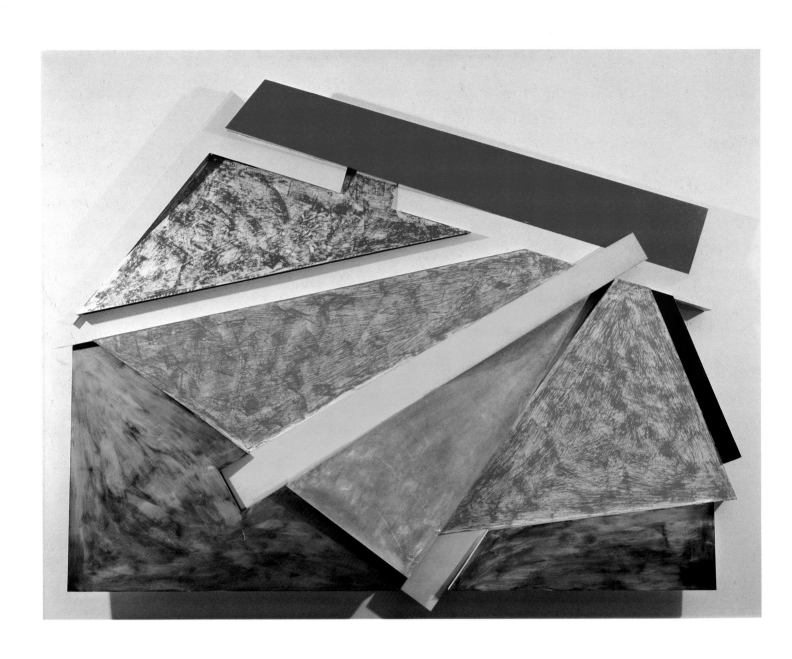

THE FRUITS OF Stella's persistence are clearly visible in the metal reliefs of the Brazilian series of 1974–75, which can be taken as both an extension of the Polish Village pictures and a focussing-in on what Stella considered essential in them. The Brazilian series is much smaller than its Polish predecessor, consisting of only twenty full-size painted reliefs. Stella had executed twenty-five drawings for this series in 1974, but ultimately used only the first ten. Each of the ten was executed first in two small maquette versions (maquette I in aluminum and maquette II in steel) and then in two full-size aluminum versions (which were painted differently—as exemplified by the two versions of *Grajaú* illustrated here [pages 44, 45]). While they remained, for the most part, "irregular" (though nevertheless rectilinear) in their dominant morphology and overall silhouetting, the Brazilian reliefs hew closer to the pictorial rectangle than most of the Polish Village paintings—and this was to set a direction for Stella's immediately subsequent series, the Exotic Birds. The outer contours of most of the Brazilian compositions—*Lapa* (page 57), *Jardim Botânico* (page 42), and *Grajaú*, for example—contain considerable segments of what might be considered pictorial rectangles that at least anchor, if they do not "house," the rest of the configuration; *Arpoador* (page 46) goes further in this direction, insofar as it suggests a pictorial rectangle that is broken only slightly, along the top, except for the upper right corner.

THE RENEWED EMPHASIS on the pictorial rectangle in the Brazilian series may well have been related to Stella's execution, in 1974, of the largest of his Concentric Square pictures, while he was preparing the earliest Brazilian paintings. These are known as the Diderot pictures, as almost all of them are named after works by the encyclopedist.[27] An ongoing series, the Concentric Squares have their roots in such prototypes as *Cato Manor* and *Sharpeville* of 1962. The Diderot pictures, the first Concentric Squares Stella executed in mammoth size, must certainly be read in part as an "antidotal" testing of both the openness and the complexity of the Polish Village pictures that had occupied him during the three previous years. Indeed, the Concentric Squares could be said to have been already used by Stella for over a decade as a kind of standard, or a qualitative "scale," by which to measure the necessity of using more complicated shapes, configurations, or color arrangements. "The concentric square format is about as neutral and as simple as you can get," Stella notes.

It's just a powerful pictorial image. It's so good that you can use it, abuse it, and even work against it to the point of ignoring it. It has a strength that's almost indestructible—at least for me. It's one of those givens, and it's very hard for me not to paint it. It is a successful picture before you start, and it's pretty hard to blow it.

The mammoth 1974 Concentric Squares, whose titles Stella sees as evoking "the

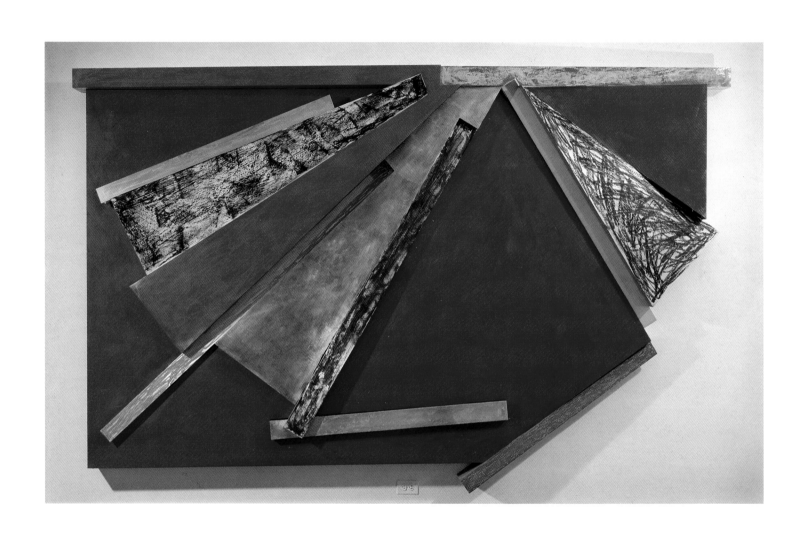

Grajaú I. (1974–75)
Mixed media on aluminum,
6′10″ × 11′2″ (208.3 × 340.5 cm)

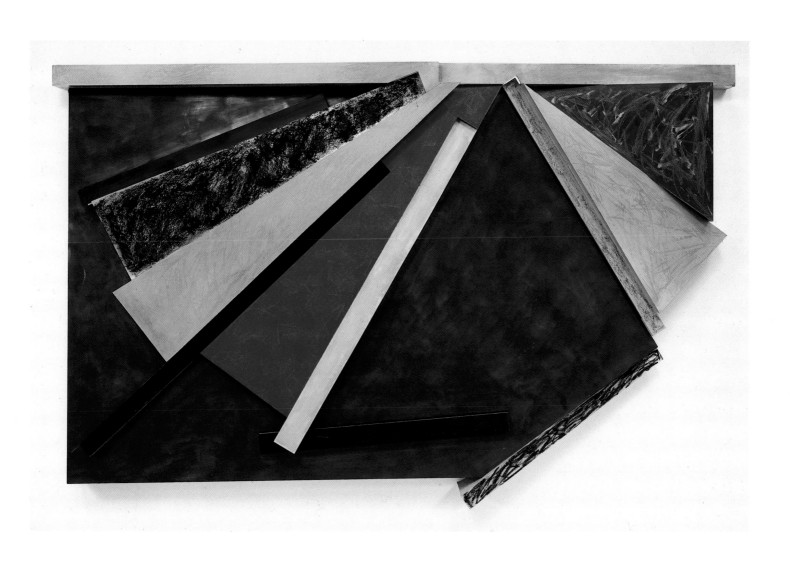

Grajaú II. (1975)
Mixed media on aluminum,
6'10" × 11'2" (208.3 × 340.5 cm)

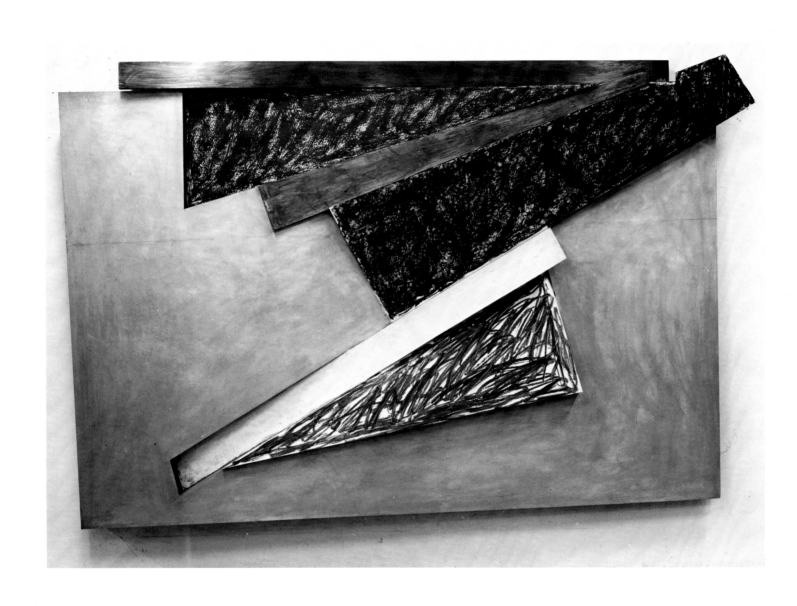

Arpoador I. (1974–75)
Mixed media on aluminum,
6′6″ × 10′4″ (198.1 × 315 cm)

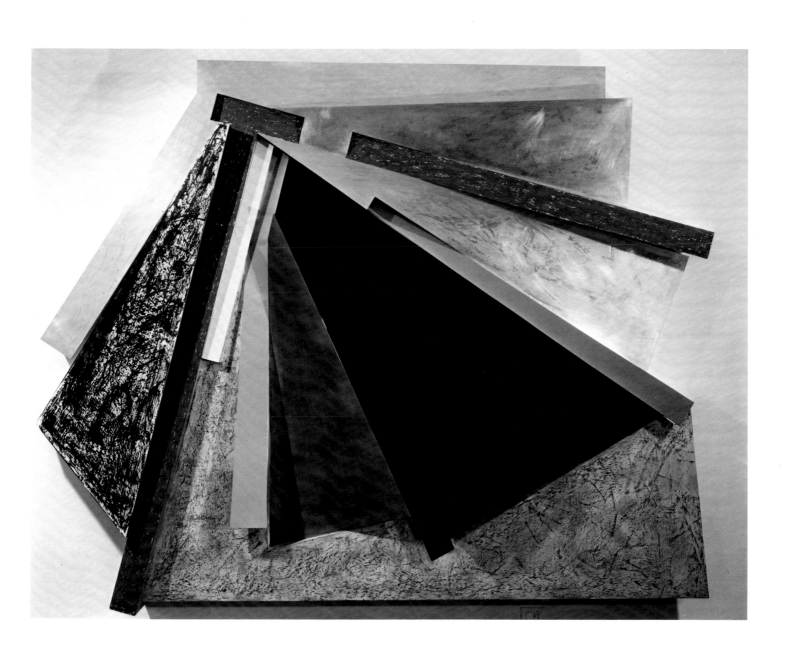

Montenegro I. (1974–75)
Mixed media on aluminum,
7′6″ × 9′9″ (228.7 × 297.2 cm)

notion of the critic" (and as referring particularly to Michael Fried's interest in Diderot),[28] share with all the earlier Concentric Squares a systemic use of both color and value scales. Systemic sequences were abstracted from the hues of the color wheel, and a division of the gray scale was made to correspond to it in number. Usually, each of these systems was used alone to constitute a picture (as in the hue sequence of *Bijoux indiscrets* [page 50] and the value series of *Sight Gag* [page 53]), but sometimes Stella juxtaposed the hue and gray-value sequences in a rectangle composed of contiguous square fields (as in *Le Rêve de d'Alembert* [page 49]). There was, of course, no real (i.e., optical or scientific) correspondence between the two sequences. In the "double concentric" pictures, the values of the successive hues did not directly correspond to the values of the gray bands that constituted their mirror-image counterpart. What the eye did distinguish, however, was the commonality of their progressive sequence—a sequence so obvious that it seemed to have been done "by the numbers." According to Stella,

The effect of doing it "by the numbers," so to say, gave me a kind of guide in my work as a whole. Everything else, everything that was freer and less sequential, had to be at least as good—and that would be no mean achievement. The Concentric Squares created a pretty high, pretty tough pictorial standard. Their simple, rather humbling effect—almost a numbing power—became a sort of "control" against which my increasing tendency in the seventies to be extravagant could be measured.

This "tendency" toward the "extravagant," which sets off all Stella's post-1967 work against the relentless sobriety of his beginnings, was not, however, without some influence on the Diderot series itself, despite the controlled and rational character that inheres in the Concentric Squares. Indeed, it is just this extra dose of "irrational" visual excitement that distinguishes the Diderot pictures from earlier Concentric Square pictures. Their particular character depends on the way Stella took advantage of their mammoth size. Expanded now to over 11 feet square (and to almost 12 by 24 feet in the double-square pictures combining the hue and gray-scale sequences), these large paintings would have looked very different had Stella simply enlarged the width of the bands in proportion to the enlarged size of the fields. Instead, Stella retained almost the same band-width he had used in much smaller pictures. And this unit of scale, when seen in the context of the much enlarged field, not only enhanced the impression of immense size, but permitted Stella to subdivide hue and value into more proximate units than ever before. In the early Concentric Squares, the leaps between hues on the color wheel had been considerable (Stella was then using only primaries and secondaries), as were the distances between gray values. The more graduated sequences permitted by the Diderot formats had implications for the images' spatial sense, for it endows these

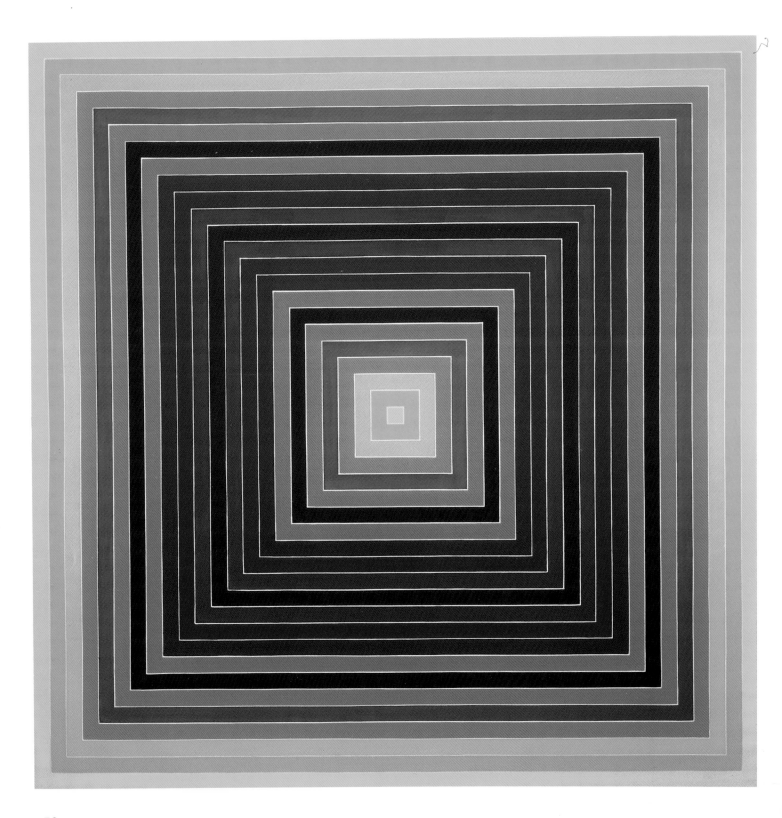

50

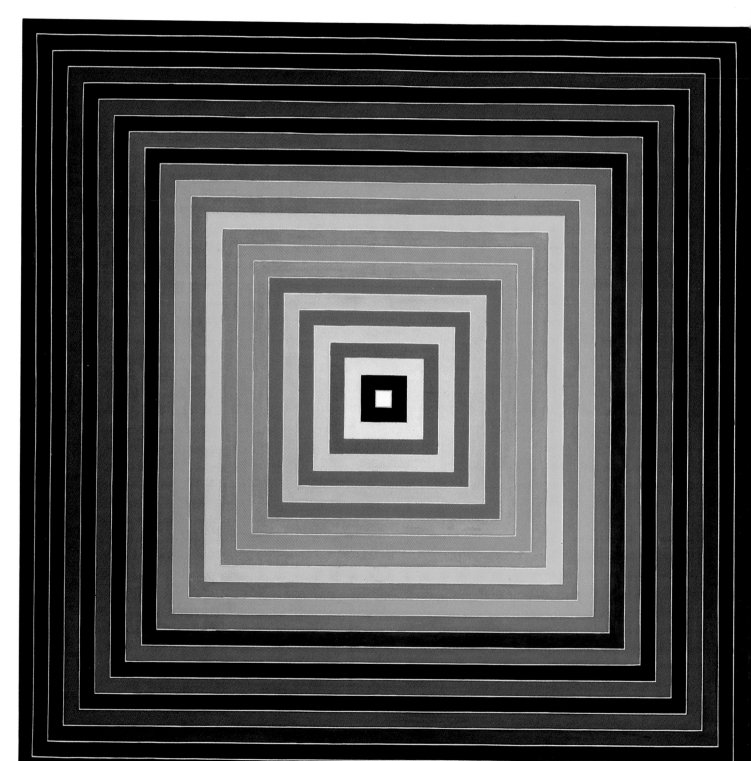

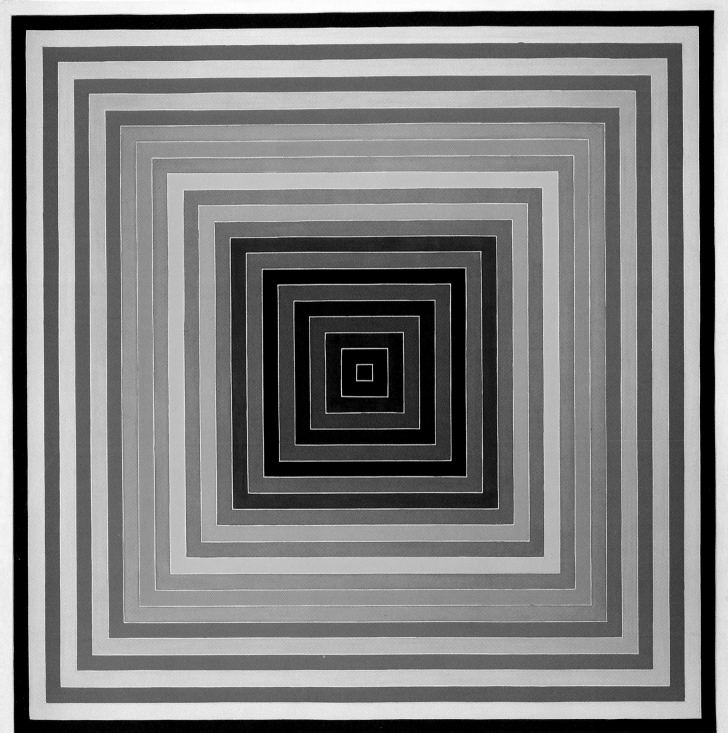

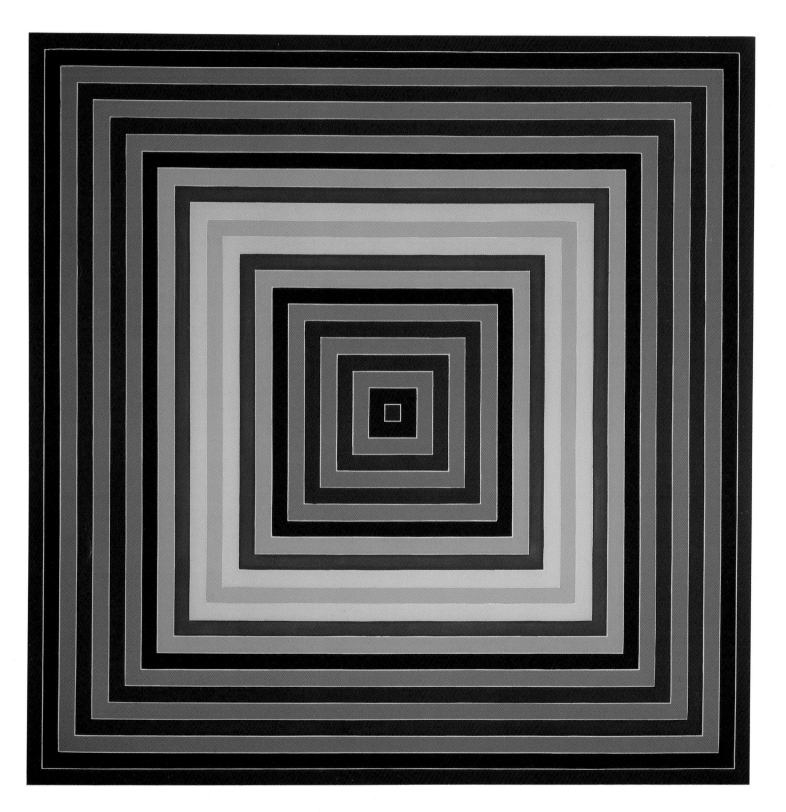

pictures with a hint of that ambiguous "schematic illusionism" that had entered Stella's work with the Polish Village pictures. This is probably what Stella had in mind when he said that he particularly liked the Diderot pictures "because they had a little hint of the extravagant—but in a very simple way that I think added to their effect."

WHATEVER THE BRAZILIAN PICTURES may owe the Diderot series in their emphasis on the pictorial rectangle, the oblique relief of their surfaces derived directly from the Polish Village works. What most clearly distinguished the Brazilian pictures as a group from these immediate predecessors was, however, the painterliness—often a kind of scribbly scumble—of their execution. Stella had never, of course, aimed at the "hard-edge" evenness of surface that characterized the work of Ellsworth Kelly and other of his contemporaries. Nevertheless, beginning with the Aluminum paintings (1960), Stella's paint application had had a studied evenness, though it breathed through the unprimed canvas in the manner of Noland's surfaces and was sometimes allowed to bleed slightly at the edges. In the Brazilian pictures, however, the now very visible marks of the brushwork and drawing, which are different in "handwriting" from panel to panel, act, in effect, to "texture" the surface in a variegated manner. In many cases, such as the brown scribble in the upper right of *Grajaú I* (page 44) or the black scumbling in the upper left of *Grajaú II* (page 45), the pictorial effect depends on the value contrast of the color seen against vestiges of the light aluminum ground. In other cases, such as the fuchsia in *Grajaú I* and *Montenegro II* and the blue in *Grajaú II*, the ground is entirely covered, but the varying densities of the prevailing colors create a subtle sense of painterliness.

While the accenting in the drawing and brushwork of the Brazilian pictures was kept within fairly tight limits, its painterliness marked a break with Stella's earlier work and a point of departure for all the freer and more dramatic drawing with color that would animate Stella's painting from the Exotic Birds of 1976 to the series of recent years. The Brazilian pictures also share with the later work a technical methodology first employed in them: the reliefs were fabricated in metal (in this case aluminum), and some of their surface planes were enlivened by scribble that was actually etched into the metal. This was accomplished by drawing on the metal surface with a lithographic grease crayon, after which the metal was passed through a caustic solution that ate away the surfaces unprotected by the drawing. The transparent lacquer-based colored inks that were subsequently applied assured that the relieved patterns of the etched lines would be highly visible.

The loosening-up of Stella's heretofore even paint application in the Brazilian pictures and, even more, the brash and dramatic gestural drawing in the Exotic Birds which followed hard upon, suggested to some critics that Stella was "returning" to the painterliness of Abstract Expressionism, which had been out of fashion for well over a decade. (And, indeed, Stella's move does seem to presage, in this

Sight Gag. (1974)
Synthetic polymer paint on canvas,
11'3" × 11'3" (343 × 343 cm)

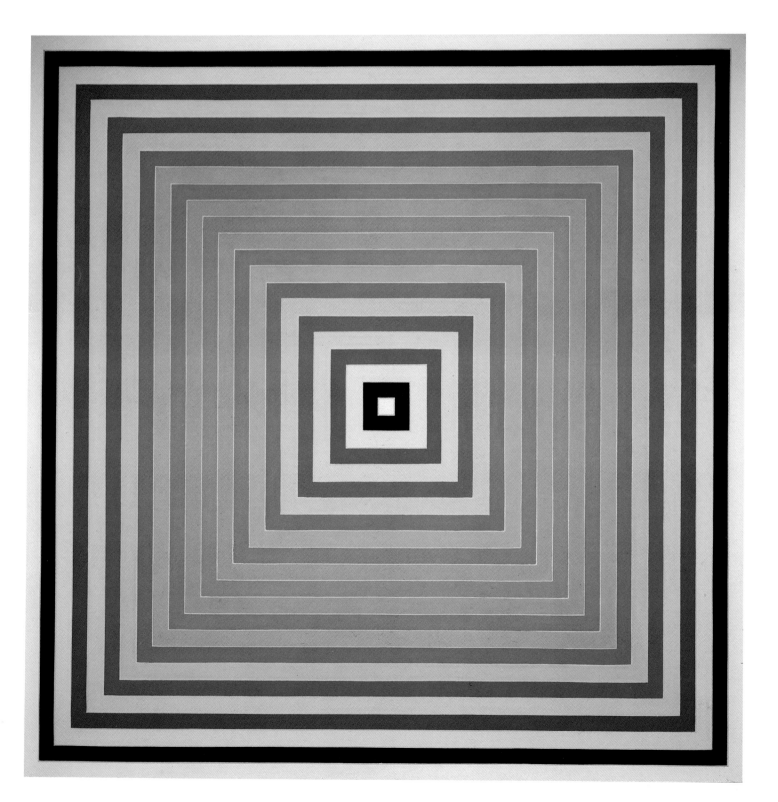

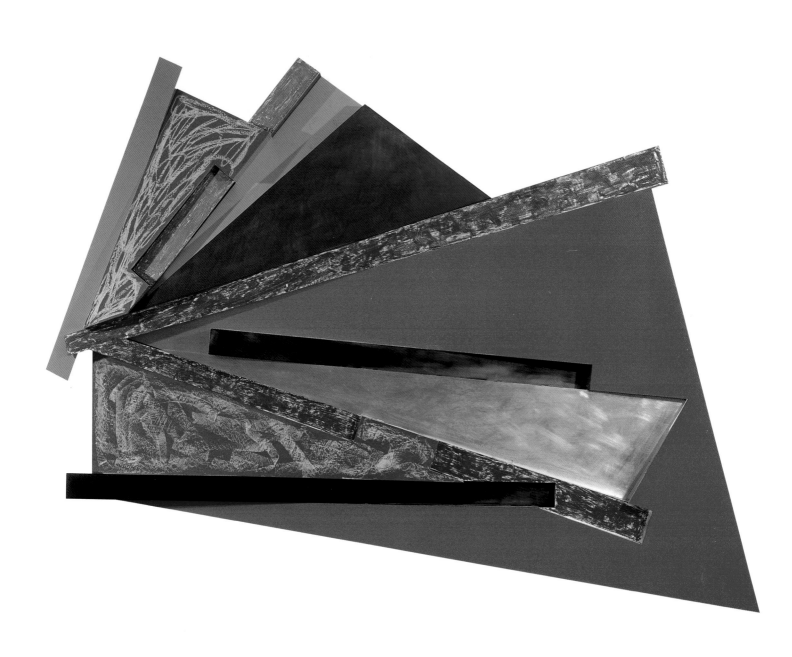

Joatinga I. (1974–75)
Mixed media on aluminum,
8′ × 11′ (243.9 × 335.3 cm)

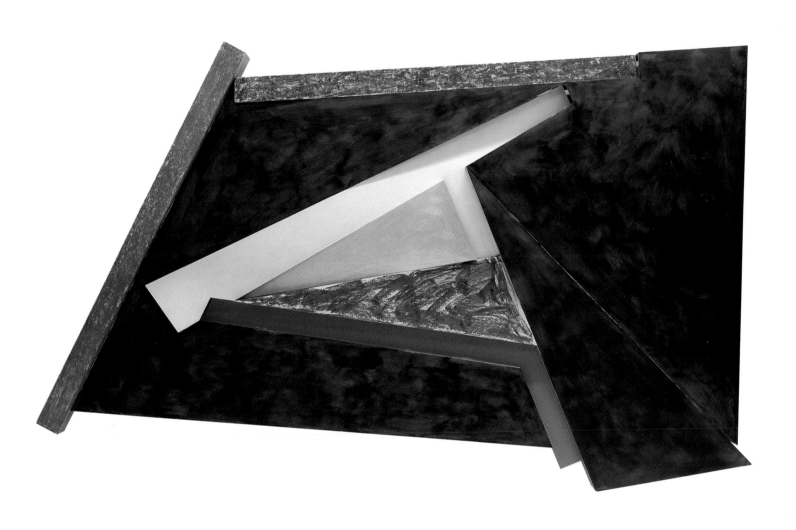

Leblon II. (1975)
Mixed media on aluminum,
6′8″ × 9′8″ (203.2 × 294.7 cm)

single respect, the swing of the pendulum that led a few years later to so-called Neo-Expressionism.) But, in fact, Stella's brushwork had little in common with that of painters such as de Kooning or Kline, for whom drawing with the brush constituted a form of contouring. If there are affinities with Abstract Expressionism, they are more with the all-over Pollocks and follow from the fact that both artists' handling is ultimately decorative: that is, aimed less at establishing form than at giving the surface a sense of overall movement and breathing—a kind of "pneuma"—by virtue of the velocity, and the changes in density and texture, of the drawing. For Stella, however, the form is already there when he begins to paint; it is preordained by the contours of the as yet unpainted aluminum planes. The role of both color and brushwork is further to endow these planes with individual character and, above all, to fix their flow and continuity within the composition as a whole. Purely as "handwriting," the type of extended drawing that Stella would launch in the Exotic Birds has a "low art" dimension, suggesting as it does certain aspects of recent graffiti-influenced painting (some years in advance, to be sure) and can be situated about midway between the more calligraphic side of Abstract Expressionism (and Dubuffet) and some East Village styles of the eighties.

Lapa I. (1975)
Mixed media on aluminum,
6'4½" × 10' (194.3 × 304.8 cm)

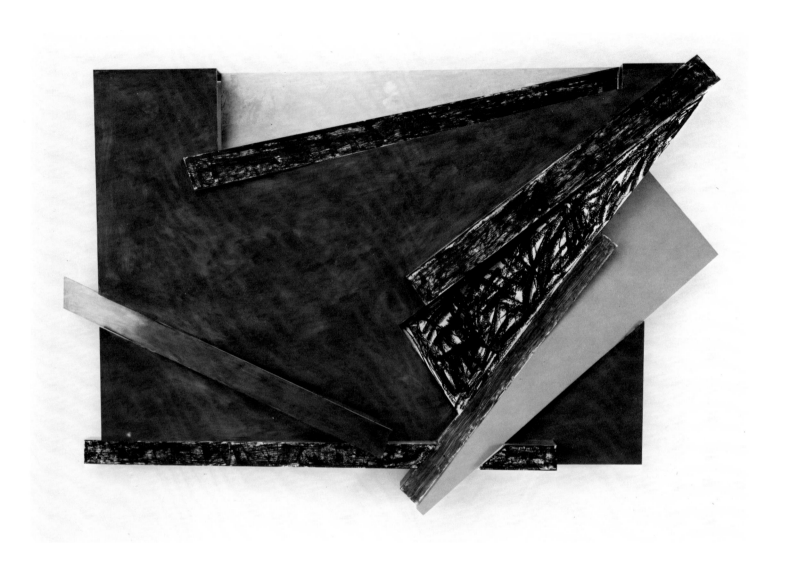

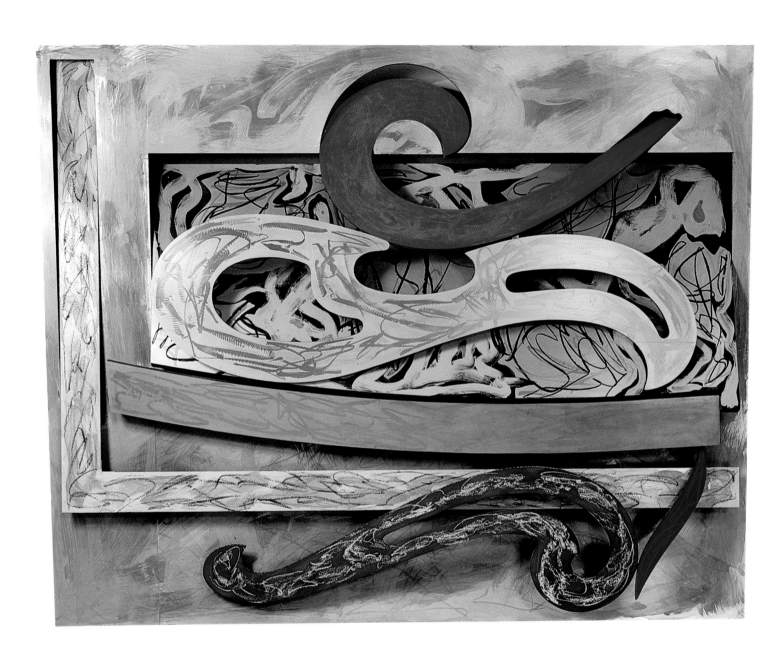

WHILE STELLA WAS executing the later Brazilian pictures in 1975, he was also formalizing his ideas for his next set of works in twenty-eight graph-paper drawings (page 60), which were shortly afterwards translated into Foamcore maquettes. The freely painted honeycombed aluminum reliefs enlarged from the maquettes (by factors of 3 and 5.5, two from each maquette) are known as the Exotic Birds. With them we enter fully into Stella's "second career." Compared to his move into the immediately preceding Brazilian pictures, the degree of change announced by the Exotic Birds was radical on the levels both of method and of pictorial language. The Exotic Birds witness the almost total subversion of Stella's geometricity and rectilinearity, in favor of a newly improvisational and apparently freewheeling curvilinearity. The latter is established first by the structure—the many asymmetrical curvilinear planes of the metal relief in its unpainted form—and intensified by the highly painterly execution. The meandering "handwriting" leaves far behind the essentially textural effects of the Brazilian reliefs, and becomes a form of extended cursive drawing with the grease crayon and brush.

Stella's new improvisational spirit informs every aspect of the Exotic Birds. In his earlier works, geometry controlled the compositions a priori, whether they were built outward by a governing "jog" in the stripes (as in the Aluminum pictures) or patterned inward from the contours of an enclosing geometrical form (as in the Protractor pictures). In the Exotic Birds, however, geometry ceases to be an all-over control, or to provide a "system" for the composition. To be sure, the pictorial rectangle—though often bent or tilted—returns in full force as the frame and ground for the pictures. But the layouts of the pictures can no longer be deduced from the geometry of the frame, any more than the outer contours of the pictures can be predicted from their interior structures.

The formal vocabulary of the Exotic Birds encompasses much more than the closed and regular geometries, such as the protractor and triangle, which had earlier been central to Stella's compositions. The morphology of the new reliefs is dominated by forms known in mechanical drawing as "irregular curves": templates of a type employed by marine and railroad draftsmen. With their use, the arabesque appears for the first time in Stella's compositional vocabulary and, typically for him, it makes its appearance not as freehand drawing, but through an appropriation of "readymade," prefabricated forms. In his earlier compositions, Stella had never drawn a freehand curve—and he would not begin now; all the curves in the Exotic Birds are taken from the fixed (though extensive) vocabulary of mechanical drawing.

The composing of each Exotic Bird began with a stunningly simple procedure. To form the major motif of his composition, Stella worked directly with the templates, moving them about on a large piece of graph paper so that they touched and overlapped. Only when he had "found" his motif did he establish the framing edge of his composition—the perimeter of the background or pictorial field—after which the smaller motifs were added and the image was further adjusted. "An important

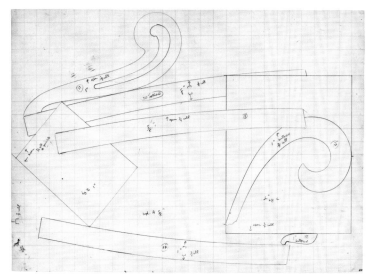

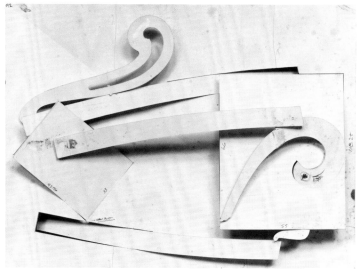

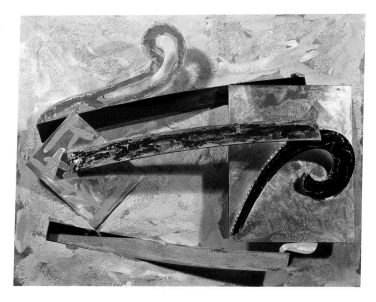

above, left
Drawing for *Inaccessible Island rail.*
(ca. 1976). Pencil on graph paper,
21⅝ × 28⅜″ (54.9 × 72.1 cm)

above, right
Maquette for *Inaccessible Island rail.*
(ca. 1976). Foamcore, 21½ × 28⅜″
(54.9 × 72.1 cm)

left
Inaccessible Island rail, 1×. (1976)
Mixed media on aluminum,
21 × 28″ (53.3 × 71.1 cm)

opposite, left
Inaccessible Island rail, 3×. (1976)
Mixed media on aluminum,
63″ × 7′ (160 × 213.4 cm)

opposite, right
Inaccessible Island rail, 5.5×. (1976)
Mixed media on aluminum,
9′9″ × 12′9″ (297.3 × 388.7 cm)

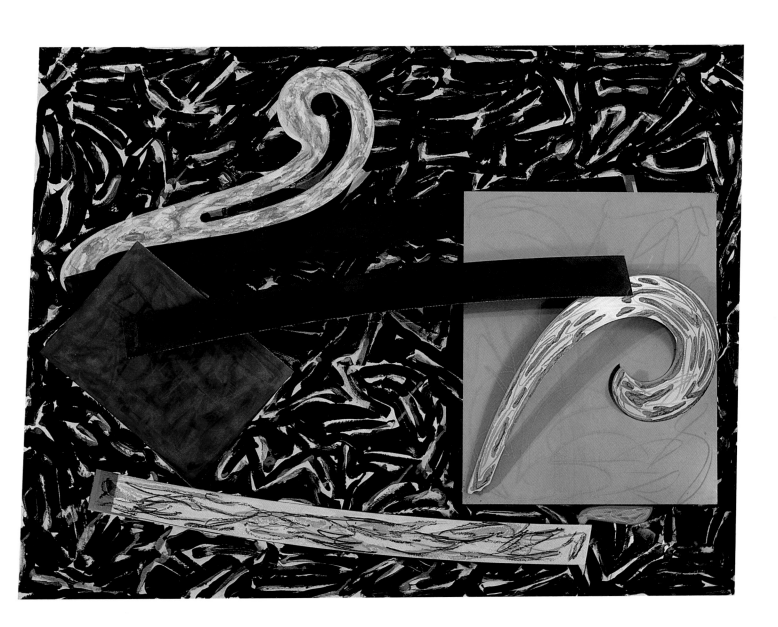

Bermuda petrel, 3×. (1976)
Mixed media on aluminum,
61½″ × 6′11½″ (156.2 × 212.1 cm)

Bonin night heron, 5.5×. (1976–77)
Mixed media on aluminum,
8′3″ × 10′5⅜″ (251.5 × 318.5 cm)

aspect of using the templates," Stella recalls,

was that they permitted me to effect my own version of coming free on the surface. I was now free to do easily what most people did the hard way. I could make so-called relational paintings or, rather, the structural schemas for such paintings, just by sliding the templates around the surface. No need to erase, paint out, or redo. Only when I had the composition the way I wanted was it transferred to the graph paper—directly into a mechanical drawing—and then into a three-dimensional Foamcore maquette, where I turned the template forms at angles to the picture surface.

Although Stella had been familiar with the templates known generically as irregular curves for some time, he had previously employed only commonplace drafting instruments—usually a ruler and/or beam compass and, less frequently, a triangle, right angle, or protractor. In 1975, in California, he stumbled on an elaborate set of ship curves, used in nautical design, which he decided to buy. "It was an incredibly elaborate and expensive set of almost a hundred templates," Stella recalls. "There were many more templates than I could ever possibly use, because the size gradations were so tiny—you could get what seemed like thirty different versions of one shape. But I liked that repetitious quality, the endless variations. Later I purchased sets of railroad curves and French curves."

Of the types of irregular curves Stella used in the Exotic Birds—he would enlarge his vocabulary of these in later series—the most elaborate are certainly those known as French curves.[29] Vaguely suggesting musical G clefs, these ornamental templates are actually used by draftsmen for the purpose of joining three disparate points by a smoothly curved line. A large horizontal French curve dominates the center of *Eskimo curlew* (page 58); a small one is used as a complex curvilinear accent in the upper left of *Dove of Tanna* (page 72). Given its enclosed spaces and complicated multi-directional contours, the French curve was the most self-sufficient, most autonomous of the irregular curves Stella chose to use—and therefore the most difficult to absorb into the overall fabric and rhythm of a composition (as is evident in the problematic aspects of such a relief as *Mysterious Bird of Ulieta* [page 76]).

Much more easily assimilated into compositional structures, because simpler and more open in form, were the ship curves. In *Newell's Hawaiian shearwater* (page 65), three of these are grouped to open outward and upward from the bottom center, the left one paired back-to-back with a shorter, wider curve of the same type. Railroad curves, used by engineers to plot the turning of railroad beds, are much closer to straight lines than the other irregular curves, and were sometimes used by Stella in the Exotic Birds as surrogates for the ruler and right angle to provide "architectural" accents in the structure, as in *Bermuda petrel* (page 62). A diagonal railroad curve is paired with a French curve in *Bonin night heron* (page 63).

Newell's Hawaiian shearwater, 5.5×. (1976)
Mixed media on aluminum,
9'4" × 12'10" (284.6 × 391.3 cm)

64

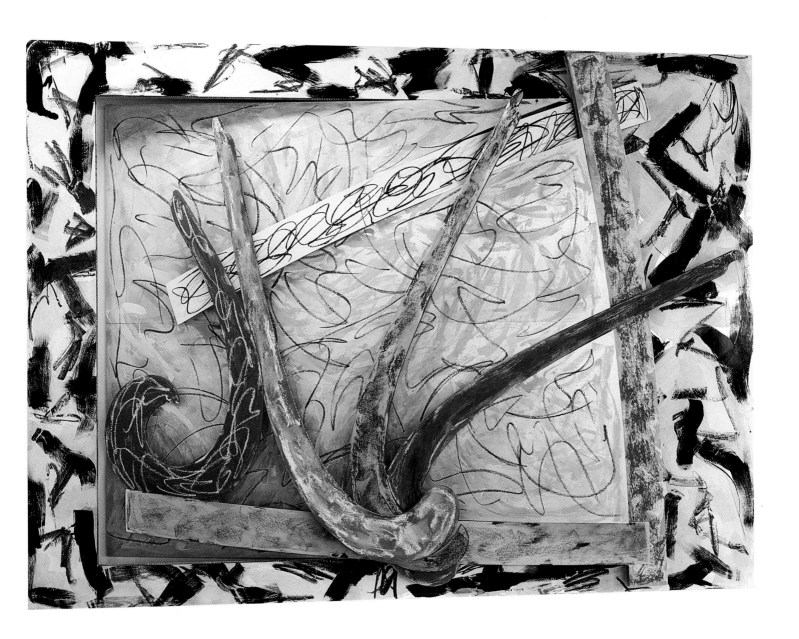

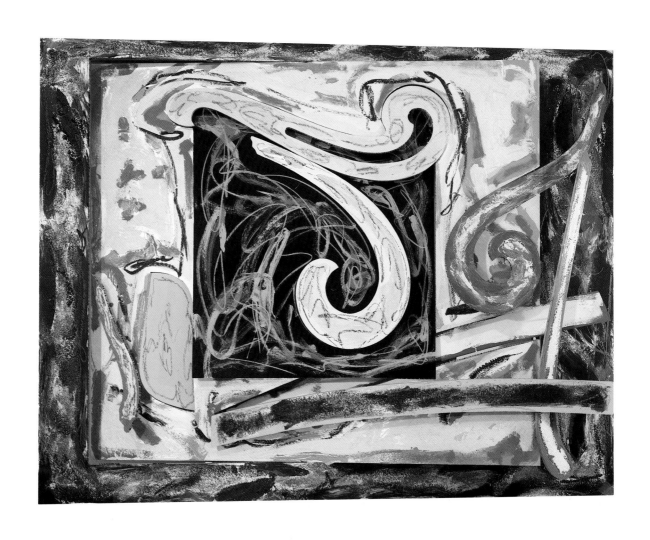

Steller's albatross, 3×. (1976)
Mixed media on aluminum,
65¼″ × 7′1½″ (165.8 × 217.4 cm)

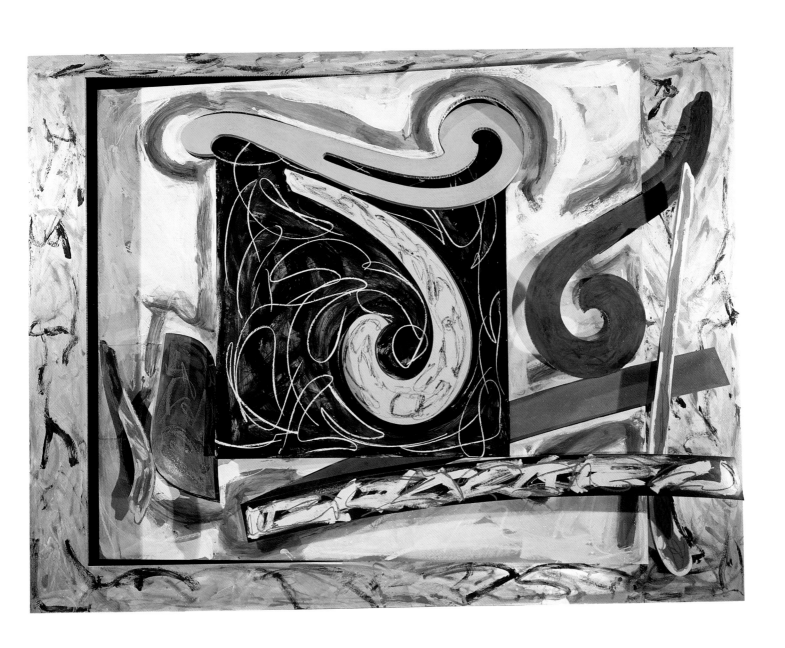

Steller's albatross, 5.5×. (1976)
Mixed media on aluminum,
10′ × 13′9″ (304.8 × 419.1 cm)

Stella at work on the Exotic Birds in his studio, 1976

Insofar as the multiple curvilinear forms in the Exotic Birds want a foil, they seem to have confirmed Stella's return to a straightedge rectangular picture field, which the artist thought necessary to support the irregular curves. The play of the curved planes against this more regular, rectilinear ground to which they were attached constituted a form of figure-ground relationship, a pictorial convention that Stella had heretofore largely avoided. (Indeed, Stella's shaped paintings of the early sixties might be described as abstract "figures" whose vestigial "grounds" had been

lopped off.) Having accepted the need for such backgrounds, Stella proceeded to do everything he could to diminish their role. Their rectangles are cut open, tilted from top to bottom, bent backward from both the vertical axis (*New Caledonian lorikeet* [page 74]) and the horizontal one (*Wake Island rail* [page 70]), and sometimes "doubled" inside or outside the compositional network (as in *Steller's albatross* [pages 66, 67]).

This "distressing" of the backgrounds was simply a first stage in Stella's attempt to minimize the presence of a compositional constituent he felt obliged to readmit. In the second stage, the actual painting of the reliefs, he further minimized figure-ground distinctions by bringing the grounds forward optically, subsuming them into a fabric of all-overness through their active, painterly execution. The metal surface, which reflects through the translucent paints, and the ground glass, which was spread on certain areas before adding color, "helped give me the freedom," says Stella, "to dematerialize the background."

IT IS NOT SURPRISING that draftsman's templates should have held a special fascination for Stella, given his proclivities as "engineer." To be sure, they are, in the first instance, simply objects in the world of objects. But unlike most objects, they are themselves abstractions—intended as tools for representing the structure of objects that have a more conventional level of reality. In putting these tools in the service of a painterly and improvisational style, Stella could be said to have deflected their rational spirit as well as practical purposes. Their use is, of course, consistent with the morphological sources (rulers, protractors, and so on) Stella had used earlier, insofar as they are part of the draftsman's battery. But within that order, they clearly represent a choice in the direction of the Baroque—which was also the spirit in which the forms derived from them were subsequently painted.

In his continuing commitment to a resolutely non-figurative type of painting, Stella had always used a vocabulary of abstract geometrical forms. But the forms that he used in his earlier painting, in part because of their simplicity and/or symmetry, never had the insistent image-making quality possessed by the irregular curves. With their use, Stella approached a kind of "abstract figuration," whose antecedents go back through Pollock to Kandinsky. As Stella himself observes, "The template forms function figuratively—though in an abstract sense." Rosenblum characterizes the irregular curves as "the abstract equivalent of figures that move, twist, and collide in a shallow space. . . . In these works, abstract art suddenly seems to have a new kind of bone and flesh that muscles its way from two to three dimensions with the epic struggle we recognize from centuries of old-master figural compositions."[30]

The problem of getting the abstract "figures" to cohere meaningfully and dramatically within the spatial structure of the work had to be solved essentially in the initial composing of the maquette. The task of refining those relationships, of overcoming

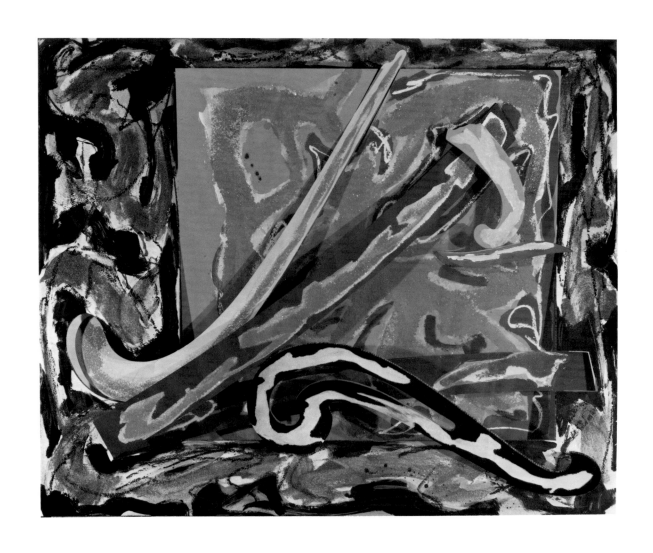

Wake Island rail, 3×. (1976)
Mixed media on aluminum,
54 × 69″ (137.2 × 175.3 cm)

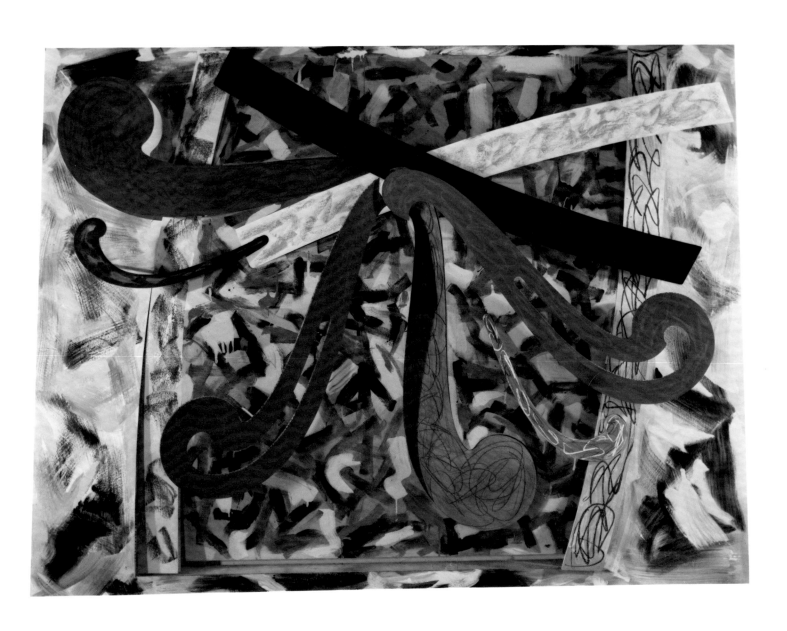

Puerto Rican blue pigeon, 5.5×. (1976)
Mixed media on aluminum,
9′4⅛″ × 12′9⅝″ (284.8 × 390.2 cm)

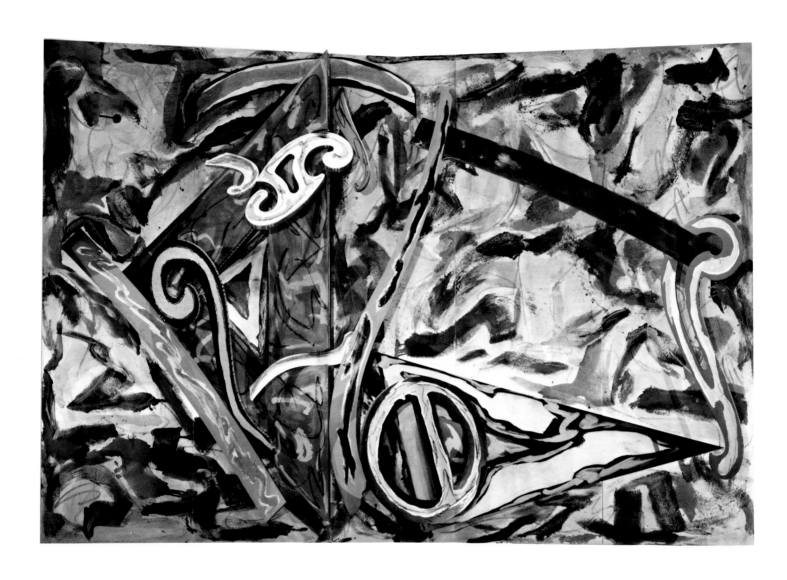

Dove of Tanna, 5.5×. (1977)
Mixed media on aluminum,
12′10″ × 18′9″ (391.2 × 571.5 cm)

the mechanical quality of the template "figures" and bringing them, in the artist's terms, "to life," was left to the act of painting. The "life" with which these "figures" were to be invested was to be pictorial, and was unrelated to the templates' original purpose or existence. "The templates start," Stella observes,

with an image value and an aesthetic existence of their own, whether or not you recognize them—as I do—as tools. I wanted to transform that, to raise the level of it from design into art, and to make it physical; in effect, to give the templates a real presence, a pictorial presence. The huge shift in scale alone changes everything. There's a different perception. The irregular curves cease to be design....The struggle to make the forms in the painting "real," to make them physically present, is the lesson—if I can call it that—which I learned from Picasso. It's not the presence of a recognizable figure in Picasso that in itself makes things real, but his ability to project the image and to have it be so physical, so painted. It's so aggressively painted that it bursts out into image, and that image has a sense of being real, of breaking through pictorial boundaries to coexist in our everyday space. For me, painting these metal reliefs is a way of infusing the piece with life; the brushstrokes, the flow of paint, might be compared to the circulatory process in the body. Abstraction has to be made "real" in Picasso's pictorial sense of that word....To the extent that the abstract image has to be infused with a physical pictorial presence, abstraction has, in some curious sense, not to be abstract.

Stella conceived of his abstract "figures" above all as a means of creating and articulating a viable new space, one that could compensate non-figurative painting for the space choked out of it by medium-oriented painters in the decades following Abstract Expressionism. "The crisis of abstraction," Stella insists, "followed from its having become mired in the sense of its own materiality, the sense that the materials of painting could and should dictate its nature. That's not enough, and the belief that it was was killing painting."

To defy the "dictatorship of the medium" was at once to challenge the premises of the absolute literalism that had earlier been the starting point for Stella himself, and for his sixties colleagues, and to reopen the door to other alternatives. The result, seen in the Exotic Birds, was the projection of a more flexible, more ambiguous— i.e., less emphatically literal—space. The relief space measured by actual three-dimensional forms is constantly being fused and confused with alternative spatial cues suggested by color, painterly brushwork patterns, and eliding forms. Within this "mixed" space—at once literal, optical, and illusive—Stella wanted the shifting planes of his irregular curves to create a modern version of "that spatial mobility which the human figure articulated in the illusionism of the Old Masters." For an analogy to this difficult-to-determine space, Stella turns to what mathematicians call "fractals," irregular (or chaotic) figures whose dimensions are not limited to descrip-

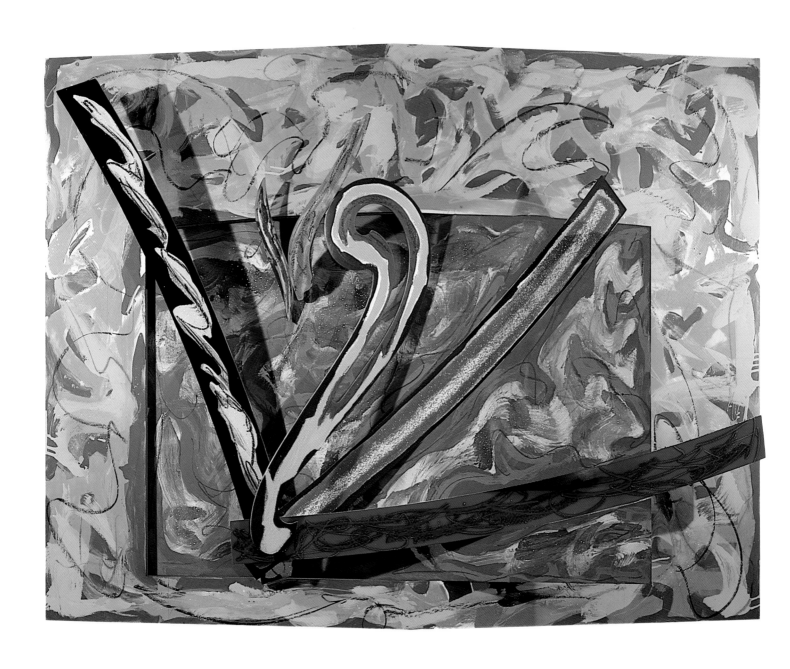

above
New Caledonian lorikeet, 5.5×. (1977)
Mixed media on aluminum,
10′ × 13′ (304.8 × 396.3 cm)

opposite
Brazilian merganser, 5.5×. (1980)
Mixed media on aluminum,
10′ × 8′ (304.8 × 243.8 cm)

74

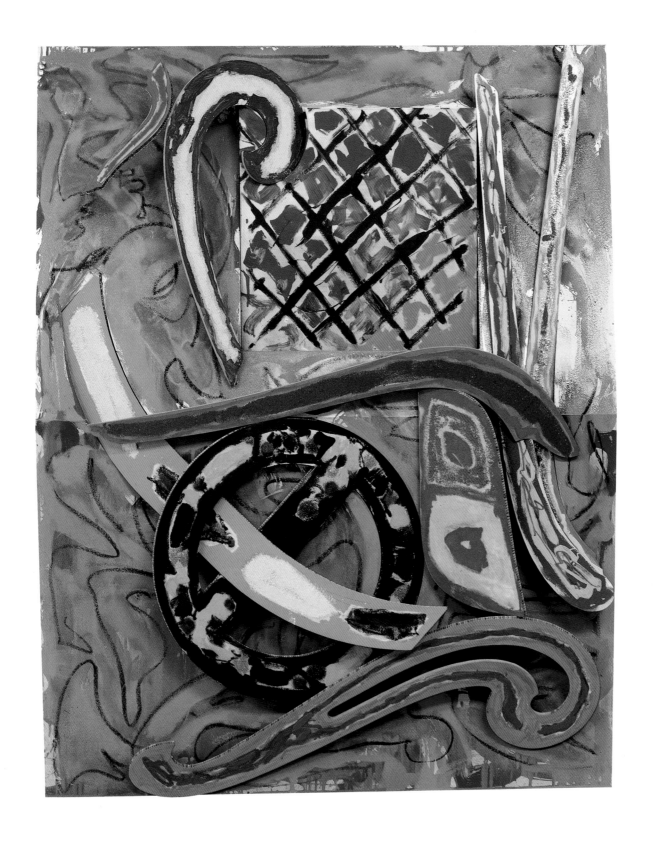

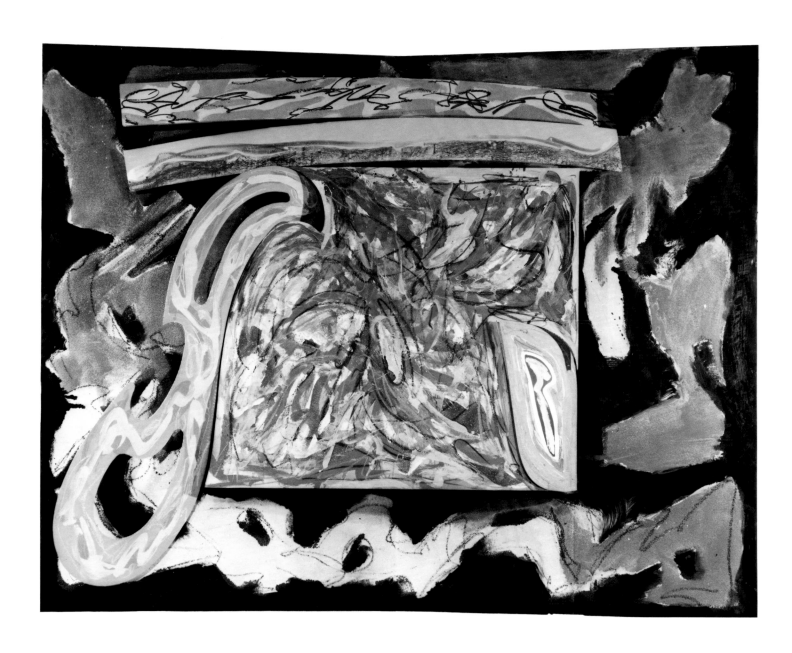

tion by whole numbers. "Mathematicians talk now about figures of 1.78 dimensions, or 2.3 dimensions," Stella observes.

I can imagine getting a grasp on these figures, on what it might be like to measure a cloud or the coastline of England. It seems to me that there's some hint of this kind of chaotic, ambiguous figuration in painting, with its inherent three-dimensional illusionism in constant tension with its two-dimensional surfaces. Pictorial space is one in which you have two-dimensional forms tricked out to give the appearance of three-dimensional ones, so that the space you actually perceive comes down somewhere in-between. And somewhere in-between isn't a bad analogy for my work. I work away from the flat surface but I still don't want to be three-dimensional; that is, totally literal ... more than two dimensions but short of three so, for me, 2.7 is probably a very good place to be.

Whatever reservations Stella may have had about using a regular ground to support his projective "figures" in the Exotic Birds, it is clear that he was not unhappy with the results, and that the execution of these works occasioned a more relaxed exploitation of his pictorial gifts than he had ever experienced before. Beginning with the Exotic Birds, there is a sense of expansiveness—a confidence and freedom—in Stella's art that stands alone in the abstract painting of the seventies and eighties. Free now of the pervasive a priori planning demanded by the seriality of the stripe paintings, Stella could enjoy the painterly execution of the metal reliefs in a more spontaneous way. The mood of Stella's work becomes, for the first time, exuberant. And the sense of the painter as *homo ludens* established in these pictures has persisted to the present. As Stella tends to view the development of his painting strictly from within its own interior dynamics, he does not identify this overall change of mood in his work with particular events in his personal life. Yet it is hard not to see the change at least in part as a function of his happy second marriage, to Harriet McGurk, and a new family; the titles of the Exotic Birds, in any event, relate directly to a new interest encouraged by his wife. Apart from assiduously playing tennis and squash, Stella's recreations had previously been the racetrack (where he sometimes runs his own horses)[31] and watching Grand Prix auto racing. "But Harriet got me into bird-watching," he recalls. "I couldn't believe I was in the Everglades instead of being at Hialeah. Before that, my idea of an exotic bird was The Flamingo—a grade-one stake race."

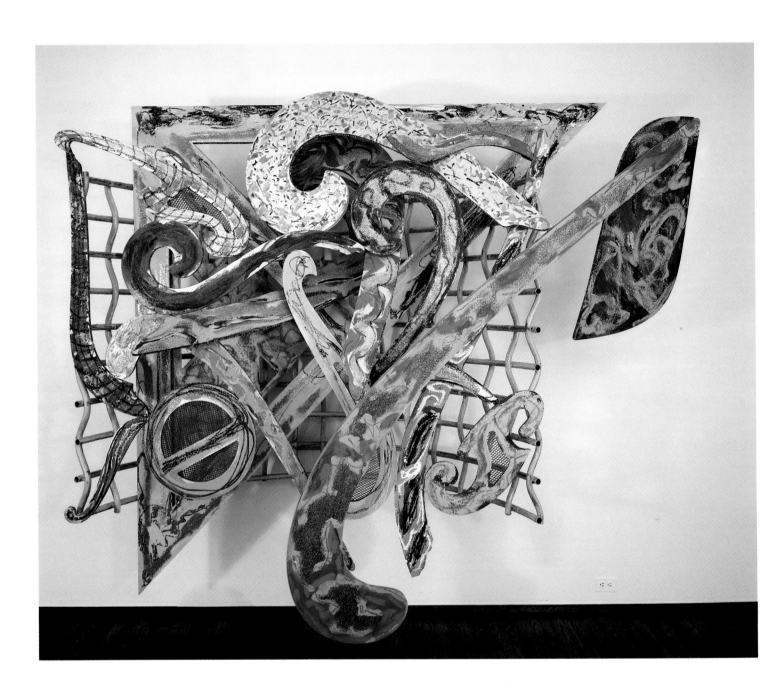

Jungli kowwa, 5.5×. (1978)
Mixed media on aluminum, metal tubing, and wire mesh, 7′2″ × 8′6″ × 38″
(218.5 × 259.1 × 96.6 cm)

WHETHER OR NOT, like the Japanese artists, one changes one's name, a "second career" remains the career of the same human being. Not surprisingly, therefore, despite the differences that distinguish the Exotic Birds from Stella's earlier work, some important continuities exist. There remains, as Rosenblum puts it, an "overriding sense of method in his madness....[Stella's] wildest exuberances, we realize after prolonged looking, finally tick away with the same clockwork order as his most taciturn reductions."[32] The structural part—the reliefs themselves—is still adapted from forms that pre-exist in the rational world of geometry and mechanical drawing, and the reliefs are constructed from drawings plotted methodically on graph paper. This essentially conceptual first step is intended, as in the early work, to provide Stella with something more than a neutral surface on which to paint. Its aim is a surface that *inspires* him to paint, and thus give a corporeal pictorial presence to an abstract idea (in the same sense that painting the Black pictures transformed diagrams into art). "I think one's understanding of structure, one's sense of the relationship between things, remains largely the same," Stella says.

I think you're born with a particular sense of structure and you can't really change it. My sense of how things go together, of what constitutes equilibrium, stays the same—as, for example, the way I put things edge-to-edge, point-to-point. If you look carefully at work as different as the Exotic Birds and the Running V stripe pictures, you'll see that the V's relate edge-to-edge and point-to-point in a similar way. Although it looks very different, it's the same sensibility.

THE INDUSTRIAL FABRICATION of the middle-size (3×) and large (5.5×) aluminum reliefs that were to be enlarged from the maquettes of the Exotic Birds proved to be a complex and time-consuming process. Given the large number of works involved, it is not surprising that their making (in the factory) and their painting (in the studio) spread over several years. The earliest Exotic Birds left the studio in 1976; the last were completed only in 1980. In the meantime, however, Stella was impatient to develop a new idea for a group of pictures in which he would be able to eliminate the figure-ground relationships that had seemed inevitable in the Exotic Birds. These were to be the Indian Birds; for them Stella created an openwork grille structure on which the irregular curves could be affixed, effectively replacing the "background" supports of the Exotic Birds. These discreet curved grilles permitted one to see through to the wall behind (pages 85, 87), and made the compositions attached to them seem almost to float free of support. As such, they constituted a counterpart in Stella's work to a unique Pollock that had always interested him, *No. 29, 1950*, in which Pollock seemed to make his web of oil paint, pebbles, and wire mesh autonomous by supporting it on a transparent pane of glass. At the same time, Stella points out that the seemingly invisible suspension of the Indian Birds contained

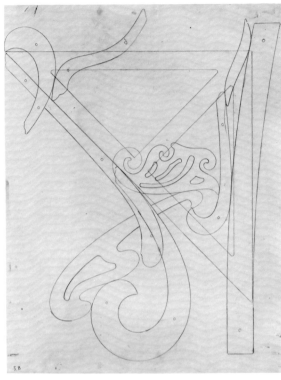

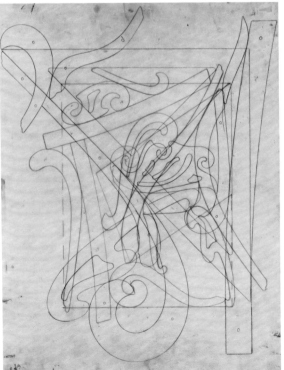

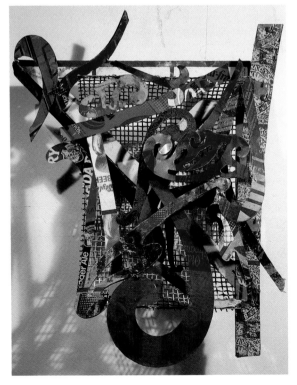

top, left
Drawing A for *Rām gangra*.
(1977). Pencil on transparent paper, 22 × 17″
(55.9 × 43.2 cm)

top, right
Drawing B for *Rām gangra*.
(1977). Pencil on transparent paper, 22 × 17″
(55.9 × 43.2 cm)

bottom, left
Drawing B superimposed
on drawing A for *Rām
gangra*. (1977)

bottom, right
Maquette for *Rām gangra*.
(1977). Silkscreened metal
and wire mesh,
20¼ × 16½ × 6½″
(51.4 × 41.9 × 16.5 cm)

opposite
Rām gangra, 5.5×. (1978)
Mixed media on aluminum,
metal tubing, and wire mesh,
9′7″ × 7′6½″ × 43½″
(292.2 × 230 × 110.6 cm)

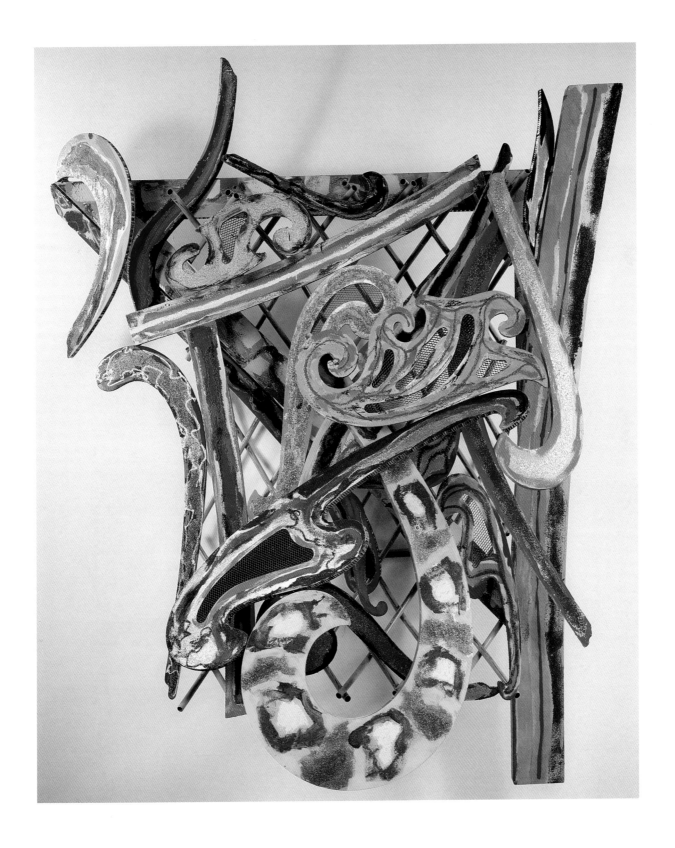

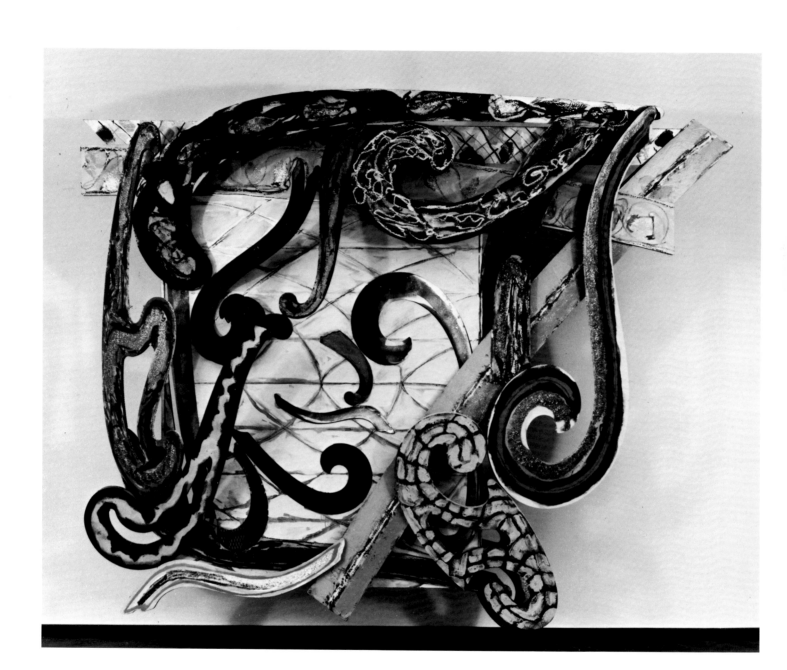

Bulal-chashm, 5.5×. (1978–79)
Mixed media on aluminum, metal tubing,
and wire mesh, 7′10″ × 9′9″ × 45½″
(238.8 × 297.2 × 115.6 cm)

echoes of a work on glass even more remote in time and style than the Pollock, but one for which he had always had an affection, namely the *Large Glass* of that earlier "engineer," Marcel Duchamp.

There are only twelve large reliefs in the Indian Bird series, all of them painted in 1978–79, on 5.5× enlargements of maquettes Stella had executed in October 1977, while a guest of the Sarabhai family at their residence in Ahmedabad, India. The Sarabhais' foundation regularly played host to visiting artists and was generous in furnishing assistants. Starting with four, Stella's crew grew to twenty-four (including part-timers), which permitted him to realize the maquettes of the twelve works in just that many days. (A duplicate was executed for each maquette, and Stella gave the second set to the Sarabhais; the working set actually used for making the large reliefs was later donated to The Museum of Modern Art.) The finished maquettes reminded Stella of birds in cages, so he found a book on birds of India, from which the titles are taken. ("It struck me as a nice idea to use them.... It was very casual.")[33]

The conception of this series had begun to be elaborated before Stella's departure for India. He carried a few drawings with him as well as one maquette (in Foamcore and paper) for what eventually became *Maha-lat*, the second Indian Bird in the sequence of drawings. Whereas the maquettes of the Exotic Birds had been composed by manipulating the templates themselves, the densely overlapped, more three-dimensional compositions of the Indian Birds obliged Stella to return to the "control" of preliminary drawings. Each maquette was therefore developed by means of a pair of drawings (A and B) on transparent paper. These showed different "layers" of the reliefs, and could be superimposed on one another (page 80). As Foamcore was not available in Ahmedabad, the forms for the maquettes were traced on, and cut from, discarded sheets of tin alloy originally intended for use as soft drink and food cans. (The sheets had been scrapped because their silkscreening had misregistered or been overprinted.) This serendipitous choice of materials proved providential, for the printed tin endowed Stella's maquettes with an aesthetic all their own. The fragments of commercial logos and other print and design elements on the tin enriched the irregular curves cut from them with a quasi-painterly, all-over flicker of light and dark that had legible "pop" associations (page 80). After shaping, these surfaces needed only a bit of overpainting or crayon drawing in order to be accommodated to the compositions.

The governing structure of the Indian Birds is essentially tripartite: the opaque rectangular ground that supported the irregular curves in the Exotic Birds is replaced by the openwork grille support, which is curved into what could be described as a segment (or segments) of a cylinder (clearly visible in the side view of *Kastūra* [page 90]). The two forward edges of the grille support the second element of the structure, a plane of irregular curves set at right angles to the viewer's line of vision, as they are shown in drawing A for *Rām gangra* (page 80). The drawing shows how this plane can quite literally hold itself together through the fastening of

the parts (by soldering, in the maquettes) at the multiple touchings of its twelve very different irregular curves (which are varieties of ship curves, French curves, and railroad curves); the plane is secured along the horizontal top and bottom of the grille, which are represented in the drawing by straight lines (the broken lines represent the vertical sides of the grille receding into deeper space). The planes of irregular curves shown in each drawing A for the twelve compositions thus constitute a kind of free-floating "picture plane" that establishes and maintains the pictoriality of the relief's structure.

Penetrating this "picture plane" at different angles, as well as passing both in front of it and behind it, is the third component of the tripartite structure. This is made up of another group of irregular curves, chosen from a scale group three times larger, as in drawing B for *Rām gangra* (page 80). Such second (or B) drawings for the Indian Birds are not, as in the case of the A drawings, diagrams of a flat plane of irregular curves, but rather a kind of "schematic of intentions" identifying curves that would actually be attached at different angles and levels of space in the three-dimensional model. As they are not drawn in perspective, these shapes would undergo a slight displacement in the translation from drawing to model (the way the French curves and ship curves in the center of drawing B for *Rām gangra* have moved in the maquette so that these very forward elements of the composition partially overlap the large vertical railroad curve that closes the composition on the right). In addition, the actual maquettes contain some elements not foreseen in the transparent drawings for them, Stella having subsequently added odd bits of scrap, such as screening, wire, metal rods, and mesh.

In many respects, the Indian Birds represent the apotheosis of Stella's Baroque tendencies. The irregular curves that appeared in them were grander, more asymmetrically handled, larger in number, and more complex in their structural interrelationships than those of the Exotic Birds. Gone were the large straightedge fields that had provided backgrounds for the latter; there are very few straight lines in the Indian Birds, and they never contour more than fragments of the relief. The absence of a containing background, combined with the seemingly bolder angles at which the large irregular curves projected, made the visual assimilation of the Indian Birds no simple matter. Their challenge was reinforced, moreover, by a glitzy palette which (especially in *Khar-pidda* [page 85], *Shāma* [page 89], and *Rām gangra* [page 81]) made the color schemes of the Exotic Birds seem almost classical by comparison.

Though Stella's color schemes in the Indian Birds move further from primaries than had those of the Exotic Birds—apart from quantities of gold paint, they are abundantly charged with remote off-shades of "candy-box" colors—their appearance of willful "bad taste" was even more due to the sequin-like glitter of many of the panels. This effect—which has analogies with the Cubists' use of sand—was produced by adhering particles of metal shaving and/or ground glass to a first layer of color, and then painting or, more often, staining over that. Although metal

Khar-pidda, 5.5×. (1978)
Mixed media on aluminum, metal tubing, and wire mesh, 10'2" × 7'4" × 35" (309.9 × 223.5 × 88.9 cm)

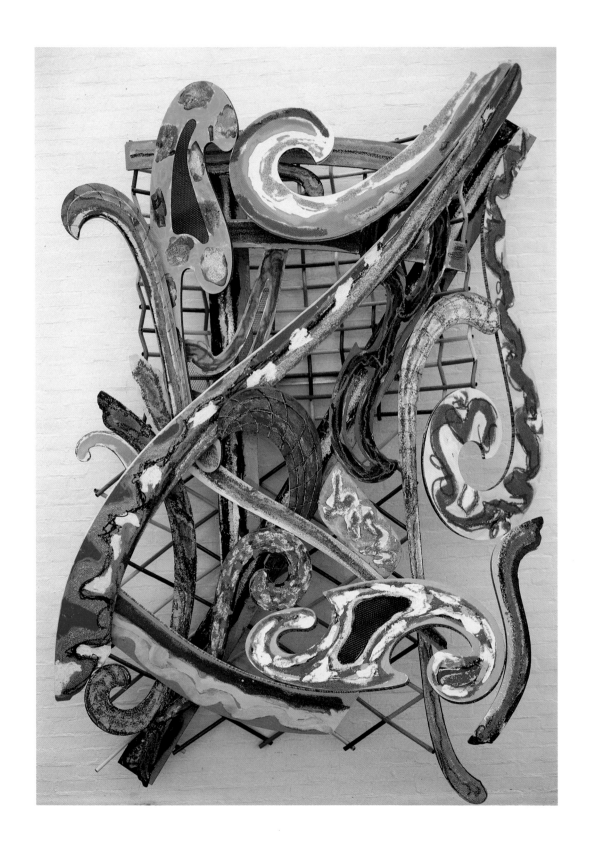

shavings and ground glass had already been used to texture some panels in the Exotic Birds, their far more liberal use here, and the fact that they were often gone over with translucent washes rather than opaque paints, accounts for the more emphatic sense of glitter. Time has taken some of the sting, however, from the deliberately treacly palette of the Indian Birds. "To me they look quite tame now," Stella observes, "but some people did find them outrageous."

Neither before nor during his trip to India did Stella show a particular interest in that country's art. The glitter, the gold, and the "bad taste" hues that were painted,

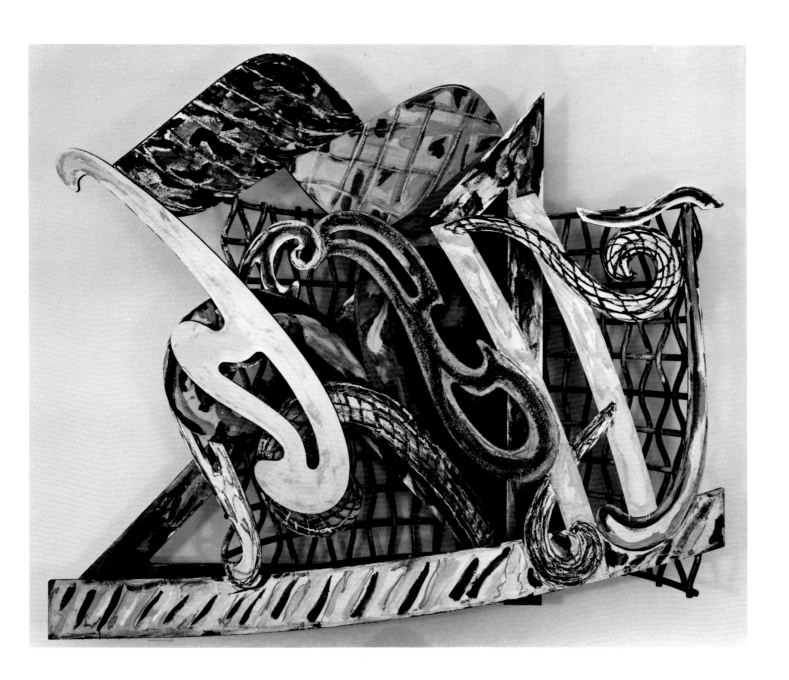

stained, or washed into the Indian Birds sooner reflect his experience of India's urban scene—the sequins and cosmetics ("people with blue faces"),[34] the exotic dyes of the textiles, the colorism of street life. But something in their singular color schemes also resonates with the American scene. When the Indian Birds were first shown, their garish palette struck some critics, not entirely mistakenly I think, as "disco." And there is, in fact, an artificiality and brashness to their hues and their surface effects that can as easily be said to encompass Las Vegas, Coney Island, and Little Italy as Bombay. In the Indian Birds, more than in any of his other metal reliefs, Stella proposes a palette that is "popular" in a far more insistent manner than that of most pioneer Pop painting, in which the color schemes are often closer to earlier Parisian painting (Léger, in particular) than to the palette of urban life.

IN SOME ESSENTIAL RESPECTS, the spatial structure particular to the Indian Birds comes closer than any of Stella's work before or after to what he would later describe, in his Harvard lectures on Caravaggio, as a kind of "spherical" space, which provides a "spatial experience of a painting" that does "not seem to end at the framing edges or [seem to] be boxed in by the picture plane."[35] As Stella sees it, the manner in which Caravaggio resolved a crisis in the depiction of pictorial space that developed in the sixteenth century is not without interest for recent abstraction and its "entrapment in flatness."[36] Whether or not one wholly accepts Stella's description of Caravaggio's illusionism, as it unfolds in his lectures, published as *Working Space*, his description clearly hints at something that Stella himself had already been moving toward in his own work at the time he became deeply involved with Caravaggio's painting. Indeed, Stella's fascination with Caravaggio's example was surely prompted by the fact that it seemed to provide an analogical model in the past for what he himself was trying to do in another context. But Stella is "not only...eager to construct a heroic genealogical table for his own ambitions," as Rosenblum points out; he is also "willing to measure [his own success] against these venerable standards...."[37]

Stella sees Caravaggio as having added a "projective" dimension to the inherited fifteenth-century Renaissance spatial formulation. Renaissance space, all of it located between the proscenium-like picture plane and the vanishing point, seemed to unfold only away from the spectator. The "convincing projective illusionism" of the foreshortened figures and objects in the front of Caravaggio's space constitutes, for Stella, an added dimension—a "sensation of real presence and real action [that] successfully expand[ed] the sensation of pictorial space."[38] Whereas art historians would locate the picture plane in a Caravaggio picture by definition at the very front edge of the most advanced foreshortened form, Stella describes Caravaggio's space as if the foreshortened forms had burst through the picture plane; one must imagine that the picture plane had remained as it was in fifteenth-

Shāma, 5.5×. (1979)
Mixed media on aluminum, metal tubing, and wire mesh, 6′6″ × 10′5″ × 34⅝″ (198.3 × 317.6 × 88 cm)

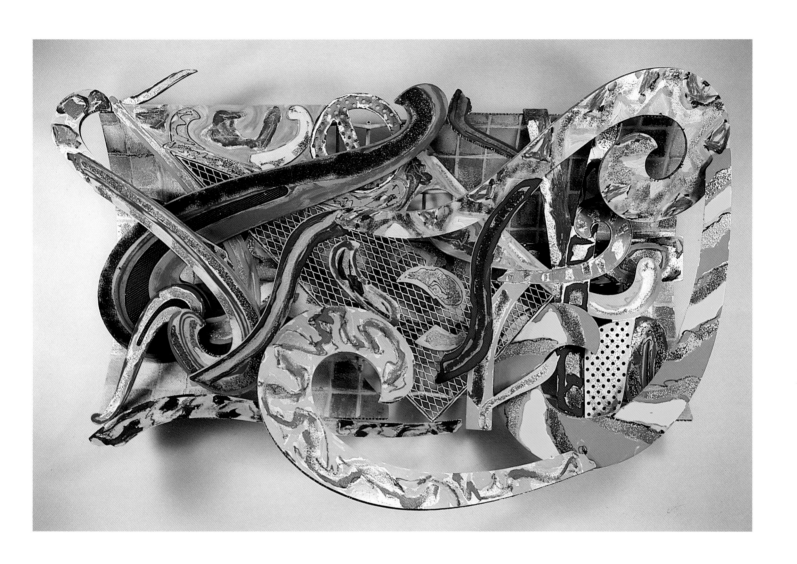

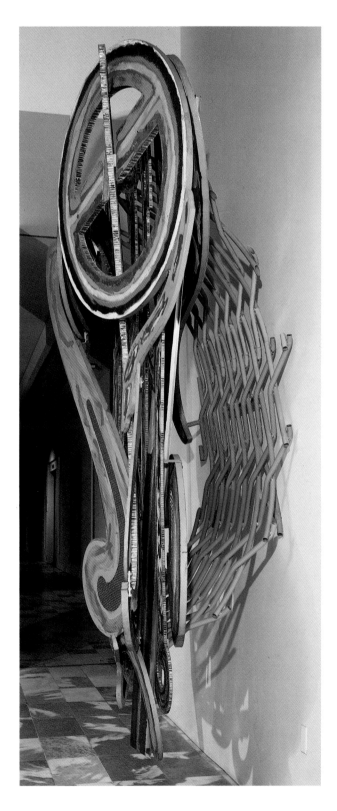

left and opposite
Kastūra, 5.5×, two views. (1979)
Mixed media on aluminum,
metal tubing, and wire mesh,
9'7" × 7'8" × 30"
(292 × 233.5 × 76.2 cm)

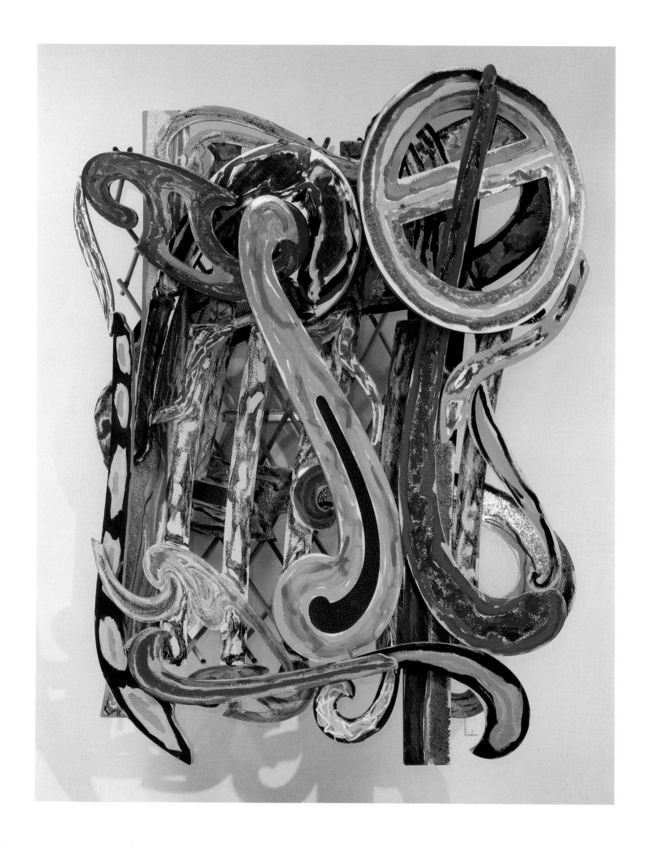

century painting, the curtain of a stage space, and that Caravaggio's frontmost forms projected outside that spatial box, as if beyond the proscenium (see pp. 18–20). Thus the highly foreshortened forms in the front of Caravaggio's pictorial space are in effect defined by Stella (although he never quite puts it this way) as being located on the viewer's side of the picture plane, almost as if they constituted a kind of (illusioned) relief added on to the front of the picture.

Stella reads the frontal space created by these projecting forms in Caravaggio as essentially hemispheric, and continuous with the space of the middle and rear ground, which Stella also reads as hemispheric. Thus the whole of Caravaggio's space—a "double-sided illusion"—becomes "spherical." Since the forms within it are illusioned by Caravaggio both in movement and at "tilted" angles, "the image that comes to mind is that of the gyroscope—a spinning sphere...."

The sense of projective roundness, of poised sphericality, is important because it offered painting an opportunity that was not there before, and that was, amazingly enough, diluted soon afterward. The space that Caravaggio created is something that twentieth-century painting could use: an alternative both to the space of conventional realism and to the space of what has come to be conventional painterliness.[39]

Stella has long been convinced that the "burden...modern painting was born with" is the need to create a pictorial space "capable of dissolving its own perimeter and surface plane." While he views the freedom acquired for illusionist painting by Caravaggio as an analogical model, he does not, however, consider a return to conventional illusionism today a valid solution. Any solution "would be worthless," says Stella,

unless it were expressed completely in our own terms. I think the problem is that you can't get pictorial drama today in the form of illustration. You can't play it out through traditional illusionism because that illusionism is gone now. It's just gone. It's used up. I can't help it.... Even Picasso couldn't really go back to illusionism. When he brings elements of illusionism into his picture, he's always at war with such illusionism as he creates.[40]

The illusionism that is "gone," that is totally "used up," as Stella has it, is the "holistic" illusionism of the Old Masters, that is, an illusionism constituting a total, closed, and consistent system. (Caravaggio had remained within this system even as he enlarged it.) Fragmentary illusionism, however, is another matter. Some suggestion of illusion is, in fact, almost impossible for painting to avoid, and most major styles in early modernism contain a modicum of it. It was the effort of the medium-oriented painters of the sixties to assure flatness, to suppress the last

vestiges of illusion, that had led to what Stella recognized as a dead end; in the course of the sixties and seventies, the sense of space in most vanguard abstraction had become, in effect, silted up by the paint substance itself. As early as the Irregular Polygons—years before he introduced any literal relief space into his art (in the Polish Village series)—Stella had already qualified his literalism by accepting bits and pieces of illusion (see pp. 34–35). Thus, by the time he arrived at the Indian Birds, he was welcoming the interplay of literal space and whatever illusionism "came along" (to use Leider's phrase) in the process. Indeed, Stella now recognizes illusion as virtually inherent in the act of painting: "There's always some illusion in my literalism, no matter how literal my paintings get. In any case, you always hope the work has some auras more than just its literal ones."

How the Indian Birds proposed a space for abstraction that approaches, both literally and optically, the "sphericality" Stella saw in Caravaggio is impossible to appreciate in photographs alone. Nevertheless, the reproduction of the side view of *Kāstura* on page 90 does show how the gaily painted grille that holds the entire relief at a distance from the wall delineates a kind of half cylinder, at least along its horizontal axis. If that grille articulates a concave rear space that anticipates, in some respects, Stella's subsequent formulation of Caravaggio's "spherical" spatial theater, the convex front curvature of that space has its counterpart in the accumulated angles at which the forward template forms of *Kāstura* are turned and tilted. Keep in mind, however, the chicken and the egg in this relationship. To whatever degree Caravaggio's art may be said to be "guiding [the modern painter] toward a more flexible contoured surface, begging [him]," as Stella has it, "to abandon flatness,"[41] the Exotic Birds, Indian Birds, and most of the Circuits series were already behind him when his exploration of Caravaggio began.

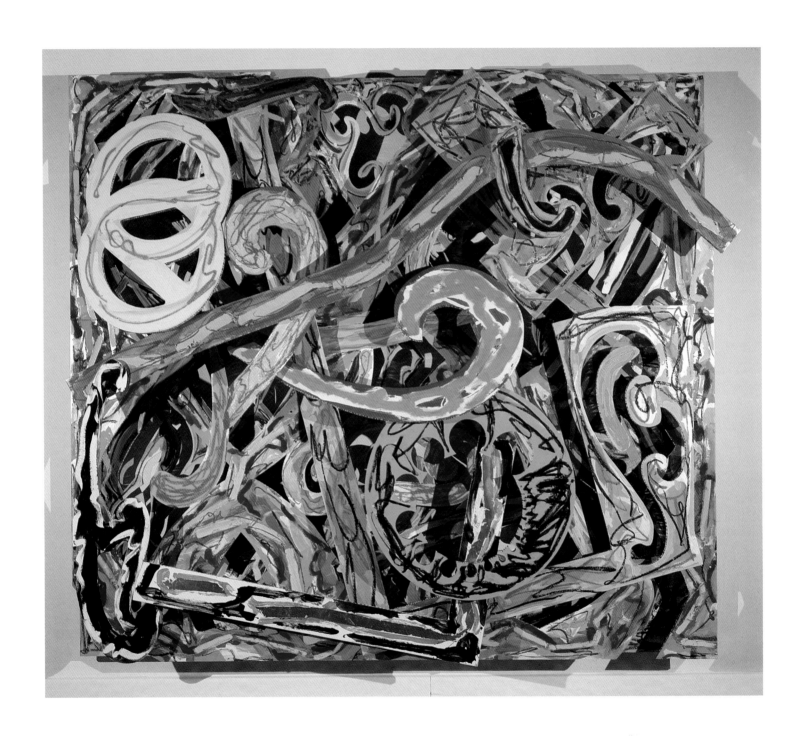

Silverstone, 4.75×. (1981)
Mixed media on aluminum and fiberglass,
8′9½″ × 10′ × 22″ (268 × 304.8 × 56 cm)

BY 1980, STELLA had completed all twelve Indian Birds and was painting the last of the Exotic Birds, among them *Brazilian merganser* (page 75). In that year, however, much of his attention was focussed on making the drawings and the twenty-four Foamcore maquettes (pages 96, 102, 112) for what became his largest and, I believe, most successful group of paintings yet, the Circuits. For several years, beginning in 1981, when the first aluminum enlargements of the Circuit maquettes arrived at the studio to be painted, Stella worked "flat out," as he described it, in what turned out to be "the longest and most concentrated streak of work that I've ever had."

This almost maniacal focus on painting ended only with Stella's stay at the American Academy in Rome, and his subsequent decision to accept Harvard University's invitation to deliver the Charles Eliot Norton lectures. As he worked on the lectures, he executed the last of the Circuits, having in the end painted sixty-eight large reliefs, some in magnesium (the surfaces of which were etched), the others in aluminum (which were not etched). These had been enlarged in two sizes from the Foamcore maquettes, by factors of three (3×) and four and three quarters (4.75×). Stella also painted twenty-seven small aluminum Circuits, enlarged only 25 percent beyond the format of the maquettes.

A glance at the Circuit maquettes reveals that Stella inscribed most of his forms with patterns of crisscrossing parallel lines based mostly on the parabolic patterns he had used in the prints called Polar Co-ordinates.[42] At the factory, these lines were etched on the surfaces of the large reliefs executed in magnesium; at least one such etched version in 4.75× size was made of each of the compositions Stella had decided to enlarge from the maquettes. A comparison of the etched and unetched versions of the enlarged *Nogaro* (pages 106, 107) shows the characteristic differences in effect. The etched lines, which are mostly visible through the paint, create a pattern that breaks up large areas and runs counter to the contours of forms, creating a kind of autonomous linear rhythm. The function of the etched lines is thus not wholly unrelated to that of newsprint in Cubist collages, or the listings on the telephone-book pages that Franz Kline used as grounds for his sketches. But to the extent that etching attenuates the paint substance of the Circuits—impastos with more body than the glaze-like colors of the Indian Birds—it also functions in a manner parallel to the metallic glitter of the earlier series. Finally, the etching alters the scale and character of the reliefs. "When the much enlarged metal pieces come from the factory," Stella notes,

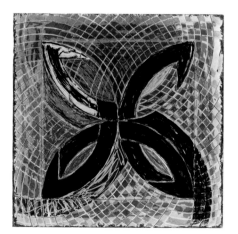

Polar Co-ordinates V for Ronnie Peterson.
(1980). Offset lithograph and screenprint,
38 × 38½″ (96.6 × 97.9 cm)

they can also be fairly forbidding, that is, overly strong, overly metallic objects. By etching the surface beforehand, I've already made the piece a little bit less factory-made. In making the surface seem more handmade, the etching also established a human, more personal, scale for these big pieces. Insofar as the etching tends to break up individual surfaces and relate them to the overall pattern, I think it repre-

sented a conscious effort on my part to get something very close to the effect that I got more or less by accident with the overprinted tin in the maquettes of the Indian Birds.

The most distinctive of the new shapes Stella was now to add to his cumulative lexicon of irregular curves and other templates were the snake-like arabesques provided by a draftsman's tool called the Flexicurve. As its name suggests, the Flexicurve can be altered to provide a variety of smooth, arcuated curves. It is ubiquitous in the Circuit series, frequently appearing three or four times in a single work. In *Misano* (page 105), for example, the green and blue Flexicurve in the upper left is directly echoed by a plum, pink, and blue one on the right, while the lower of two overlapping greenish Flexicurves in the lower left is doubled in width and winds its way across the bottom of the entire composition.

The Flexicurve is the morphological symbol for the snaking roadways of some of the international automobile racing circuits whose names provide the titles of the individual works in the series. "We've left the Birds," says Stella with a smile, "and I guess we're travelling through the landscape where the Birds live." We have already seen that Stella was a passionate fan of road racing. In 1978 he visited in Europe with the drivers in BMW's training project, an extensive support program in which young drivers are seasoned in small-time tracks. "That's how I got to minor circuits such as Pergusa and Vallelunga," Stella recalls. "The generic title Circuits," he adds, "is

above, left
Drawing for *Zeltweg*. (ca. 1982)
Ink on layers of acetate,
23⅝ × 27" (60 × 68.6 cm)

above, right
Maquette for *Zeltweg*. (ca. 1982)
Foamcore, with pencil and ink,
23⅝ × 26⅞ × 3⅛" (60 × 68.3 × 8 cm)

opposite, left
Zeltweg, 3×. (1982)
Mixed media on etched magnesium,
6' × 6'9" × 12⅝" (182.9 × 205.8 × 32.1 cm)

opposite, right
Zeltweg, 4.75×. (Second version, 1982)
Mixed media on etched magnesium,
9'6" × 10'8" × 20" (289.6 × 325.6 × 50.8 cm)

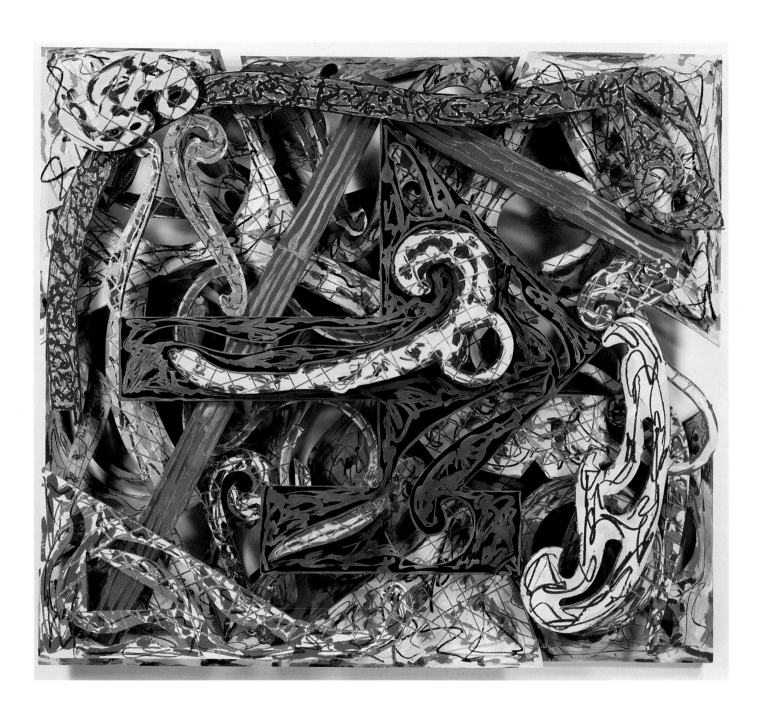

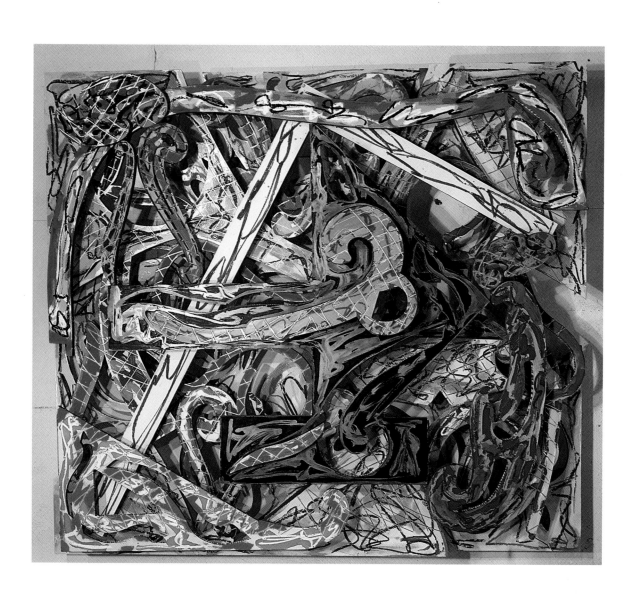

meant to refer to road racing. But it's intended to be a bit ambiguous. In my mind it also refers to the intricate connections within the structural networks of the pictures."

The compositions of the Circuits fall, broadly speaking, into three typological groups; they will be discussed in the order in which the maquettes were conceived, inasmuch as the order in which the enlarged metal reliefs were actually painted depended on their random arrival at the studio from three different factories that realized them. (For example, *Pergusa* [page 113] and *Zandvoort* [page 115], which number nineteenth and twentieth in the order of the composing of the maquettes, were actually among the earliest reliefs in the series to be painted.)

Not surprisingly, the first of the three compositional types of Circuits is closest in vocabulary and structure to the Exotic Birds. At its outer edges, the background plane of *Silverstone* (page 94), for example, virtually forms a rectangle, in the manner of the backgrounds of the Exotic Birds. In the earlier series these background planes form a largely continuous field; in *Silverstone*, however, as in the other early Circuits, the interior ground has been radically cut away in all quadrants of the picture, its discontinuity attested to by bits and pieces of the wall that are everywhere visible through the relief's layered shapes. Except around the edges of the compositional field, *Silverstone*'s background has been so perforated that those pieces of it which remain are indistinguishable in nature and character from the shapes on other planar layers of the picture.

As in other early Circuits, such as *Zeltweg* (page 97), the morphological vocabulary of the forward layers of *Silverstone* includes the ship curves and French curves charactertistic of the Exotic Birds, as well as the right angle and protractor forms that date from still earlier phases of Stella's morphology. In the Exotic Birds, however, such template forms figured as discrete entities, and played salient compositional roles. In *Silverstone* and *Zeltweg*, most of them are harder to isolate visually. So much have the original template forms been multiplied in number, overlapped in position, and compounded in form (i.e., fused with one another—as exemplified by the joined protractors in the upper left of *Silverstone*) that we are less aware of individual morphologies than of the overall pattern of their relationships. As in Pollock's classic poured paintings, the fabric of interconnections—which might be called the compositional "circuitry"—overwhelms the identities of its individual components.

This change is certainly enhanced by Stella's use, for the first time in his work, of a multiplicity of irregular shapes no longer derived from a fixed, a priori, and hence recognizable vocabulary. Such forms—some large, some very small—were recuperated by Stella during the process of making the models, that is, they were discovered in, or modified from, the remnants of the Foamcore boards from which template shapes for previous maquettes had been cut out. These altered "residual" shapes or leftover patterns have both straight edges—often the borders of the rectangular Foamcore boards—and curvilinear contours, usually the negative con-

Mosport, 4.75×. (Second version, 1982) Mixed media on etched magnesium, 9′6″ × 10′6½″ × 24″ (289.6 × 321.4 × 61 cm)

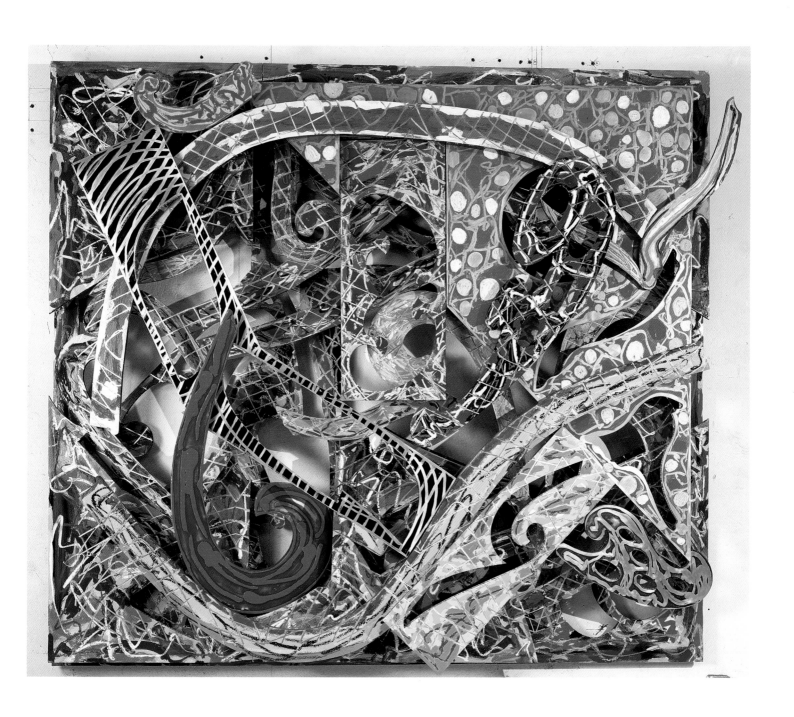

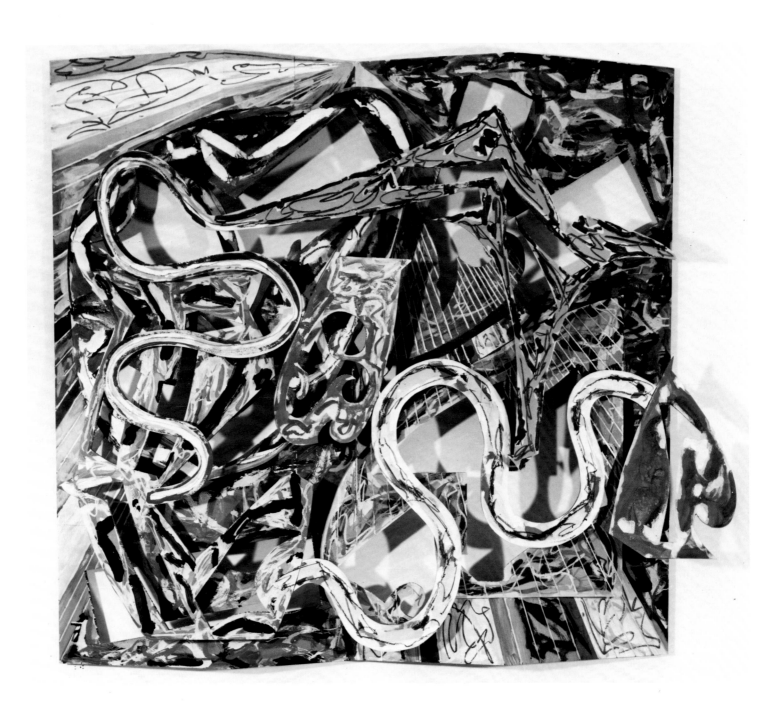

100

Vallelunga, 4.75×. (1981)
Mixed media on aluminum,
9'4" × 10'8" × 21" (284.5 ×
325.1 × 53.3 cm)

tours of irregular curves cut out earlier. The green, orange, and red plane in the upper left quadrant of *Anderstorp* (page 109) is typical of their irregularity. But sometimes that irregularity is more a question of interior than exterior contours. The large black and aluminum "arrow" that dominates the center of *Zeltweg*, for example, is a residual panel that Stella decided to make into a kind of screen for the work. He perforated this geometrical remnant by cutting six template shapes, of contrasting sizes, from its interior; through these "holes" we see the crisscrossing of lower levels of the relief and, in places, the wall behind. As the "screen" panel seemed too open to Stella, he filled in the form cut from the center horizontal of the "arrow" as well as smaller shapes in the lower left of it, tilting them at angles to the surface.

Stella's use in the Circuits of new forms (such as Flexicurves), compound template shapes, and recuperated or residual shapes constituted, morphologically speaking, a quantum change in his work. Making these many dissimilar elements cohere made the actual painting of the reliefs' surfaces more crucial than ever. Most of the Polish Village reliefs made credible pictures without being painted at all (pages 27, 33). And although the Exotic Birds wanted color, they were entirely comprehensible in their unpainted states. But the intricate maquettes for such compositions as *Zeltweg* (page 96) and *Talladega* (page 102) already suggest something different about the Circuits. These models seem to constitute a self-imposed challenge to invest their extraordinarily complicated structures with pictorial clarity. A comparison between such paintings as *Zeltweg* and *Talladega* and their unpainted maquettes makes Stella's accomplishment manifest; indeed, the full-scale versions of the two illustrated here (pages 97, 103) are among the most lucid of his pictures.

Talladega, the seventh Circuit in the order of composing, suggests some aspects of Stella's transition toward a second type of Circuit, though it mostly shares the characteristics of *Zeltweg*; both are crowded compositions, marked by an unusual morphological range, a multiplicity of "handwritings," highly variegated palettes, and backgrounds that have been radically cut into. What separates *Talladega* from *Zeltweg*, what marks it as a transitional picture, is that its background has been divided by "folds" that turn its remaining forms at angles. This difference goes hand in hand with a crucial change in morphology. The French curves and ship curves that are still very visible in *Zeltweg* (French curves in its upper left, center right, and lower right; ship curves in every quadrant) are largely left behind in *Talladega*. Instead, the majority of *Talladega*'s forms are of the residual type that Stella developed out of leftovers from the template-cutting process. Its morphology, therefore, signals further separation on Stella's part from the type of a priori vocabulary so long central to his methods. Finally, *Talladega* promotes the Flexicurve to a major role; its snaky forms become the Circuits' signature motif. In *Zeltweg*, the Flexicurve had appeared only once, and then only as a compound form; looping softly upwards from the center left, turning the left corner and passing across the top

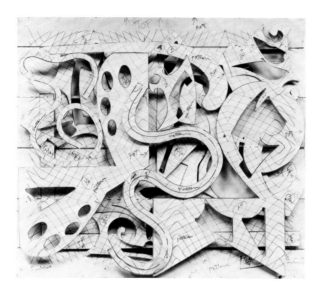

left
Maquette for *Talladega*. (ca. 1981)
Foamcore, with pencil and ink,
23⅝ × 27 × 3⅞″ (60 × 68.6 × 9.9 cm)

opposite
Talladega, 4.75×. (1981)
Mixed media on etched magnesium,
9′ × 10′5½″ × 17¼″ (274.4 × 318.8 × 43.8 cm)

of the composition, its green-scribble shape terminates by fusing into an irregular leftover shape (from which a ship curve has been cut out). Though the Flexicurve's appearance in *Zeltweg* is as yet almost unrecognizable, the snaky loops it produces in the center and left of *Talladega* are more characteristic for the way this instrument would be used throughout the rest of the series.

In the three Circuit reliefs discussed thus far, the background layer was deeply cut away and, in the last of the three, the transitional *Talladega*, it was folded as well. Nevertheless, *around the edges of the field* the background planes of all these compositions make themselves felt as nearly continuous, rectangular silhouettes; they retain, to that extent, the explicitness of the backgrounds of the Exotic Birds. In the reliefs that make up the second of the three typological groups of Circuits, Stella attacked the integrity of the rectangular background plane at its edges as well as in its interior.

This change is clear in *Misano* (page 105), in which the interaction between the painted metal forms of the relief and the voids through which we see the wall totally replaces conventional figure-ground relationships. In its exquisite equilibrium of solid and void, its play of open and closed, *Misano* is one of the most classically ordered of Stella's metal reliefs. The explicit outlining of the picture field charac-teristic of the early Circuits has ceased in *Misano*; only the upper right corner hints directly at a pictorial rectangle. Nevertheless, its configuration strongly *implies* such a rectangle, in much the same way that the "set" of Pollock's irregular webs implies their rectangular pictorial field. Indeed, the pattern of the painted shapes taken together with the spaces between them (and inside them; i.e., where subsidiary interior shapes have been cut away) has a distinctly Pollockian "pneuma."

To be sure, a reference to Pollock in this context may raise eyebrows, given the

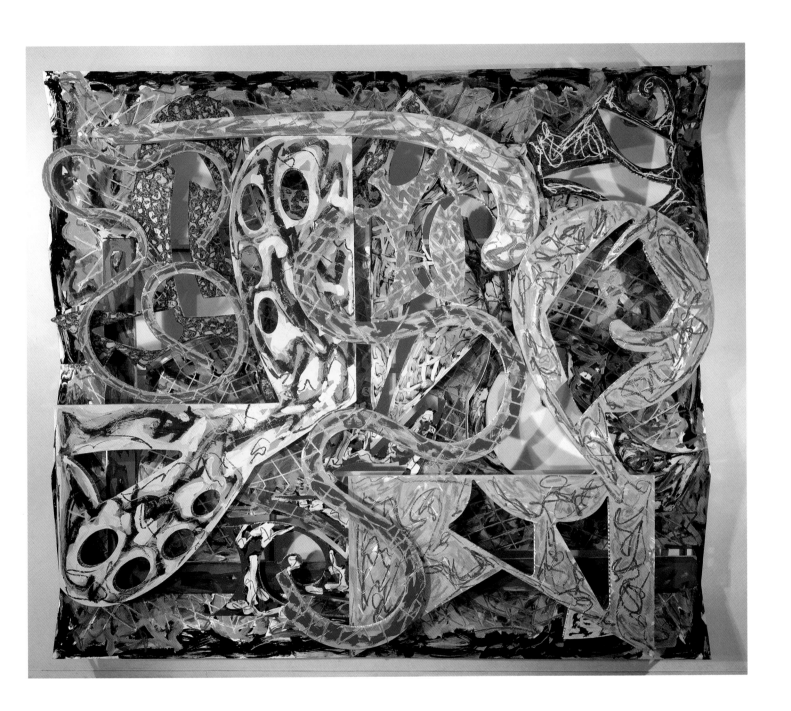

immense difference between his work and Stella's, simply on the level of appearance. Yet even in Stella's stripe pictures—where such a rapport was perhaps even more difficult to apprehend than here—the lessons of Pollock's all-over pictures were there to see. In *Misano*, the parallels to Pollock are not just a matter of the classical "breathing" in the openings and closings of the configurational pattern, or the way the disposition of the composition implies its pictorial rectangle, but also of Stella's ability to handle a multi-layered configuration of highly variegated components without slipping into visual congestion. In Pollock's case, except when he "lost touch" with a composition, his webs retained a remarkable transparency, permitting one to see with great clarity each successive layer as well as bits of ground behind them; only when Pollock faltered did opacity enter, the paint of one layer obfuscating or obliterating that of another. A comparable clarity and transparency of layering is the hallmark of the successful Circuits. In *Misano*, for example, the resolution is so complete that we tend to lose sight of how many diverse elements have been absorbed into the many layers of its compositional space.

The most daring among the second group of Circuits are those, such as *Nogaro* (pages 106, 107) and *Anderstorp* (page 109), in which Stella clearly establishes a pictorial rectangle by filling in parts of it, but also permits that picture field totally to dissolve away. In *Nogaro*, for example, the background plane marks off a considerable portion of the upper and right perimeters of a pictorial rectangle. But once we move inside the rectangle, everything seems to come apart under the pressure of a phalanx of anti-architectonic forms led to by two extended Flexicurves. The configuration of *Anderstorp* is equally unexpected. The perimeter of a pictorial rectangle is closely approximated on all its sides except at the bottom right. There, the dense compositional fabric suddenly falls away, leaving two small, irregular forms to stretch almost pathetically toward what would have been the right corner of the composition. The empty wall space at this point, which our eye assimilates into the field of the composition, turns out to be the ideal foil for the density and evenness of the rest of the configuration.

The third and final group of Circuits (in the order of conception) is best illustrated by two of the series' greatest successes, *Pergusa* (page 113) and *Zandvoort* (page 115). In these, Stella turns away from the atomization of surface and the Pollockian all-overness that dominated the earlier Circuits in favor of compositions with fewer, larger, more discrete, and more salient parts. The monumentality of *Zandvoort*, for example, depends on its reduction to just eight large forms (as compared to the over forty in *Zeltweg*) and such bold rapports and analogies as the repetition of the gray, blue, yellow, and red "dragon" in the lower left as a negative cutout that renders "transparent" the huge curvilinearly contoured shape in the upper right. Although the "handwriting" in early Circuits such as *Zeltweg* differed from unit to unit, the multiplication of units itself led to an "averaging out" of notational differences, which reinforced, in turn, those pictures' all-overness. In *Zandvoort*, however, the dif-

Misano, 3×. (1982)
Mixed media on etched magnesium, 67″ × 6′9″ × 11″ (170.2 × 205.8 × 27.9 cm)

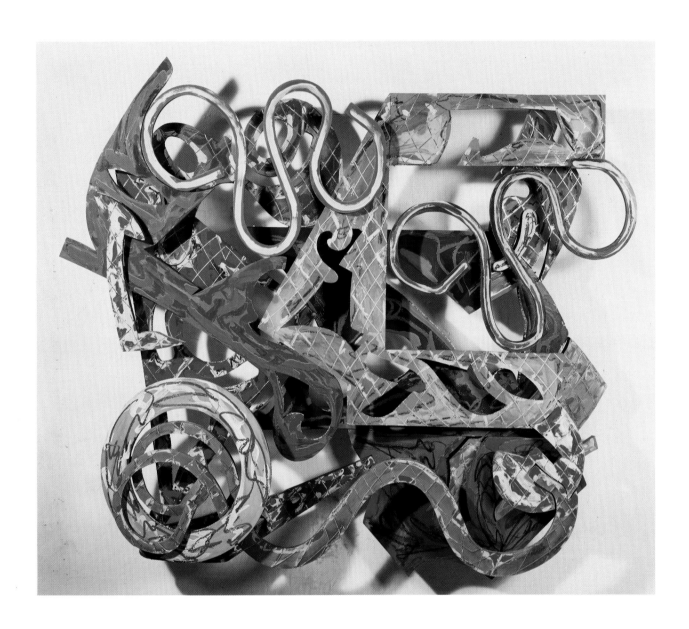

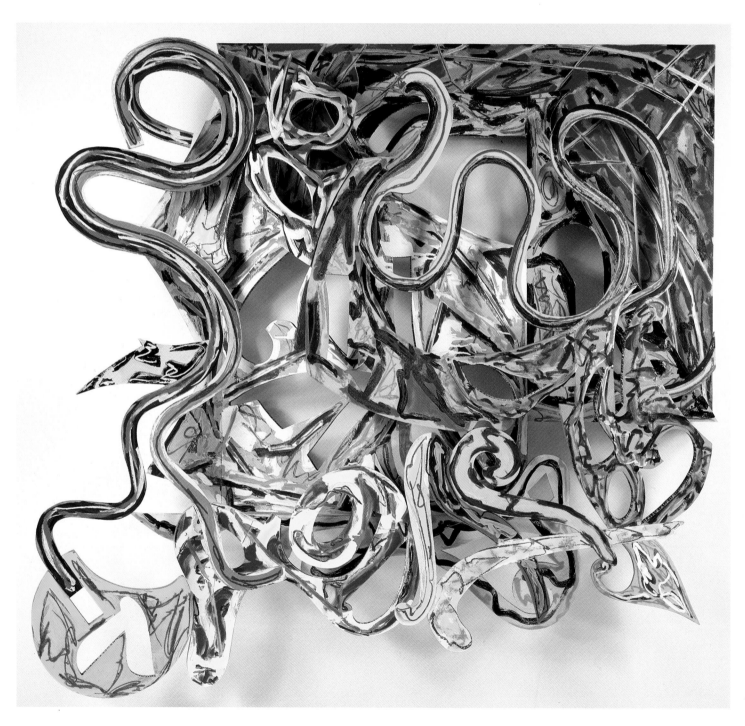

Nogaro, 4.75×. (1981)
Mixed media on aluminum and fiberglass,
9'7" × 10' × 24" (292.2 × 304.8 ×
61 cm)

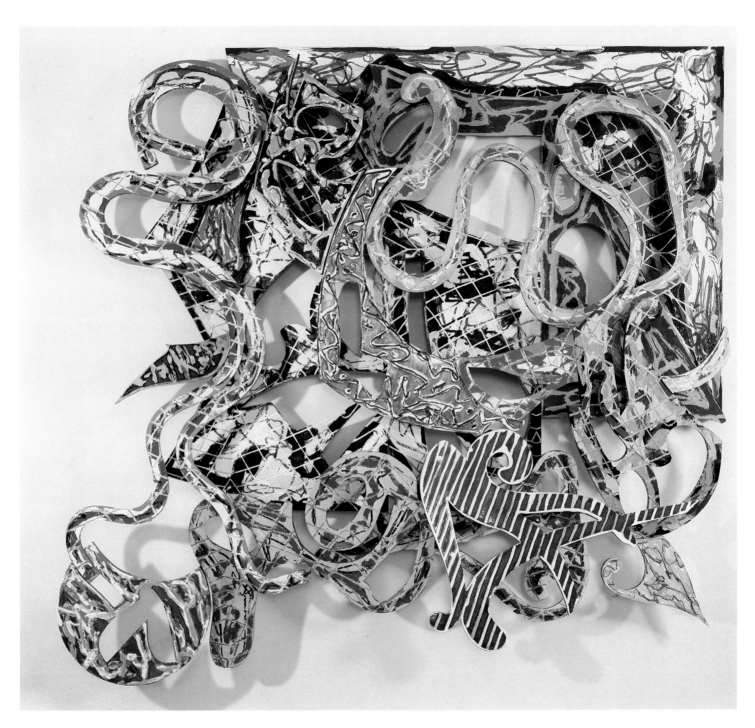

Nogaro, 4.75×. (Third version, 1984)
Mixed media on etched magnesium,
9'7" × 10' × 22" (292.1 × 304.8 ×
55.9 cm)

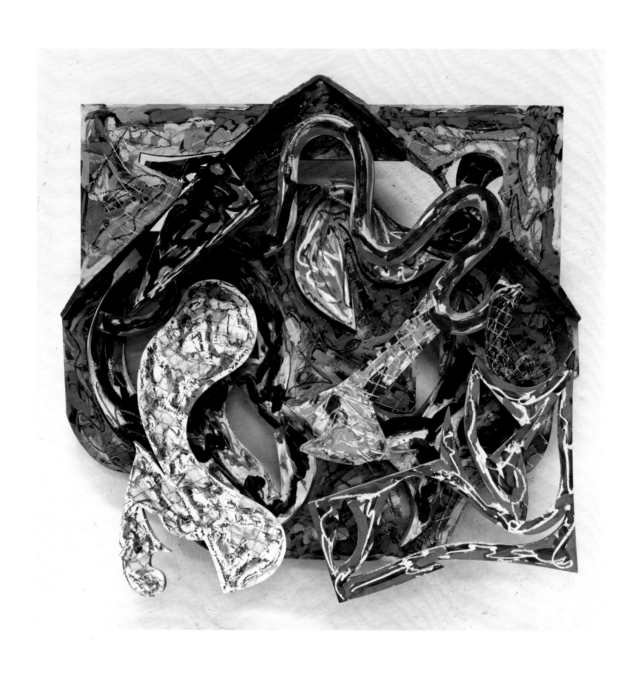

Thruxton, 3×. (1982)
Mixed media on etched magnesium,
6'3" × 7'1" × 15" (190.5 × 215.9 ×
38.1 cm)

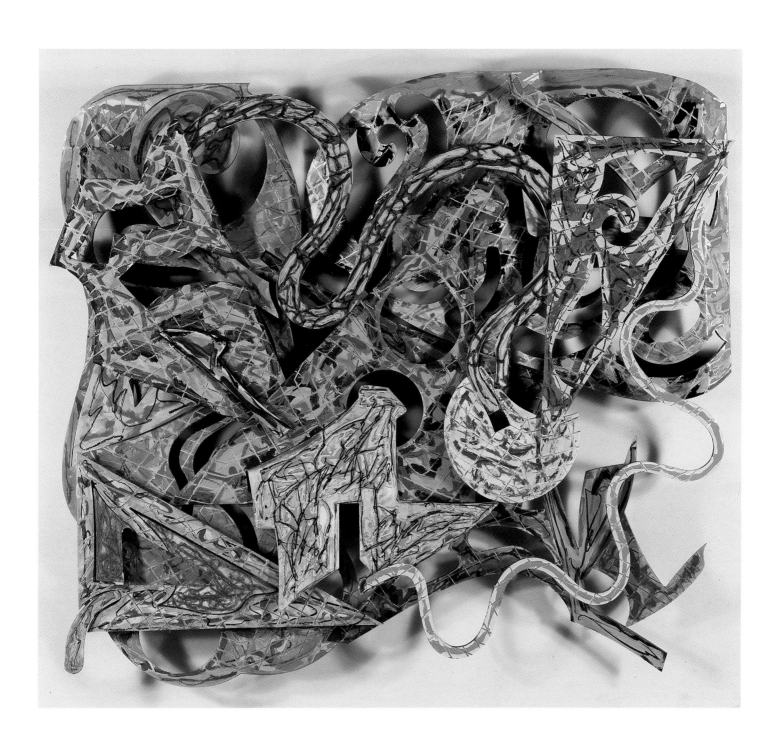

Anderstorp, 4.75×. (1981)
Mixed media on etched magnesium,
9'1½" × 10'3½" × 15¾" (275.7 × 313.6
× 40 cm)

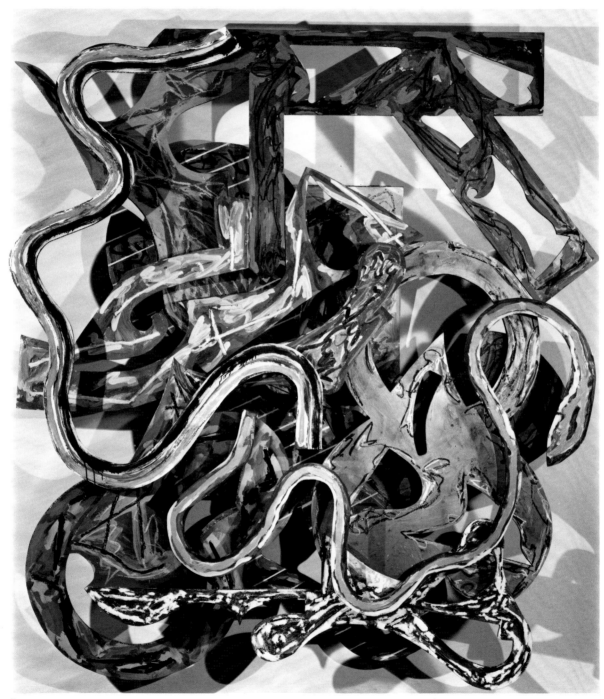

above
Norisring, 4.75×. (1982)
Mixed media on aluminum,
9′7″ × 8′10″ × 30″ (292.1 × 269.3 × 76.2 cm)

opposite
Jarama, 4.75×. (Second version, 1982)
Mixed media on etched magnesium,
10′6″ × 8′4″ × 24¾″ (319.9 × 253.9 × 62.8 cm)

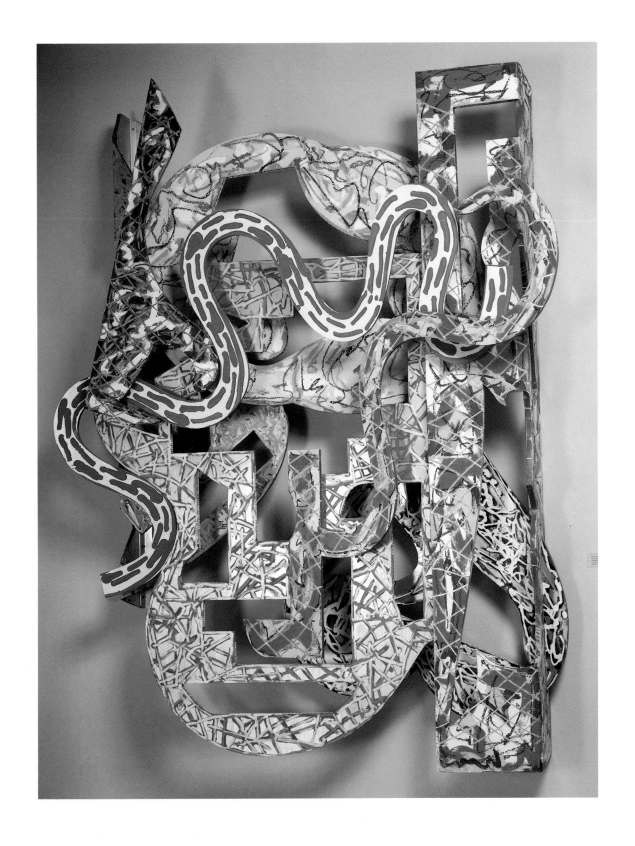

left, top and bottom
Maquette for *Pergusa,* two views.
(ca. 1981). Foamcore, with pencil and ink,
20½ × 29⅝ × 5½″ (52.1 × 75.3 × 14 cm)

opposite
Pergusa, 4.75×. (1981)
Mixed media on etched magnesium,
8′2″ × 10′5″ × 28″ (249 × 317.5 ×
71.1 cm)

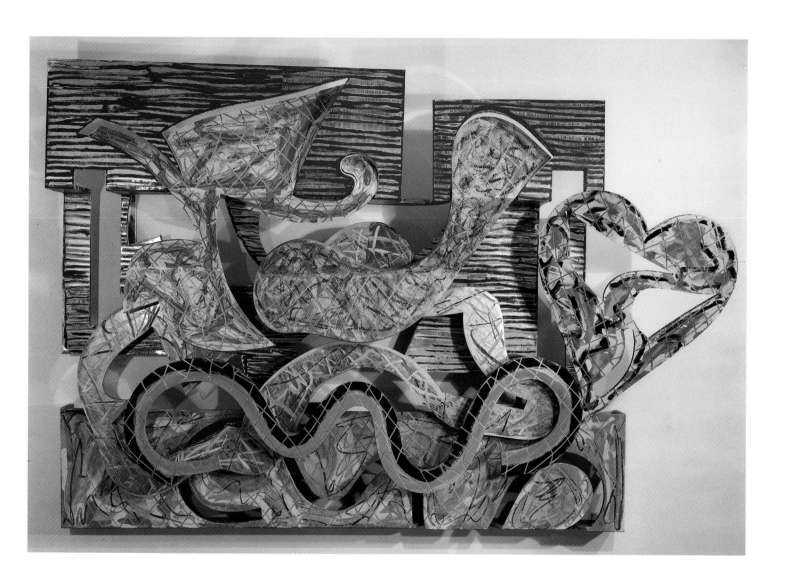

ferences in notation from form to form function to *distance* the units from one another, reinforcing each one's unique character. That character is further strengthened by the particular patterns of brush or crayon drawing on each unit in *Zandvoort*, which seem—more than in Stella's earlier reliefs—directly related to the shape of that unit.

In our reproduction of *Zandvoort*, photographed head-on, it is not at all clear that a number of its forms are bent back horizontally at right angles; this characteristic of the third group of Circuits is somewhat more evident in the reproduction of *Pergusa* (and, more particularly, in the obliquely photographed reproductions of its model [page 112]). The bending back of planes exemplified by the striped green plane of *Pergusa* created what Stella characterizes as a "box-like" structure for most of the last Circuits. And although one would hardly recognize it in the finished pieces, this box-like structure was, in part, a response to the Cubist collages and constructions that engrossed Stella on repeated visits to The Museum of Modern Art's Picasso retrospective of 1980. "The boxing of the later Circuits," he recalls, "seemed to me directly related to Cubism. I don't believe it's any accident that I made the maquettes for these right after seeing the Picasso show....While I was doing them, I was terrified that even the painted reliefs of these pieces would have a tremendous Cubist echo. But in all honesty, I don't think they do."

It is not surprising that Stella's gloss on Cubism should bear parallels with collage as well as constructed relief. After all, the process of cutting out shapes had suggested some of the same obvious possibilities to Picasso; one that he exploited not infrequently in the 1912–13 collages was the use of the echoing "negative" shape which remained behind in his newsprint after he cut out a form. Picasso often placed the "negative" shape at a certain distance on the surface from the "positive" one, sometimes changing its orientation, and separating the two by a linear structure that fixed them on different planes in the schematically indicated space. That Stella does something similar is easier to see in the "serpent" at the bottom of *Pergusa* than it was in the "dragon" of *Zandvoort*. Although the width of the Flexicurve has been doubled, it is evident from its contours that it was originally cut and displaced from the plane below. Less clear in *Pergusa* is the total reciprocity of both the yellow and red "bird" in the upper left and the green and lavender "whale" in the center with the striped, folded plane that surrounds them. This relationship is evident at the top of the "bird" and "whale" forms. But the photograph of the metal relief does not make clear that the "negative" contours of the "bird" and "whale" continue on in the horizontal portions of the background plane that has been folded back to form the box-like picture space. The resultant disjoining of positive and negative contours veils their relationship in a manner recalling Picasso's displacement of newsprint in the 1912–13 collages, where only prolonged looking reveals certain of the elusive positive-negative relationships.

Although the morphological battery of the Exotic Birds and Indian Birds derived

Zandvoort, 4.75×. (1981)
Mixed media on etched magnesium, 9′ × 10′4″ × 20″ (274.4 × 315 × 50.8 cm)

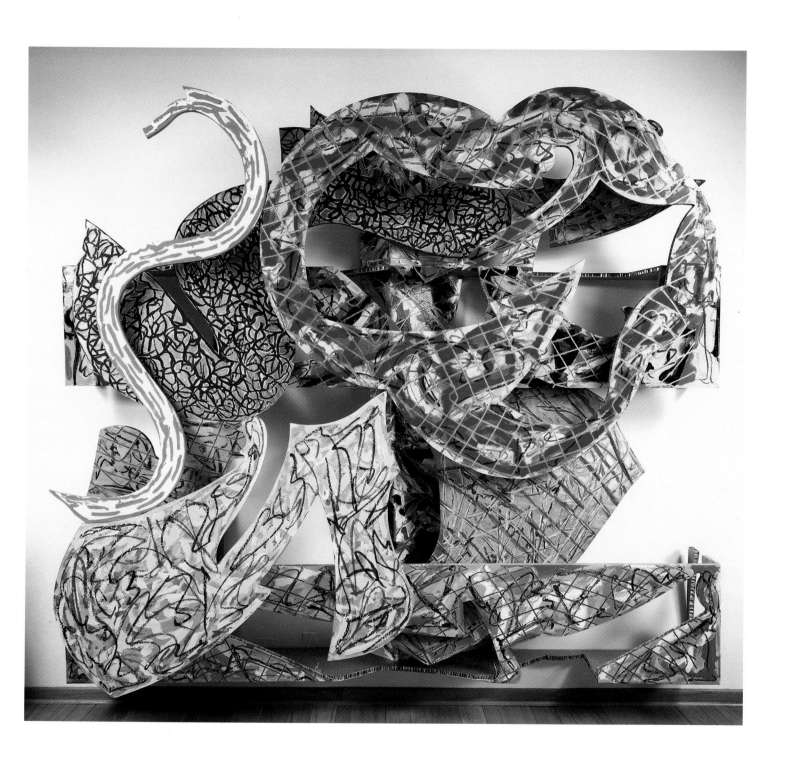

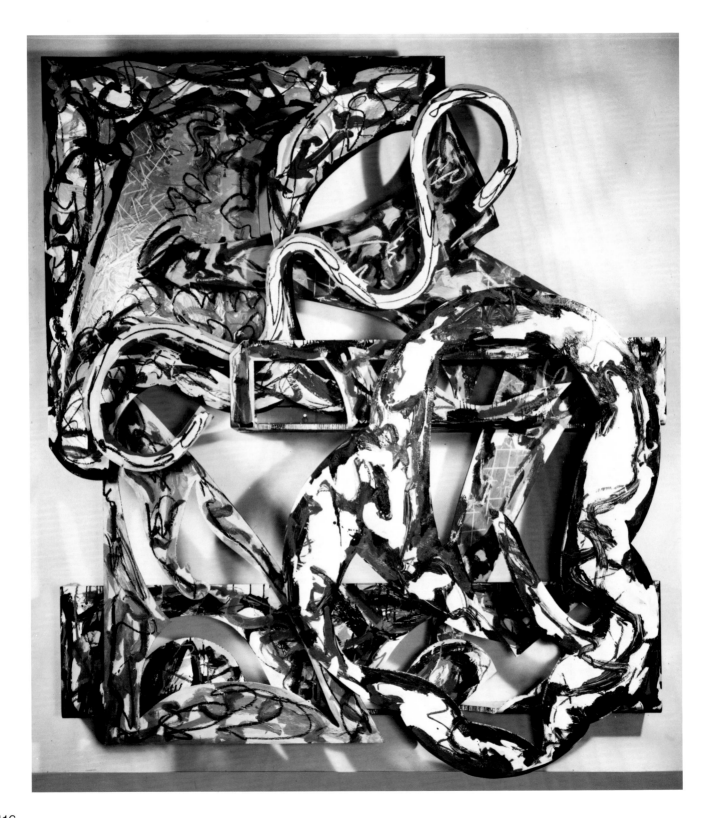

from pre-existing mechanical-drawing templates, it was Stella's feeling that in enlarging these templates, translating them into another material, and, above all, painting their surfaces he "made them my own." Many of the shapes in the Circuit series, however, were Stella's own in a more direct, less appropriative sense. We have already observed that the later Circuits were increasingly made up of "accidental" or "found" shapes taken from elements recuperated from the procedure of cutting out templates. Some of these were simply taken as is. Others, however, were actively cut, trimmed, punctured, or otherwise reordered. In this modification process, Stella occasionally arrived at a shape that spoke to him in a particularly intense way, and that he therefore promoted to a more prominent role in his personal vocabulary. What Stella refers to as the "heart"-shape, on the right of *Pergusa*, is a good example of such a "selected-out" shape—as are the forms he describes as "like a whale" and a "kind of bird" in the same relief. "I feel involved with these shapes," says Stella.

They mean something special to me. I love the shapes as shapes and, for me, they have an intrinsic identity and value. I like them in themselves and don't see them just as forms to be manipulated. They're very personal; I like them the way someone might like his girlfriend's ankle. I distinguish them from some other forms in the reliefs; they have something more for me—I can't elaborate it—though I don't expect anyone else to like them in that kind of way.

It must be kept in mind, of course, that Stella's use of the word "heart" (or "whale" or "bird") is essentially a matter of convenience, and that his "heart"-shape only very roughly resembles that on a playing card (its configuration being asymmetrical— the bottom left contour is concave—and folded to the left of its axis). While Stella wants the viewer to feel free to "associate loosely" to these shapes, to "be relaxed by them so better to find his or her way into the paintings," he hopes that the shapes are speaking to the viewer *as shapes*, rather than in terms of the imagistic symbols he or others might use as verbal conveniences in referring to them. "It would be wrong," says Stella,

simply to say that the Flexicurve on the bottom of Pergusa *is a snake, or that the forms above it were a bird, a whale, or a heart. But I like the fact that these shapes function evocatively. Indeed, you short-circuit that evocativeness precisely by giving such shapes too particular an identity. That shuts out lots of other reverberations which they possess simply as shapes.*

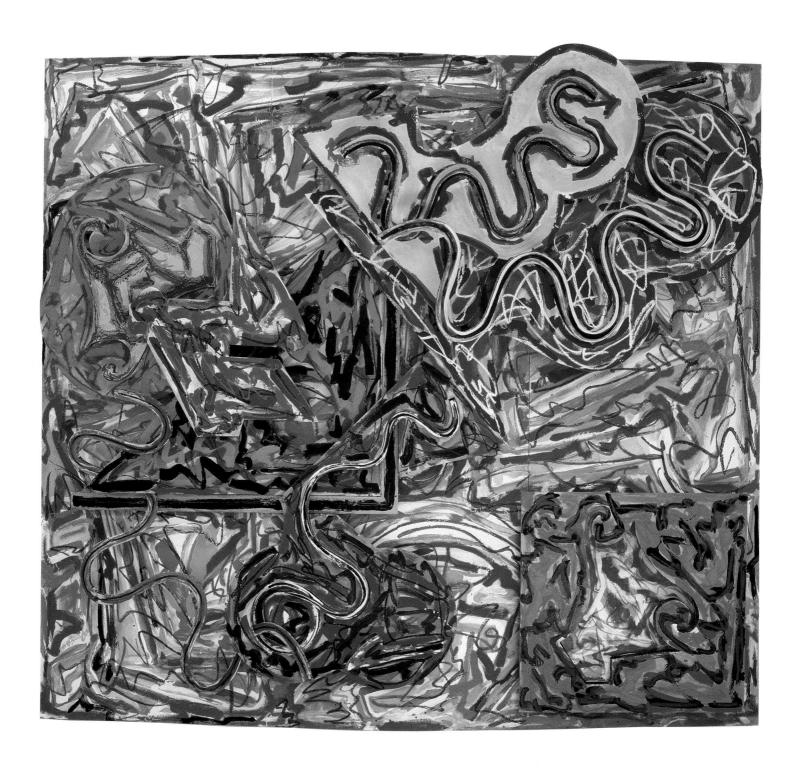

Shards IV, 3×. (1982)
Mixed media on aluminum,
10′ × 11′2″ × 27″
(304.8 × 340.5 × 68.6 cm)

MOST OF THE CIRCUITS were executed in 1981 and 1982, but a few were delivered so late from the factory that Stella was still painting the last ones in 1983 and into the winter of 1983–84. By that time, two subsequent smaller series, the Shards (nine reliefs) and the South African Mines (nine reliefs), had already been completed, and Stella was well into a third, the Malta series (twelve reliefs).[43] The Shards and the South African Mines may be considered together a kind of dual postscript to the Circuits; the improvisational aspects of the Mines in particular testify to a relaxation of the pressure that had been mandated by the methods used in realizing the Circuits. The Shards and South African Mines depart from the Circuits in opposite directions, the former reaching a pole of pictoriality among the metal reliefs, and the unadorned monumental high relief of the latter marking an extreme, for Stella, in the direction of the sculptural.

The Shards relax the tension established in the Circuits between literal and illusioned space in the direction of the pictorial, largely because of Stella's comfortable acceptance, once again, of a regular rectangular picture field. This aspect of the Shards' form, plus a characteristic new vocabulary element, the pantograph, were both inherited from the lithographic series of the same name. In this unique instance, the maquettes for Stella's large metal reliefs were made directly from the drawings for the prints (page 120), rather than from their own preparatory drawings. The lithographs had been called Shards because they were constituted primarily from the forms of scrap left over in the process of making models; hence, the large metal reliefs of the same name share with the later Circuits a morphology centered on residual shapes.

The pantograph, the characteristic new vocabulary element of the Shards, is an adjustable draftsman's tool resembling a parallelogram whose contours have been extended. It becomes a signature shape for this series in an even more obvious way than the Flexicurve was for the Circuits, as witness the immense pantograph that "reclines" across the front of *Shards V* (page 121). The pantograph's use as an enlarging instrument, says Stella, "implied the idea of juxtaposing the same shape in a different scale—as in the upper right corner of *Shards V*—which is a theme of this series." The pantograph thus serves as an emblem as well for the extraordinary size of these reliefs,[44] among the largest of the metal reliefs. Stella hastens to say, however, that he did not aim "at being monumental or impressive." The Shards, he says, "seem to me more generous than gigantic." Indeed, they are pictures in which Stella's delight in broad fields of brushwork is self-evident; he recalls very clearly that the impulse to make this series—an impulse he had already felt in planning the later Circuits—was a desire to have "larger individual areas to paint on."

If there is a purely structural counterpart to Stella's pleasure in brushing large areas improvisationally (in the Shards), it is the improvisational assembling of scrap and miscellaneous fragments found on the factory floor, which was the method used in making the South African Mines. "I had created a lot of my own junk," Stella recalls,

"and it just seemed crazy not to use it. It was also tempting to use the scrap because the shapes are more relaxed, and you avoid all the [preparatory] drawing. I liked the break in my routine, which had involved visits to the factory just to see prepared work [the enlarged metal reliefs]; there was something good about actually working with everybody there at the factory myself." Stella recalls that in choosing these works' titles, he very much liked the sounds of the mine names, such as *Stilfontein, Western Deep, Blyvoors,* and *Welkom,* "but also something in the look of the words as well— their angles and sharpness." The titles were not, in any case, inspired by the political situation in South Africa, as had been the case with some 1962 titles, such as *Sharpeville* and *Cato Manor,* which Stella refers to as "my apartheid pictures." "The South African Mines had to do with the theme of machinery digging and burrowing, but their titles also had to do with mining gold," he adds. "There was a kind of metal-market madness in America in those years, between the Hunts trying to corner the silver market and the people running in from Queens, jumping out of the subway to pawn their gold necklaces."

Drawing for *Shards V.* (ca. 1982)
Felt-tip marker, 39¾ × 45¼"
(101 × 115 cm)

Welkom (page 122) is quite clearly Stella's monumental paraphrase of Picasso's relief constructions by way of David Smith's Zig series and certain of his stainless-steel pieces. But the particular nature of the scrap Stella uses ties it intimately to him through his characteristic morphology. In the plane of the upper right of *Welkom,* cut and folded along its diagonal, we recognize a ship curve and other forms no doubt cut out for one of the Circuits. In this most purely sculptural of Stella's series of large reliefs—which Stella refers to as relatively "purist"—he did not yield to his temptation to take up the brush. The aluminum scrap is used as found in *Welkom,* such color as appears being part of the scrap (for example, the brown at the edge of the plane at the left, which is the paper filling of a found panel).

Shards V. (Color trial proof, 1982)
Mixed media on lithograph,
39¾ × 45¼" (101 × 115 cm)

Of the three smaller series that separate the Circuits from the Cones and Pillars of 1984–85, which were Stella's next major effort, the twelve reliefs of the Malta group show him at his most challenging. As in the South African Mines, structural concerns remain central, though painting now seems informed more by architecture than by sculpture, and color returns to play a not insignificant role. The architectural spirit of the Malta pieces is embodied in the form of the box frame, out of which almost all the compositions in the series grow. The box frame is clearly the cohesive element in *Marsaxlokk Bay* (page 125), where its etched verticals have been colored con-trastingly with copper printer's ink. "*Marsaxlokk Bay* is typical of certain Malta reliefs that are borderline kinds of pieces," according to Stella. "They're not architecture and they're not sculpture. Although they have a little bit of both those arts in their spaces, they still remain painting." The monumental play of interlocking circles of *Mellieha Bay* (page 124), whose scrap fiberglass discs had originally been blown up from paper-plate models for another work, would seem to be entirely at the opposite pole from the architectonic spirit of *Marsaxlokk Bay.* Nevertheless, the principle of building out from a box frame still obtains. In *Mellieha Bay,* however, this architectural

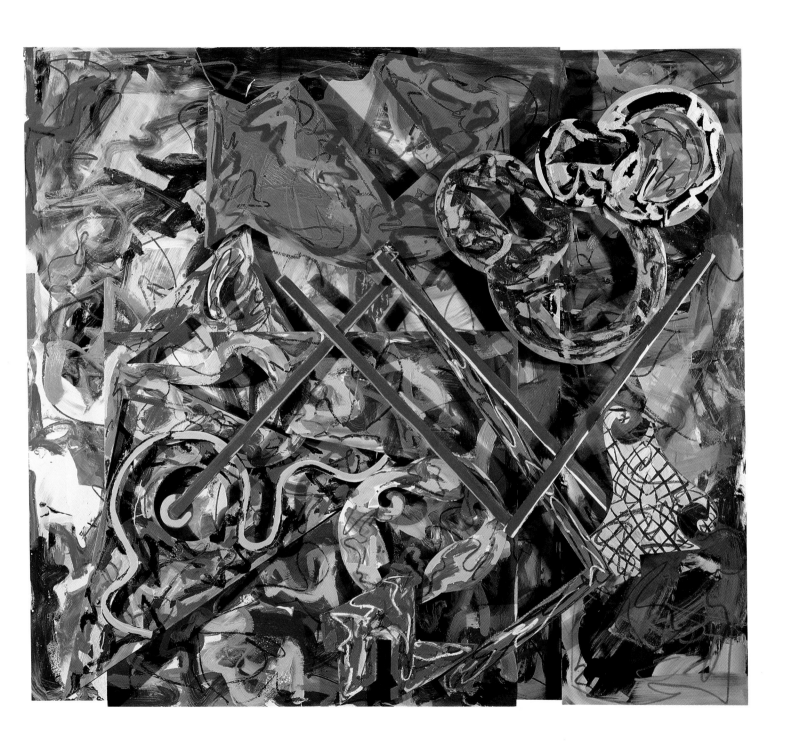

Shards V, 3×. (1983)
Mixed media on aluminum,
10′ × 11′5″ × 32″
(304.8 × 348 × 81.3 cm)

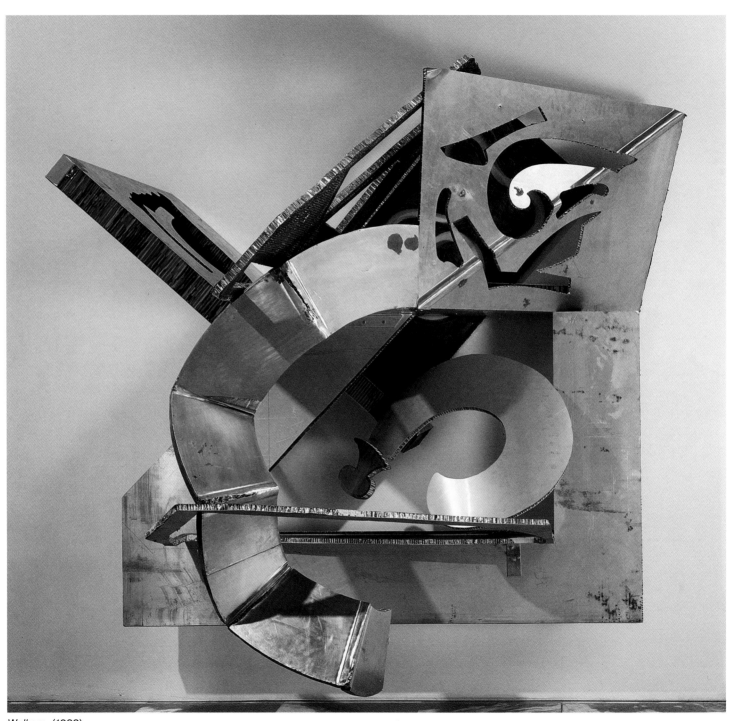

Welkom. (1982)
Unpainted honeycombed aluminum,
8'2" × 7'6" × 64" (249 × 228.7 × 162.6 cm)

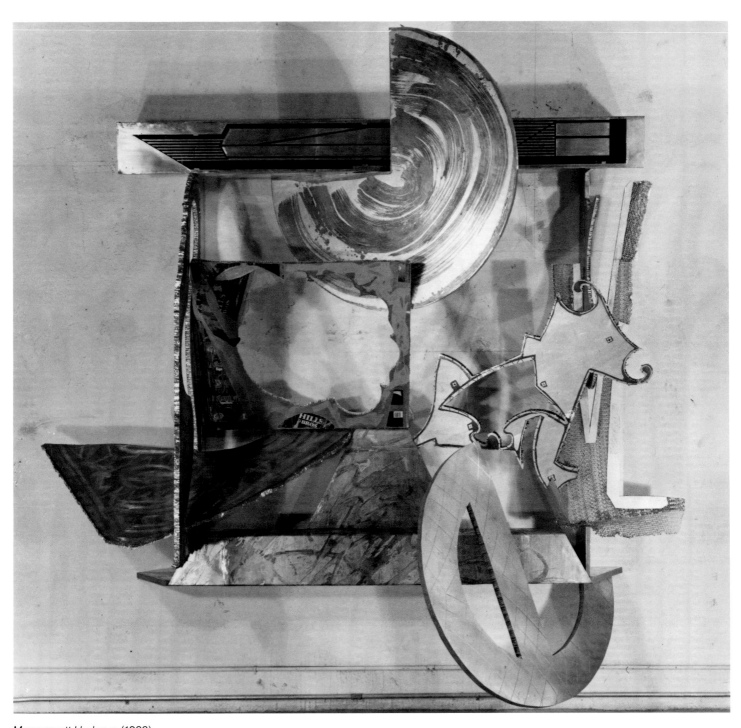

Marsamxett Harbour. (1983)
Mixed media on etched aluminum, etched
magnesium, and sheet steel, 9′10″ ×
9′10″ × 35¼″ (299.8 × 299.8 × 89.5 cm)

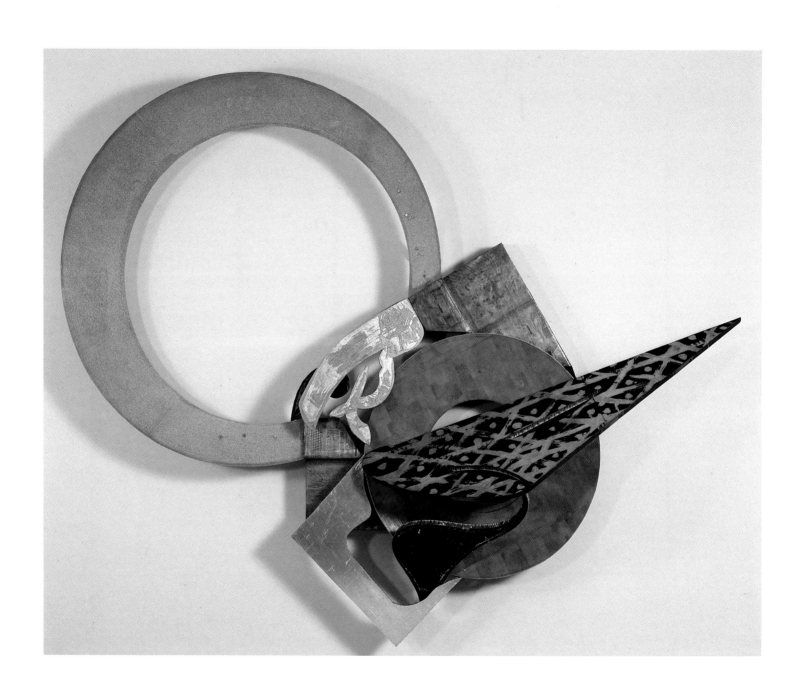

above
Mellieha Bay. (1983)
Mixed media on fiberglass, etched
aluminum, etched magnesium, and
sheet steel, 11'6" × 14'5" × 42"
(350.6 × 439.5 × 106.7 cm)

opposite
Marsaxlokk Bay. (1983)
Mixed media on etched aluminum,
etched magnesium and sheet steel,
11'2" × 9'11½" × 51" (340.4 × 303.5 ×
129.5 cm)

124

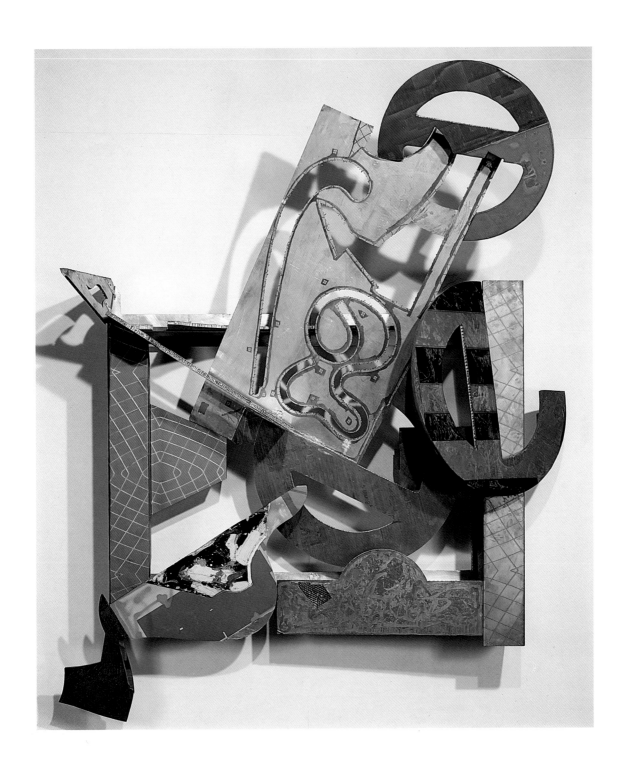

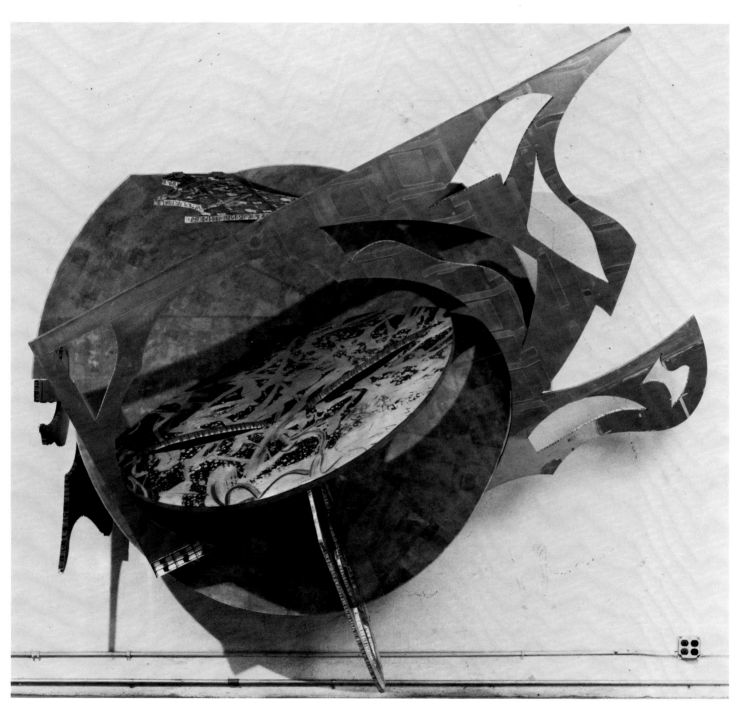

above
Zonqor Point. (1983)
Mixed media on fiberglass, etched aluminum,
etched magnesium, and sheet steel, 9'2" ×
10'2" × 66" (279.4 × 309.9 × 167.7 cm)

opposite
St. Michael's Counterguard. (1984)
Mixed media on fiberglass, etched aluminum,
etched magnesium, and sheet steel, 13' ×
11'3" × 9' (396.3 × 343 × 274.3 cm)

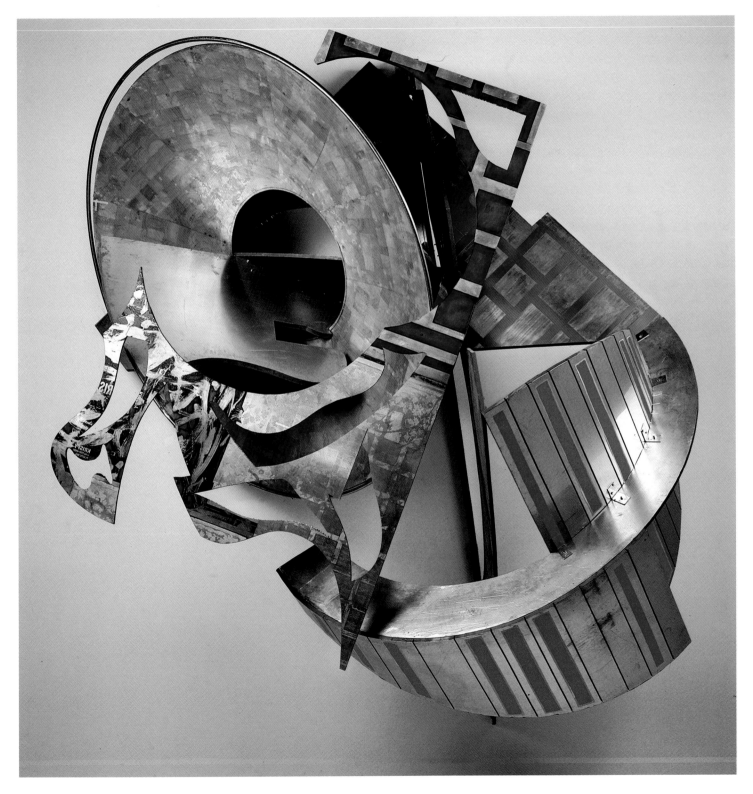

127

element is much smaller (it can be made out between the two discs), and though its rectangle is echoed at an angle at the very bottom of the relief, the box frame is largely obscured by dramatic and semaphoric forms that spill out of it.

The imposing size, architectonic character, and dramatic layouts of the Malta reliefs reflect the profound impression made by the island of Malta, which Stella visited in order to see Caravaggio's monumental *Beheading of St. John the Baptist*. The great flange, perforated by earlier cutouts, which billows up from the center of *Marsaxlokk Bay*'s rectilinear architecture and terminates in a turquoise and rust protractor, is almost an abstract evocation of ship sails and flags projecting above the fortified architecture of Malta's harbor. "There's something very particular about the making—the building up—of the harbor at Malta," Stella recalls, "something in the way these stones are set in the fortifications, in the character of the wharves, the overall harbor mentality of the city. For a time, some special power radiated out from that island. It was as if some sort of uranium was there, as if they possessed the power of the pyramids."[45]

Playskool Yard. (Artist's proof, 1983)
Mixed media on cast metal and wood,
32 × 28 × 9″ (81.3 × 71.2 × 22.9 cm)

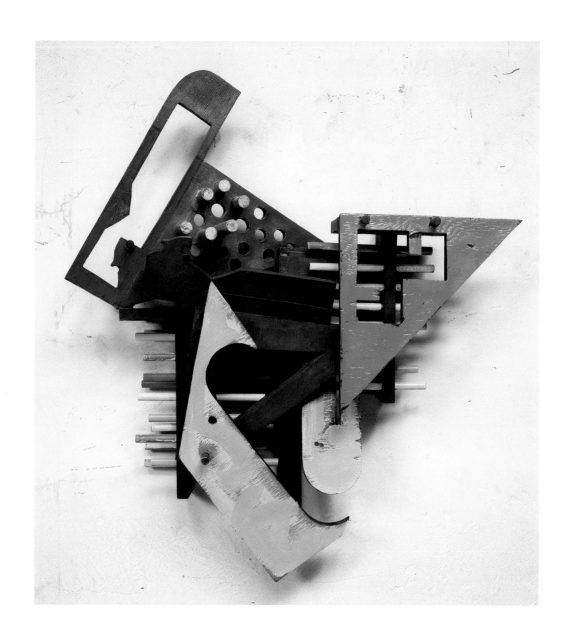

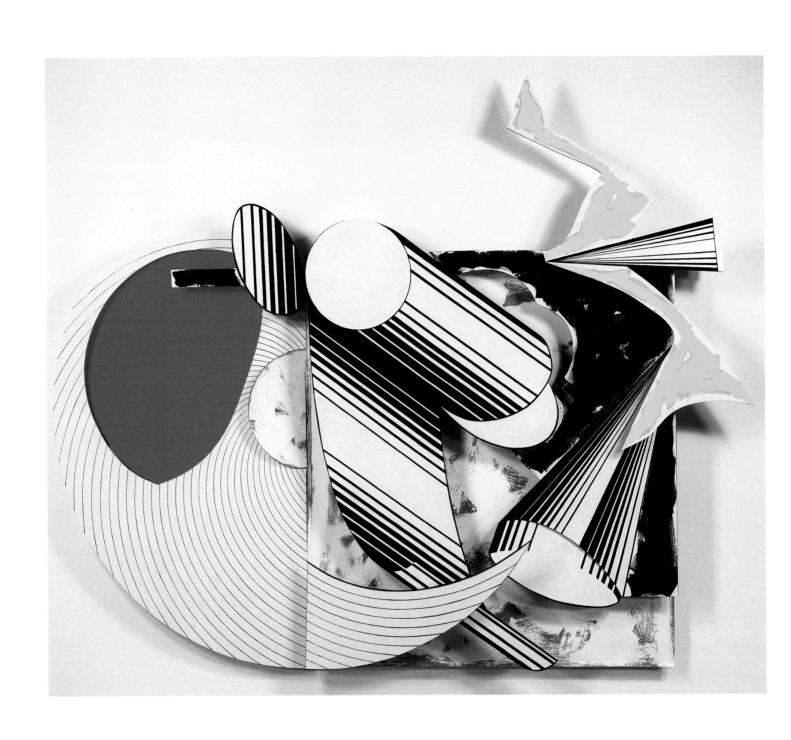

Diavolozoppo, 4×. (1984)
Mixed media on canvas, etched
magnesium, aluminum, and fiberglass,
11′7⅛″ × 14′1¾″ × 16⅛″ (353.4 ×
431.3 × 41 cm)

Then Came a Stick and Beat the Dog, Illustration no. 4 from *Illustrations after El Lissitzky's Had Gadya.* (1982–84). Hand-colored and collaged lithograph, linoleum block, and silkscreen prints, 52⅞ × 52¾″ (134.3 × 134 cm)

El Lissitzky
Then Came a Stick and Beat the Dog, Illustration no. 4 from the *Had Gadya.* (1919). Lithograph, 11 × 10¼″ (28 × 26 cm)

IN HIS EARLIEST PRINTS, Stella did little more than record the catalogue of his paintings—in smaller format. The story of how he transformed himself during the last fifteen years into one of the country's most innovative printmakers has been told elsewhere.⁴⁶ Nevertheless, any account of his painting must take stock of his printmaking at certain crucial moments of intersection. We have already seen that the characteristic etched pattern of the Circuits (and of certain Malta series pieces made from Circuit scrap, such as *Marsaxlokk Bay*) originated as the novel element in the print series known as Polar Co-ordinates (page 95), which was otherwise developed from the Saskatchewan group of Protractor pictures. We have also seen that the configurations of the Shards were taken directly from the antecedent print series. Despite the fact that their maquettes were conceived independently, however, the Cones and Pillars, Stella's major series of reliefs of the mid-eighties, are probably closer in spirit to the prints that anticipated them, the *Illustrations after El Lissitzky's Had Gadya,* than are any other group of Stella's paintings to his printed work.

The *Had Gadya* prints were begun in 1982 and completed two years later as the earliest of the Cones and Pillars were being painted; the two years were necessitated by the complex methods they entailed: a collaging onto hand-painted surfaces of shaped paper forms printed lithographically, by linoleum block, silkscreen, and rubber relief. The series was inspired by the illustrations El Lissitzky had executed in 1918–19 for the "Had Gadya" (a moralizing folkloristic song of *shtetl* life that is included in the Haggadah, a compilation of texts relating to the Passover celebration; see p. 40). These illustrations provided Stella with a model for a narrative image so simple, so reduced to essentials, that it could be treated in a virtually iconic manner—a simplicity that was made possible for Lissitzky, in turn, by the nature of the text itself: e.g., "Then came a dog and bit the cat"; "Then came a stick and beat the dog"; "Then came a fire and burnt the stick."

The folkloristic Cubism Lissitzky employed in his *Had Gadya*—a style that resembled the one his compatriot Chagall had been using for some years—could not, however, have challenged Stella, artistically speaking, as much as other, more non-figurative aspects of Lissitzky's work, such as the "Proun" compositions. The morphology of the "Prouns" is largely geometrical and resolutely non-figurative, and their execution—much in the spirit of modern architectural renderings (Lissitzky was himself a trained architect)—defines schematically an "inconsistent" perspectival space (page 135). (By "inconsistent," I mean that the orthogonals do not cohere to make a single, unified system, as in older perspective; "schematic" refers to the fact that all graduated modelling—as well as aerial perspective—is suppressed, so that only the linear orthogonals, in combination with evenly shaded planes, act as spatial cues.) Stella must certainly have been interested by the manner in which Lissitzky employed his non-figurative vocabulary to narrative ends, as he did in his 1920 book of prints *About Two Squares.* There, the legend for each image has something of the same sort of simplicity as the lines of the "Had Gadya" song; the

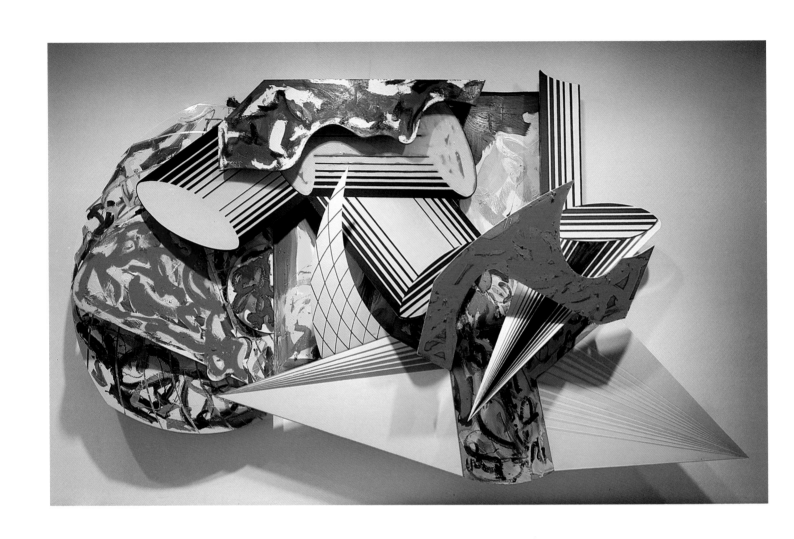

Giufà, la luna, i ladri e le guardie, 3.8×. (1984)
Mixed media on canvas, etched
magnesium, aluminum, and fiberglass,
9′7¼″ × 16′3¼″ × 24″ (292.7 × 495.9 ×
61 cm)

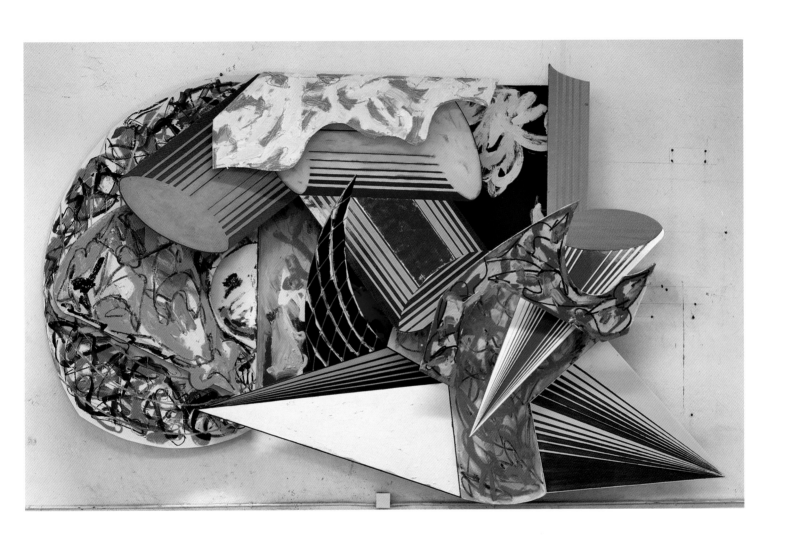

Giufà, la luna, i ladri e le guardie, 4×. (1985)
Mixed media on canvas, etched
magnesium, aluminum, and fiberglass,
10'3¾" × 16'5" × 27⅜" (314.4 ×
499.4 × 69.6 cm)

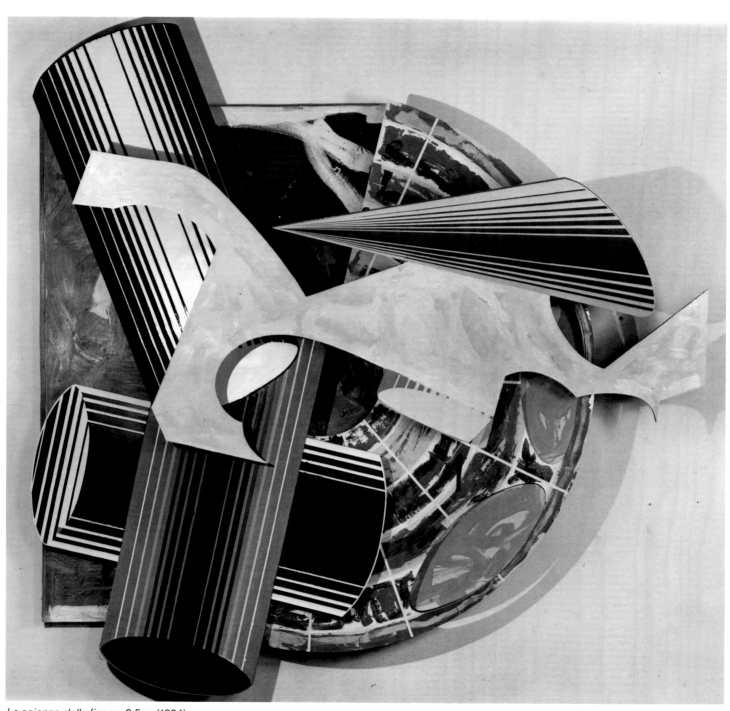

La scienza della fiacca, 3.5×. (1984)
Mixed media on canvas, etched
magnesium, aluminum, and fiberglass,
10′4½″ × 10′9¼″ × 31¼″ (316.3 ×
328.3 × 79.4 cm)

title, for example, of the print for which The Museum of Modern Art owns the preparatory watercolor is *They Fly Around the Earth Back and Forth (and)*.

Stella was seriously engaged by this question of "abstract narrative," as the full title of the *Had Gadya* series suggests; they are very pointedly called "illustrations" after the Lissitzky work. At the same time, Stella does not seem to have wanted to illustrate anything in quite so straightforward a manner as Lissitzky had in *About Two Squares*. If we search Stella's imagery for symbols of particular narrative components, a few seem to suggest themselves, but their role is not consistent. The mirror-image step-like form, for example, is colored blue when it first appears in the fourth print, *Then Came a Stick and Beat the Dog* (page 131), and turns red in the fifth print, *Then Came a Fire and Burnt the Stick*. If, however, we hypothesize that it stands for the "stick," we are obliged to explain its presence later in *Then Water Came and Quenched the Fire* and *Then Came an Ox and Drank the Water*. Are we to be so literal as to imagine it as a burnt stick-in-the-mud?

It is, I think, more profitable to attach less constant and precise values to individual shapes in Stella's *Had Gadya*, but nevertheless somehow to conceive of the overall vocabulary of shapes—the cylinders (or pillars), the cones, the "Mickey Mouse,"[47] the grilles, the wave-form, etc.—as a kind of cast of characters that may be used interchangeably to act upon one another, to tell a story whose events are more pictorial than literal. But those pictorial events involve divergences, movements through space, clashes, fusions, metamorphoses, confrontations, obliterations, and all manner of happenings that have a feeling of narrative action about them.

What Stella is about here, I think, is an attempt to reclaim for painting as much of the narrative drama of older art as is possible within what remains abstract imagery, yet to reclaim it more as a way of firing the artist's imagination than as a message for the viewer. We have already seen that in regard to the Exotic Birds, Stella spoke of the irregular curves as "functioning figuratively." In the *Had Gadya* and the Cones and Pillars that grow out of them, the dramatis personae are if anything more distinct and variegated. Not that Stella lays out his picture according to a storytelling order. Rather a single action, a narrative happening, becomes a stimulus to composing a picture, which will retain expressively (i.e., pictorially) the residue of that inspiration. To be sure, the viewer would probably not recognize—or even suspect—such a particularized narrative source despite the titles the *Had Gadya* prints come supplied with; in that sense, the iconography, like the "girlfriend's ankle" Stella recalled in discussing the Circuits, remains a private association. We cannot but feel, however, that the richness if not the specificity of these associations comes through in the finished works.

This reclamation of the inspirational spirit, if not the particulars, of narrative is a logical extension of the "maximalist" position Stella has taken in his "second career." In place of the kind of questions that propelled sixties abstraction—"How spare can my art be? How few conventions of painting can I use and still make it good?"—

El Lissitzky
Proun 23, No. 6. (1919)
Oil on canvas, 20½ × 30¼″ (52 × 77 cm)

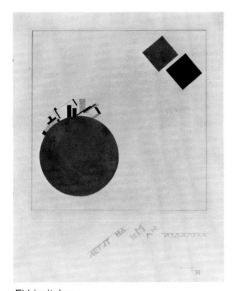

El Lissitzky
Drawing for *They Fly Around the Earth Back and Forth (and)* from *About Two Squares in Six Constructions: A Suprematist Story.* (1920). Watercolor and pencil on cardboard, 10⅛ × 8″ (25.6 × 20.2 cm)

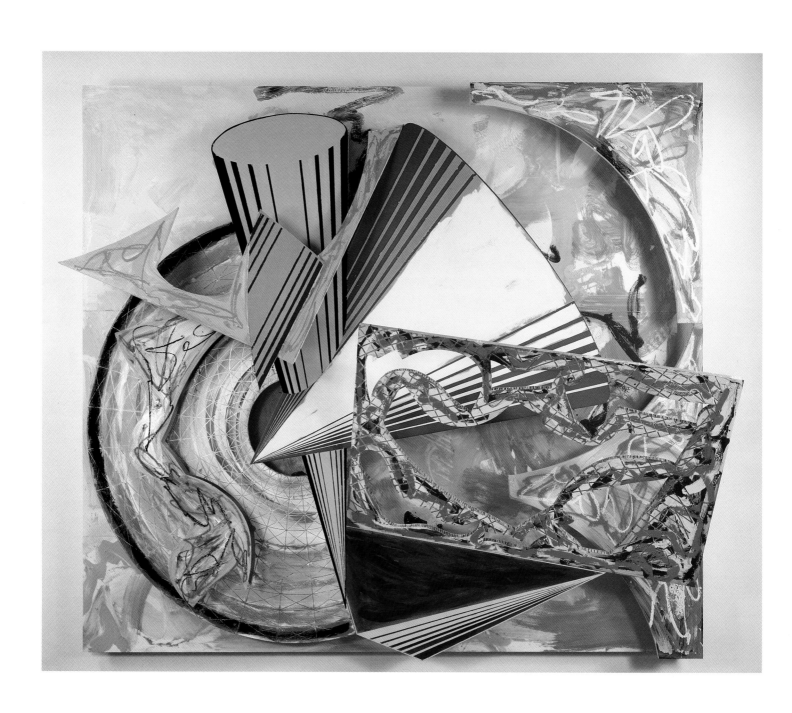

above
Il Drago e la cavallina fatata, 3×. (1985)
Mixed media on etched magnesium,
aluminum, and fiberglass,
10′ × 11′5¼″ × 35½″ (304.8 × 348.9 ×
90.2 cm)

opposite
Gobba, zoppa e collotorto, 3×. (1985)
Mixed media on etched magnesium,
aluminum, and fiberglass,
11′5″ × 10′⅛″ × 34⅜″ (348 × 305.1 ×
87.3 cm)

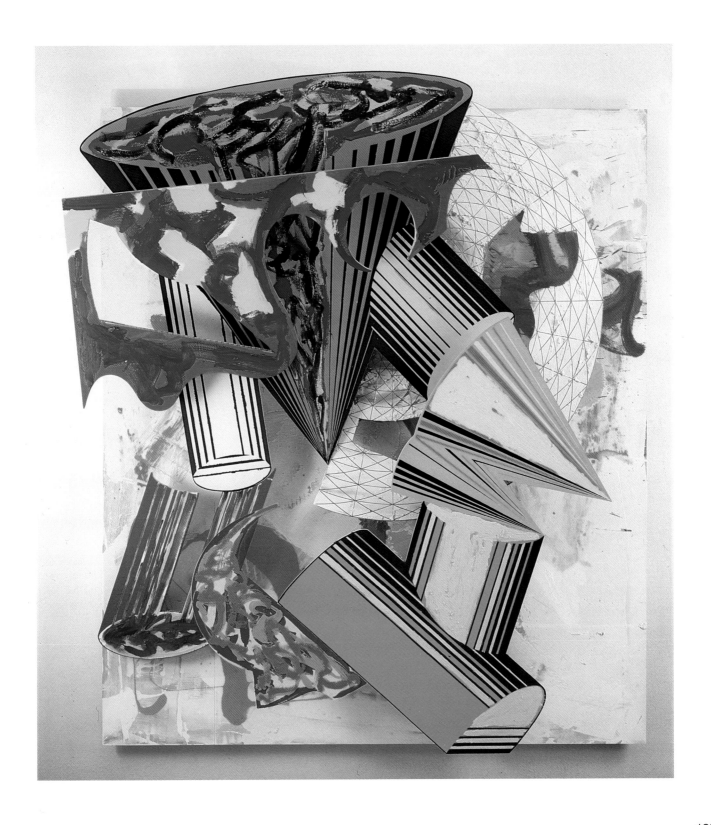

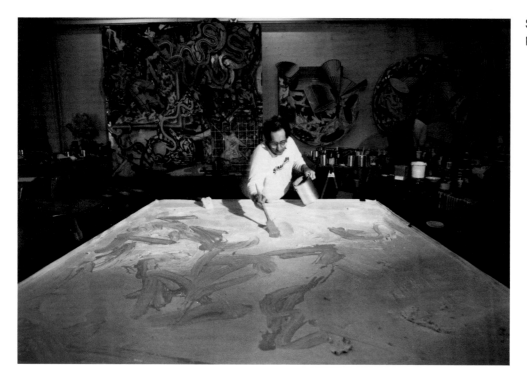

Stella now reconsiders older art to see which of its discarded conventions can again be made viable. We have seen this result in the creation of a "mixed space" that fused literal relief with purely optical cues and ambiguous fragments of illusionism. The latter took the form of the "schematic" perspective first visible in the Irregular Polygons and developed differently in the Polish Village series and the Cones and Pillars themselves; in different ways, artists such as Matisse (*The Red Studio*), Picasso, de Chirico, Klee, Léger, and, of course, Lissitzky had anticipated the recuperation of schematic perspective. We have also seen Stella recuperate the *Malerischkeit* of Abstract Expressionism in a forward-looking manner that subsumed an interest in graffiti. That Stella should also return to dramatic action was probably triggered by his interest in the work of older painters, Caravaggio in particular. Yet the concern for narrative has been widespread in twentieth-century art as well, despite the fact that its most important generating style, Cubism, was inherently iconic in character. Nevertheless, in Picasso's virtually unreadable high Cubist pictures and in some equally unreadable ones of the twenties and thirties, real-life events and situations inspired the compositions—however little those stimuli were visible in the finished work. Picasso's strong narrative tendencies did not disappear entirely, but "went underground," into an essentially symbolic state, in 1909,[48] prior to returning in force after World War I. In the meantime, however, artists as different as Léger, Klee, Boccioni, Picabia, and Lissitzky were working toward

138

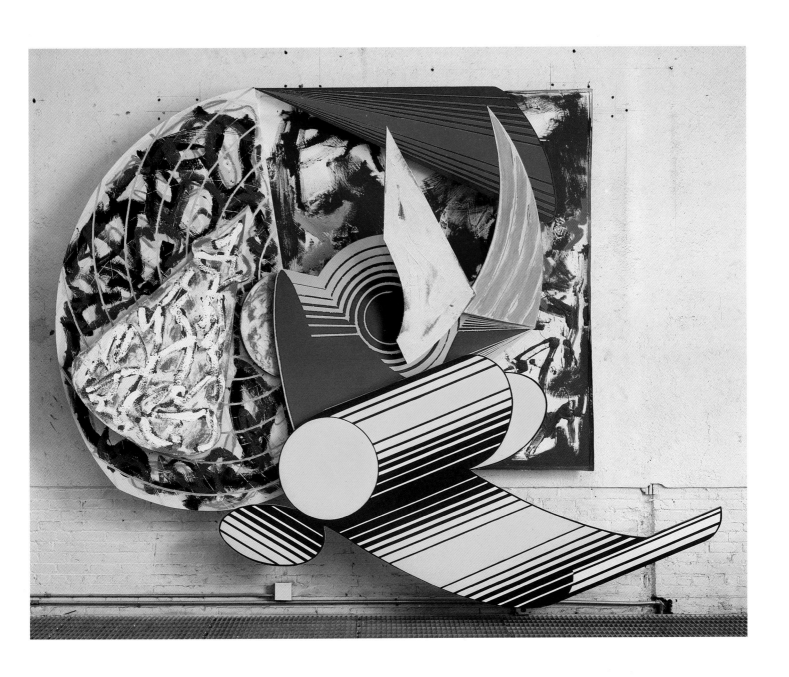

above
Giufà e la statua di gesso, 3.8×. (1985)
Mixed media on canvas, etched
magnesium, aluminum, and fiberglass,
10'2½″ × 13'3⅜″ × 26⅜″ (311.2 ×
404.8 × 67 cm)

page 140
Salta nel mio sacco!, 3.8×. (1985)
Mixed media on etched magnesium,
aluminum, and fiberglass,
13'2⅜″ × 10'11⅞″ × 15⅞″ (420.3 ×
335 × 40.3 cm)

page 141
Lo sciocco senza paura, 3.8×. (1985)
Mixed media on etched magnesium,
aluminum, and fiberglass,
10'6″ × 9'9¾″ × 20¾″ (320 × 299.1 ×
52.7 cm)

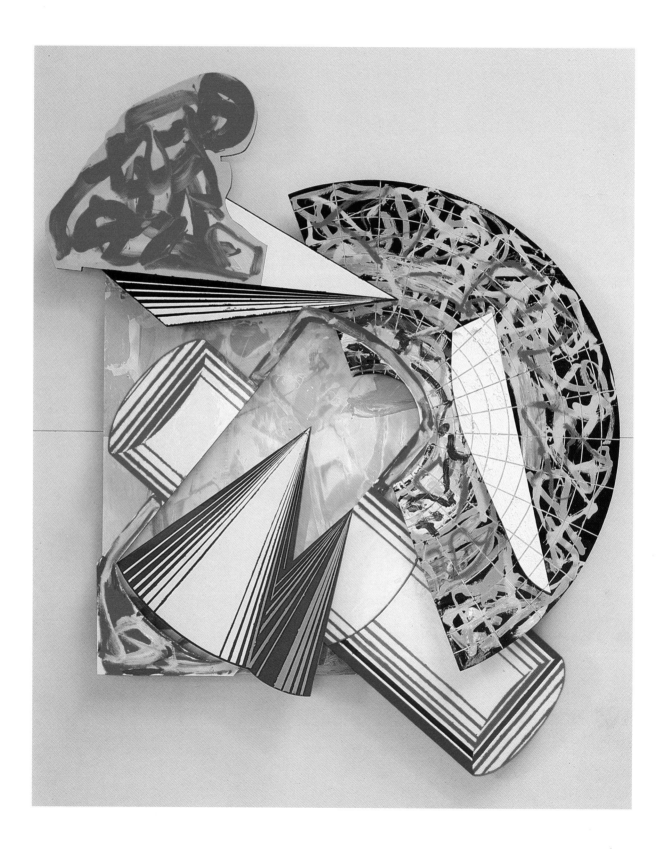

140

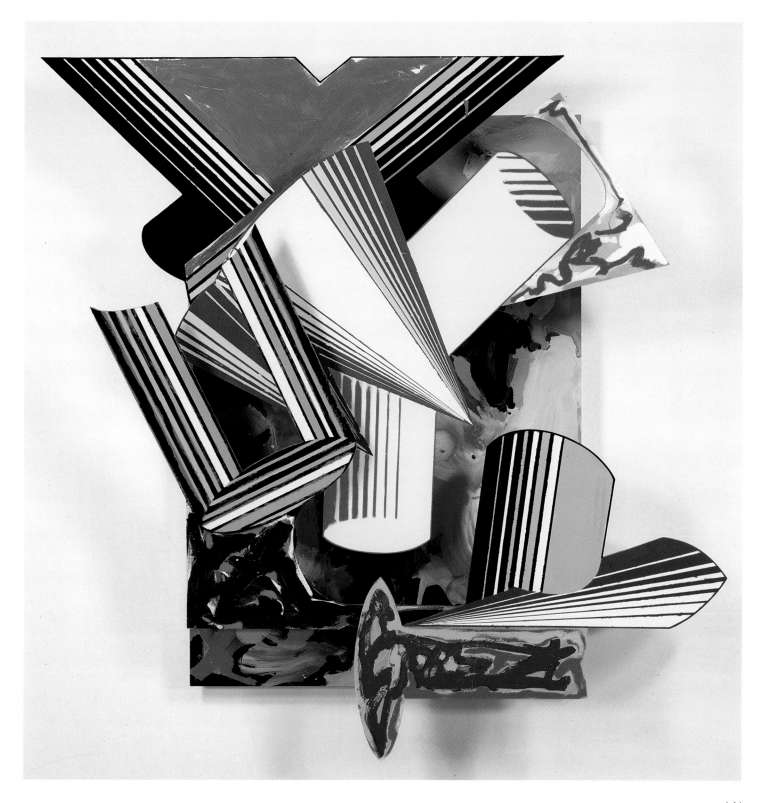

their own accommodations of abstract forms and narrative values.

Stella had been especially drawn to Lissitzky's illustrations for the "Had Gadya" song "because they were beautifully done, very simple and very graphic."

This story was so simple—such lines as "The stick beat the dog"—that the text is already in itself very close to being abstract. You know the stick has to have someone behind it, but it's being abstracted, separated out and given a life of its own. It would be easy just to draw a narrow rectangle and a conventional rectangle and identify them as stick and dog.

This would have been in line, of course, with what Lissitzky did in *About Two Squares*. But in his *Had Gadya*, Stella was inspired even more directly—at least as regards morphology—by some diagrammatic drawings in a late nineteenth-century architectural treatise on stonecutting given him by his friend and dealer John Kasmin. Some of the plates in Louis Monduit's *Traité théorique et pratique de la stéréotomie* illustrate in schematic perspectival form with linear shading the kind of interpenetration of regular solids that Stella developed further in his *Had Gadya*.

THE CONES AND PILLARS, the forty-eight metal reliefs developed in the same style as Stella's *Had Gadya* prints, were given titles from the *Italian Folktales* of Italo Calvino, whom Stella met in connection with the Norton lectures. These story titles were chosen after the fact (the reliefs having been composed before the titles were assigned) but they were picked "for a certain appropriateness," and in some cases because they seemed to echo a narrative implication that Stella felt in the picture. "The Cones and Pillars have a blunt, primitive quality to them as paintings," says Stella.

They have very much the spirit of the well-told folktale. They are very active, they're very fantasy-like, and they're very simple—even brutal—in the way that fairy tales are....I had the feeling that with a little bit of mental jockeying their forms could represent things. It wasn't hard to imagine them being a cat or a person.

The Cones and Pillars deliver a greater impression of movement through space, of a dramatic pictorial happening, than do the *Had Gadya* prints, not only because of their large size, but because their oblique movement—suggested in schematic perspectival fashion by the orthogonals of such forms as the cones—is reinforced by the *actual* obliqueness of those metal planes in relation to the supporting wall. Indeed, among the very last pictures in the series are some in which Stella has relieved the cone and pillar forms almost three-dimensionally (page 146). The intersection of the large forms in the Cones and Pillars represents yet another gloss on those seminal pictures of the sixties, the Irregular Polygons. But the force with

Detail of *Some Penetrations of Solids,* from Louis Monduit, *Traité théorique et pratique de la stéréotomie.* (n.d.)

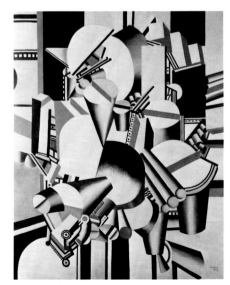

Fernand Léger
Mechanical Elements. (1918–23)
Oil on canvas, 6'11" × 65⅞"
(211 × 167.5 cm)

La vecchia dell'orto, 3×. (1986)
Mixed media on etched magnesium,
aluminum, and fiberglass,
10'7" × 12'8¾" × 42¼" (322.6 × 388 ×
107.3 cm)

which the giant cylinders and cones impact upon one another and upon the more irregular forms in the reliefs also recalls monumental works by Léger (such as the Basel Kunstmuseum's *Mechanical Elements* [page 142], which Stella knows and admires). Léger's forms differ, however, in often having a descriptive volume; that is, their relief is suggested by graduated modelling. In the end, what separates the Cones and Pillars not only from both Léger and Lissitzky but from Stella's own earlier work as well is the encounter within them of two polar styles of execution, the painterly and the precise (or "hard-edge"). While a comparable simultaneity of manners was deployed successfully on occasion by Picasso, it is a rare thing in painting, and not at all easy to bring off. Yet half the drama of a picture such as *Diavolozoppo* (page 130) would be lost if the yellow and blue areas on the right did not contrast in their surface character as well as in their shapes with the pink form and the areas described linearly.

The pictorial drama of the shaped metal cutouts in the Cones and Pillars is enacted against a rectangular canvas "background" that Stella paints first. As already in the case of the grounds of the Exotic Birds, the colors of the ground become a major determinant of the palette of the rest of the picture. "It's the most demanding part," says Stella. "It has to be strong enough to carry in relation to the other forms, but it can't get in the way of their action." These canvas rectangles, which Stella decided to replace by aluminum ones for the last third or so of the series, have some graffiti-like linear brush-drawing but are mostly painted in a loose and soft manner; in the improvisational and lyrical ground of *Lo sciocco senza paura* (page 141), for example, there are echoes of the painterliness of the later de Kooning. The background of the densely compacted *La vecchia dell'orto* (page 143) is more cursive and contrasty; its large size also virtually encompasses the action of the other forms—which is true of many of the later works in the series. In the earliest—as in the two versions of *Giufà, la luna, i ladri e le guardie* (pages 132, 133)—the ground is so small relative to the action of the other forms that it fails to distinguish itself from them.

Loomings, 3×. (1986)
Mixed media on etched magnesium and aluminum, 11'10⅛" × 13'6½" × 44" (361 × 412.8 × 111.8 cm)

146

STELLA'S COLOR in the metal reliefs, like that of most American painting, owes more to the primary-based palette of the French tradition than to that of European Expressionism, which built its color chords on secondary and tertiary hues. Yet within this framework, depending on the series, he will incline in different directions. There are unexpected consonances and dissonances, some involving highly artificial, neon-like hues (anticipated in Stella's early work by his Day-Glo palette) or deliberately "bad-taste" colors, others at the edge of the arbitrary. Indeed, Stella's method invites a certain serendipitousness in the color. From the moment he conceives his reliefs, he has a general idea of what will be the range and character of their color. "By the time you're trying out more chancy things you're already working in a key that has been established," Stella observes. "I start out with a whole set of combinations at hand. There's the pink-orange-brown variation, or maybe I'll go with the gray-violet-black combo." But insofar as the colors are mixed and the individual units of the large reliefs painted while they are on the studio floor, Stella does not have available the constant reference to the work as a whole which is normal for easel painting. To the extent that his mental image of the way the colors go together may be imperfect, there enters into the execution, at least on the first go-round, a certain aleatoriness, which no doubt accounts for some of the freshness of his color. When the painted reliefs are put together, some seem right to Stella, others wanting. When he first began the metal reliefs, he expected the reworking of color to account for about a third of his time; in the event, it has worked out to be only about half what he expected. Nevertheless, he may keep a picture on the wall for weeks just reworking the color of one metal panel.

No color choice can be truly aleatory, of course, because the painter does not—in fact, could not—entirely relinquish his imaginative engagement; even if only unconsciously, Stella's colors are indeed chosen. Nevertheless, to the extent that he may momentarily forget just where in the configuration a certain panel sits, or what colors its neighbors are, a margin of accidentality enters in. Stella considers this a sufficiently important stimulus that he has sometimes exaggerated its role,[49] and has had to recant:

The color is nowhere as arbitrary as I've occasionally said. It's just that I don't pay much attention to the colors because, in a sense, I already know what I'm going to do. I imagine that all artists, after working for a while, get into practice—something like a surgeon. Then you sort of do it automatically.... Sometimes the picture gets hung up and you say to yourself, "The only way out of this is red," but you probably somehow knew that before you started. Yet you may say to yourself, "I'm just not going to end up with red there," so you search for a variation or another way out of the problem. Often the solution is in the tone—a question of finding a more interesting red than any of the ones you usually use. You hope that you get something a little better, that your reaction is such that you go beyond your abilities.

147

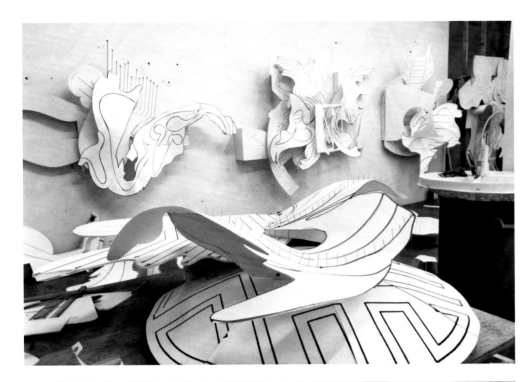

Two views of Stella's studio, with paper maquettes for an as yet unnamed series, 1986

page 150
The Lamp, 3×. (1987)
Mixed media on cast and
fabricated aluminum,
8'8¼" × 6'3½" × 71½"
(246.8 × 191.8 × 181.7 cm)

AS THIS MONOGRAPH was being written, Stella was at work on eleven reliefs that constitute the group of pictures entitled Waves; we have been able to include one of the earliest large reliefs, *Loomings* (page 145), in the exhibition. The wave-like form, which already played a certain role in the *Had Gadya* prints, has become more important here (and becomes the central morphological element in a group of fifty pictures in another, as yet unnamed series, for which Stella is now executing paper models). *Loomings* suggests that the overall painterliness and, above all, the high color that have characterized most of Stella's work since the Exotic Birds are again, if only temporarily, in suspension.

Standing amid the dozens of paper models that represent the second group of new paintings (page 148) during a recent visit to Stella's studio, I could not but be overwhelmed by the sheer profusion of his ideas, and the immense outpouring of energy on which they ride. At fifty-one, Stella seems to me even more inspired, and to be living more dangerously, than at thirty-three, his age at the time of his first Museum of Modern Art retrospective. The catalogue of that exhibition ended with the observation that Stella's "endurance faces many challenges, not the least of which is the quality of his own past."[50] In the interim, he has more than met that test. Indeed, though it smacks of comparing apples and oranges, I would consider that the best of the metal reliefs of recent years are superior even to the finest paintings of the early sixties. And with the prospect of decades of development lying ahead, one can imagine that there is still greater and more unexpected work yet to come. Certainly no painter has ever committed himself more completely in the quest to "make it better."

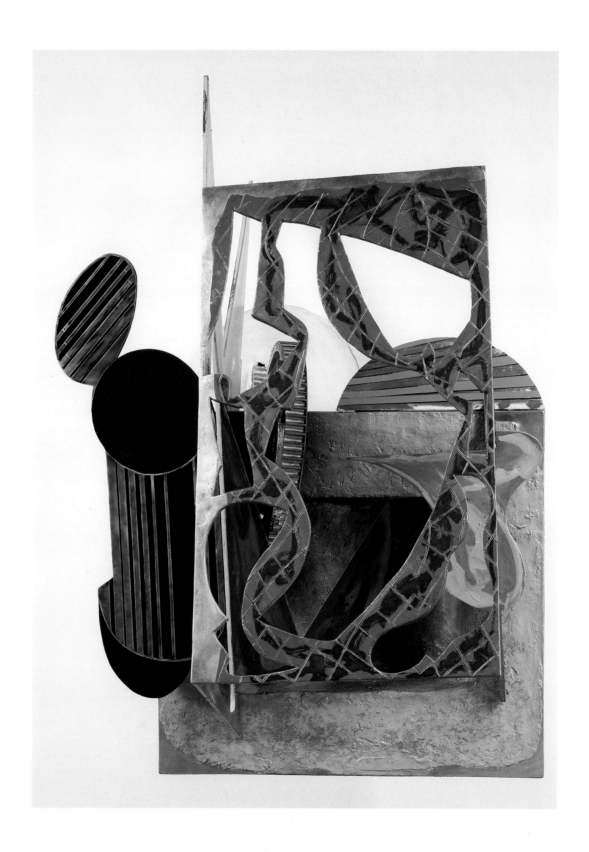

150

Notes

All comments by Stella for which no source is given are from conversations with the author taped in 1981 and 1985–87; some were subsequently edited by the artist.

1 Transcript of interviews with Frank Stella by Caroline Jones. The typescript of these discussions—which involved some question-and-answer material with students at the Fogg Art Museum, Harvard University, in relation to works exhibited there (see Chronology, 1983)—was generously put at my disposal by Ms. Jones. Small segments of it appeared in edited form in "Spaces and the Enterprise of Painting," *Harvard Magazine* (Cambridge, Mass.), May–June 1984, pp. 44–51. Stella has felt free to revise any unpublished passages of the typescript used herein.

2 *Ibid.*

3 *Ibid.*

4 Rothko considered Pollock's brief return to all-over abstract painting in 1952–53 as a "retrieval," a return to a kind of work that was on the right track, historically. He spoke to me of Jasper Johns's subsequent use of flags, numbers, and letters as motifs as a kind of regression, which he was sure was swimming against the tide of non-figurative painting that was by then firmly established, if not inevitable. There was about these opinions a vestige of historical determinism, perhaps carried over from Rothko's earlier political thinking.

5 Robert Rosenblum, "Stella's Third Dimension," *Vanity Fair* (New York), Nov. 1983, p. 88.

6 Interview by Bruce Glaser with Stella and Donald Judd broadcast by WBAI-FM, New York, February 1964, under the title "New Nihilism or New Art?"; published as "Questions to Stella and Judd," ed. by Lucy R. Lippard, *Art News* (New York), Sept. 1966, pp. 55–61.

7 Hilton Kramer, "The Crisis in Abstract Art" (review of *Working Space*, by Frank Stella), *Atlantic Monthly* (Boston), Oct. 1986, pp. 96–97.

8 See Dora Vallier, "Braque, la peinture et nous: Propos de l'artiste recueillis," *Cahiers d'art* (Paris), Oct. 1954, pp. 13–24, and William Rubin, "Cézannisme and the Beginnings of Cubism," in *Cézanne: The Late Work*, catalogue of an exhibition held at The Museum of Modern Art, New York, October 7, 1977–January 3, 1978.

9 Picasso's only sculpture in the round during these years was not a construction. *Glass of Absinth* (1914) was modelled in clay and cast in an edition of six differently painted and finished bronzes.

10 Jones, unpublished transcript; see above, note 1.

11 Rosalind Krauss, "Stella's New Work and the Problem of Series," *Artforum* (New York), Dec. 1971, pp. 40–44.

12 *Ibid.*, p. 41.

13 *Ibid.*

14 *Ibid.*, p. 44; italics mine.

15 D.-H. Kahnweiler told me (ca. 1952) that, while Picasso's neo-classicism was popular with collectors, some *amateurs* of Cubism never bought these works, and a few of them felt absolutely deceived by Picasso's new "dual track" approach.

16 The dark trapezium in the upper left of the Malevich drawing illustrated on page 34 is a case in point. While this form can be read as a trapezium situated parallel to the picture plane, and hence flat, it can also be read as a rectangle tilted down and away from the picture plane. The narrowing of the orthogonals of both the shorter and longer sides in this reading are spatial cues that are not fully illusionistic (i.e., only "schematic") because they are not accompanied by changes in the shading of the plane, or by the effect of aerial perspective.

17 Philip Leider, *Stella Since 1970*, catalogue of an exhibition held at The Fort Worth Art Museum, March 19–April 30, 1978, p. 11.

18 In three instances, *Mogielnica IV* (page 27), *Nasielsk IV* (page 33), and *Bechhofen IV*, Stella also executed full-size unpainted wooden versions, and in the case of *Kamionka Strumiłowa*, a Fourth Version of the configuration set the composition in a rectangular picture field (page 30).

 The systematic division of the Polish pictures into three types, distinguished by the degree and angle of their relief, was not instituted until after thirteen compositions of the series had been painted, some of them in more than one version. Consequently, as for example in the case of *Chodorów II* (page 11), the Second Version might not involve the high-relief materials that distinguish versions marked II later in the series. *Chodorów II* differs from *Chodorów I* only in color.

19 *Stella Since 1970, op. cit.*, pp. 93–94.

20 This "down-spill" type of composition, as in Kandinsky's *Black Lines* (1913), was a development of ideas present in Cézanne, in particular in some watercolors that Kandinsky highly valued.

21 *Stella Since 1970, op. cit.*, p. 95; emphasis Malevich's.

22 Maria and Kazimierz Piechotka, *Wooden Synagogues* (Warsaw: Arkady, 1959).

23 Carolyn Cohen, *Frank Stella: Polish Wooden Synagogues—Constructions from the 1970s*, brochure catalogue of an exhibition held at The Jewish Museum, New York, February 10–May 1, 1983, p. 4.

24 *Ibid.*

25 *Stella Since 1970, op. cit.*, p. 102.

26 *Ibid.*, p. 103.

27 The exceptions are the pictures executed in black, white, and gray, such as *Sight Gag* (page 53).

28 The critic and art historian Michael Fried had for many years been one of Stella's close friends and admirers. His writing on Stella in *Three American Painters: Kenneth Noland, Jules Olitski, Frank Stella* (catalogue of an exhibition held at the Fogg Art Museum, Harvard University, April 21–May 30, 1965) and his articles "Shape as Form: Frank Stella's New Paintings" (*Artforum* [Los Angeles], Nov. 1966, pp. 18–27) and "Art and Objecthood" (*Artforum* [Los Angeles], June 1967, pp. 116–17) were fundamental to the literature on Stella during the 1960s. In the early 1970s, Fried was preparing a book on Diderot and eighteenth-century French painting (*Absorption and Theatricality: Painting and Beholder in the Age of Diderot* [Berkeley, 1980]). During this time his relations with Stella became less close.

29 The terms *French curve* and *irregular curve* are often used interchangeably in mechanical drawing, to denote the entire category of curves of which railroad, aircraft, and ship curves are subcategories. In the present discussion, however, I have followed Stella's practice and used *French curve* to refer only to the familiar clef-like forms.

30 "Stella's Third Dimension," *op. cit.*, p. 93.

31 Under the colors of Magenta Stables.

32 "Stella's Third Dimension," *op. cit.*, p. 92.

33 Jones, unpublished transcript; see above, note 1.

34 *Ibid.*

35 Frank Stella, *Working Space* (Cambridge, Mass., 1986), p. 10.

36 Frank Stella, "On Caravaggio," *New York Times Magazine*, Feb. 3, 1985, p. 71.

37 "Stella's Third Dimension," *op. cit.*, p. 93.

38 *Working Space, op. cit.*, pp. 11, 12.

39 *Ibid*, p.11.

40 Jones, unpublished transcript; see above, note 1.

41 "On Caravaggio," *op. cit.*, p. 39.

42 See Richard H. Axsom, *The Prints of Frank Stella: A Catalogue Raisonné, 1967–1982* (New York, 1983), cat. nos. 119–28.

43 During the years 1982–84, Stella also executed a series of nine small reliefs that incorporated found objects. These works, known as the Playskool series, were replicated in tinted bronze in an edition of five of each relief. *Playskool Yard* (1983) from this series is illustrated on page 129.

44 The five Shards configurations were realized in seven large reliefs of 3× size (two of the configurations were repeated). In addition, two configurations were realized in mammoth size (4.75×), measuring nearly 17 × 15 feet (515.6 × 457.2 cm). The sense of size of the Shards is greater than their outer dimensions might suggest— as compared, for example, to the Cones and Pillars—inasmuch as the entire pictorial rectangle defined by those dimensions is filled in.

45 Jones, unpublished transcript; see above, note 1.

46 *The Prints of Frank Stella, op. cit.*

47 "Mickey Mouse" is Stella's nickname for a stencil-like tool for drawing circles of different sizes. He came upon it in a store in Zeltweg. It is visible, for example, in the upper left of the print that constitutes the "back cover" of Stella's *Had Gadya*, and (in negative) in the lower center of *Silverstone* (page 94).

48 See William Rubin, "From Narrative to 'Iconic' in Picasso: The Buried Allegory in *Bread and Fruitdish on a Table* and the Role of *Les Demoiselles d'Avignon*," *The Art Bulletin* (New York), Dec. 1983, pp. 617–49.

49 In his conversation with Caroline Jones (unpublished transcript; see above, note 1), Stella suggested that as he painted different dismounted parts of his metal reliefs, he didn't know which sections he was painting. This brought the intended reaction: Jones was "shocked."

50 William Rubin, *Frank Stella*, catalogue of an exhibition held at The Museum of Modern Art, New York, March 26–May 31, 1970, p. 149.

Chronology
1970–1987

Compiled by Diane Farynyk and Paula Pelosi

A chronology through 1969 is included in the companion volume, *Frank Stella* by William Rubin, published by The Museum of Modern Art in 1970 (see Selected Bibliography). Detailed chronologies are also included in Lawrence Rubin, *Frank Stella: Paintings 1958 to 1965—A Catalogue Raisonné* and Richard H. Axsom, *The Prints of Frank Stella: A Catalogue Raisonné, 1967–1982.*

In the chronology below, within the entries for each year Frank Stella's paintings and reliefs are listed first. All gallery exhibitions included are one-man exhibitions, unless otherwise indicated. Catalogues noted within the listings for one-man exhibitions at museums are cited in full in the Selected Bibliography.

1970

Continues Saskatchewan series.
Continues Protractor series.
Completes Newfoundland series.

January. Begins Aluminum series and Copper series of prints (corresponding to the 1960–61 painting series of the same names) at Gemini G.E.L., Los Angeles; published in June and September.
 Exhibition at Galerie Renée Ziegler, Zurich.
March. Retrospective exhibition *Frank Stella*, directed by William Rubin, at The Museum of Modern Art, New York. Exhibition subsequently travels to the Hayward Gallery, London; Stedelijk Museum, Amsterdam; Norton Simon Museum, Pasadena; and Art Gallery of Ontario, Toronto, through May 1971. (Catalogue)
May. Included in exhibition *American Art Since 1960* at The Art Museum, Princeton University, Princeton, New Jersey.
July. Begins Newfoundland series of prints (corresponding to 1969–70 painting series of the same name) at Gemini G.E.L., Los Angeles; published in February 1971.
 Included in exhibition *L'Art vivant aux États-Unis* at Fondation Maeght, Paris.
October. Travels to London and Amsterdam.
Fall. During hospital stay, makes drawings for what will become the Polish Village series.

1971

Completes Saskatchewan series.
Completes Protractor series with largest pictures of the series.
Begins Polish Village series, large-scale collage-reliefs. Titles—e.g., *Odelsk, Felsztyn*—refer to seventeenth-, eighteenth-, and nineteenth-century synagogues in Poland destroyed by the Nazis.

Exhibition at Irving Blum Gallery, Los Angeles.

January. Included in exhibition *Kelly, Lichtenstein, Stella* at Galerie Buren, Stockholm.
February. Begins Benjamin Moore series of prints (corresponding to 1961 painting series of the same title) at Gemini G.E.L., Los Angeles; published in June.
 Included in exhibition *The Structure of Color* at the Whitney Museum of American Art, New York.
March. Visits Brazil.
June. Included in exhibition *American Painting Since World War II* at the Delaware Art Museum, Wilmington.
August. Salmon fishing in Labrador with his father.
September. Included in exhibition *Amerikansk Kunst 1950–1970* at the Louisiana Cultural Centre and Museum of Contemporary Art, Humlebaek, Denmark.
October. Work from Polish Village series shown at Kasmin Gallery, London, and Lawrence Rubin Gallery, New York.
 Travels to Paris and London.
November. Included in exhibition *Formen und Strukturen der Farbe* at Galerie Hans Strelow, Düsseldorf.

1972

Continues Polish Village series, using corrugated cardboard to produce high-relief works.

February. Begins Purple series of prints (corresponding to 1963 painting series of the same name) at Gemini G.E.L., Los Angeles; published in May.
April. Begins Multicolored Squares series of prints (corresponding to the 1962–63 painting series Concentric Squares and Mitered Mazes) at Petersburg Press, New York; published in September.
August. Travels to Paris and Nice.
September. Included in exhibition *American Art Since 1945* at the Philadelphia Museum of Art, a loan exhibition from The Museum of Modern Art, New York.
October. Travels to London.
November. Included in exhibition *Recent American Painting and Sculpture in the Albright-Knox Art Gallery*, Albright-Knox Art Gallery, Buffalo, New York.

1973

Completes Polish Village series.

Exhibition at Irving Blum Gallery, Los Angeles.
January. Work from Polish Village series shown at Leo Castelli Gallery, New York.
 Included in *1973 Biennial Exhibition: Contemporary American Art* at the Whitney Museum of American Art, New York.
August. Travels to London, Geneva, and Lisbon.
October. Begins work on print *Tetuan III* (related to the Moroccan paintings of 1964) at Gemini G.E.L., Los Angeles, one of twelve prints

by twelve artists in the portfolio *For Meyer Schapiro*, published in 1974 to raise funds to endow a chair in honor of Professor Meyer Schapiro at Columbia University.

November. Work from Polish Village series shown in exhibition *Frank Stella* at The Phillips Collection, Washington, D.C., and in exhibition at Knoedler Gallery, New York.

1974

Paints Diderot series, the largest of his Concentric Square pictures. Most titles—e.g., *Bijoux indiscrets, Le Neveu de Rameau*—refer to works by the encyclopedist; exceptions—e.g., *Sight Gag*—are works executed in black, white, and gray.

Begins drawings and maquettes for Brazilian series. Titles—e.g., *Grajaú, Leblon*—refer to areas in and around Rio de Janeiro. Begins working with the Swan Engraving Company, Bridgeport, Connecticut, on the etching of the metal reliefs in this series. In the fall, begins painting the reliefs; completes a few of them before the end of the year.

January. Included in exhibition *The Great Decade of American Abstraction: Modernist Art 1960–1970* at The Museum of Fine Arts, Houston.

June. Eccentric Polygon prints (related to Irregular Polygon paintings of 1965–67) published by Gemini G.E.L., Los Angeles.

Receives honorary degree from the Minneapolis College of Art and Design.

July. Travels to Italy, including Genoa and Milan, and to Germany.

August. Begins work on Paper Reliefs series (compositions based on the Polish Village series), his first project with Tyler Graphics Ltd., Bedford, New York; published in November 1975.

1975

Completes Brazilian series.

January. Daughter Laura born to Shirley De Lemos Wyse.

April. Petersburg Press installs a lithography press on the first floor of Stella's Manhattan home.

May. Work from Brazilian series shown at Leo Castelli Gallery, New York.

In California, purchases an elaborate set of ship curves (mechanical-drawing templates) as birthday present for himself. Later adds railroad curves and French curves to his collection of templates; uses them to execute preparatory drawings upon which maquettes and metal reliefs of the series called Exotic Birds will be based.

October. Travels to London, Paris, and Germany.

Work from Brazilian series shown at Galerie Daniel Templon, Paris.

1976

Begins Exotic Birds, painted honeycombed aluminum reliefs based on draftsman's templates. Titles—e.g., *Brazilian merganser, Wake*

Island rail—are names of endangered or extinct birds. Industrial fabrication of reliefs, in sizes 3 and 5.5 times that of the maquettes, proves a lengthy process; four more years are required to complete the series.

January. Work from Brazilian series shown at André Emmerich Gallery, Zurich.

Travels to London and Paris.

Included in exhibition *Twentieth Century American Drawing: Three Avant-Garde Generations* at The Solomon R. Guggenheim Museum, New York; exhibition subsequently shown at the Staatliche Kunsthalle Baden-Baden and the Kunsthalle Bremen, through August.

March. Travels to Florida Everglades with his future wife, Harriet McGurk, for bird-watching, a new interest that prompts the titling of the Exotic Bird series.

Exhibition *Frank Stella: Neue Reliefbilder—Bilder und Graphik* at Kunsthalle Basel. (Catalogue)

April. Meets Sam Posey, factory driver for BMW and racing commentator, who brings a model of a BMW to New York for Stella's design. Car is then painted in Munich by BMW.

Stella, Hervé Poulin (race driver), and Jochen Neerpasch (BMW executive and former race driver) with a racing car painted with Stella's design, ca. 1976

June. The BMW painted with Stella's design is driven at Le Mans by Peter Gregg and Brian Redman.

Fall. In Dijon race, Ronnie Peterson drives the BMW painted with Stella's design.

October. Visits Paris; sees Centre Pompidou under construction.

Work from Exotic Bird series shown at Knoedler Gallery, New York.

November. Begins work on Exotic Bird prints (related to graph-paper drawings for Exotic Bird reliefs) at Tyler Graphics Ltd., Bedford, New York; published in October 1977.

Exhibition *Frank Stella: The Black Paintings*, directed by Brenda Richardson, at The Baltimore Museum of Art reunites most of the Black series of 1958–60. (Catalogue)

December. Begins Hand-Colored Screenprints (related to Exotic Bird paintings) at Tyler Graphics Ltd., Bedford, New York; published in September 1979.

Exhibition *Frank Stella: An Historical Selection* at David Mirvish Gallery, Toronto.

1977

Continues painting Exotic Bird series of metal reliefs and making Exotic Bird prints.

February. Exhibition *Frank Stella: Metal Reliefs from the Year 1976* at Hans Strelow and Rudolf Zwirner Gallery, Cologne.

Spring. Travels to Germany for auto races at Nürburgring; first meets drivers Ronnie Peterson and Peter Gregg.

Travels to London.

April. Included in exhibition *Art Off the Picture Press: Tyler Graphics Ltd.* at Hofstra University, Hempstead, New York.

Retrospective exhibition *Frank Stella: Werke 1958–1976* at Kunsthalle Bielefeld, Federal Republic of Germany; exhibition shown at Kunsthalle Tübingen, Federal Republic of Germany, June. (Catalogue)

Work from the Exotic Bird series shown in exhibition *Frank Stella: Aluminum Reliefs 1976–77* at the Museum of Modern Art, Oxford; exhibition shown at the Fruit Market Gallery, Edinburgh, through June.

September. Sinjerli Variations prints (related to Protractor paintings) published by Petersburg Press, New York.

Included in exhibition *A View of a Decade* at the Museum of Contemporary Art, Chicago.

October. Makes the maquettes for the Indian Bird series of reliefs during stay at Ahmedabad, India, as guest of the Sarabhai family. In the absence of Foamcore, Stella cuts the maquette forms from discarded sheets of misprinted tin originally intended for soft-drink and food cans. Titles—e.g., *Shāma, Kastūra*—refer to birds found in the subcontinent. The maquettes are later given to The Museum of Modern Art, New York.

November. Exhibition *Frank Stella: Paintings and Recent Prints* at John Berggruen Gallery, San Francisco.

December. Exhibition *Frank Stella: Paintings, Drawings, and Prints, 1959–1977* at Knoedler Gallery, London.

1978

Continues Exotic Bird series of metal reliefs.
Begins painting 5.5× enlargements of Indian Bird maquettes.

Stella with Harriet McGurk in Ahmedabad, India, 1977

February. In Florida for Daytona 24 Hours race, with Jochen Neerpasch, head of BMW Motor Sport Division, and Ronnie Peterson, driver.

Marries Harriet McGurk in New York.

Included in exhibition *Between Sculpture and Painting* at the Worcester Art Museum.

March. Exhibition *Stella Since 1970*, directed by Anne Livet in collaboration with Philip Leider (who writes the catalogue) at The Fort Worth Art Museum; includes work from the Polish, Brazilian, and Exotic Bird series. Exhibition travels to Newport Harbor Art Museum, Newport Beach, California; The Montreal Museum of Fine Arts; The Vancouver Art Gallery; The Corcoran Gallery of Art, Washington, D.C.; Mississippi Museum of Art, Jackson; The Denver Art Museum; The Minneapolis Institute of Arts; and Des Moines Art Center, through April 1980. (Catalogue)

Spring. Begins work at Petersburg Press, New York, on print series that will become the Polar Co-ordinates for Ronnie Peterson; published in June 1980.

Travels to London, Munich, Rome (Vallelunga racetrack) and Basel

with Harriet McGurk.

Summer. Travels with BMW Formula II racing-team charter from Munich to Sicily (Pergusa racetrack).

August. Exhibition at Galerie Valeur, Nagoya, Japan.

September. Travels with Harriet McGurk and Peter Gregg from Milan to Bellagio and attends Monza Grand Prix. In the race, their friend Ronnie Peterson crashes and later dies.

1979

Continues Exotic Bird series.
Completes Indian Bird series.

January. Exhibition *Indian Birds: Painted Metal Reliefs* at Leo Castelli Gallery, New York.

February. Receives Claude Moore Fuess Award "for distinguished contribution to public service" from Phillips Academy, Andover, Massachusetts.

March. Exhibition *Frank Stella: The Indian Bird Maquettes*, directed by William Rubin, at The Museum of Modern Art, New York.

May. Travels to Basel for preparations for his 1980 drawing exhibition there.

Exhibition *Frank Stella: Metallic Reliefs* at Rose Art Museum, Brandeis University, Waltham, Massachusetts.

June. Travels to London for meeting with Jody Scheckter, president of Formula I drivers' association, to discuss establishing protocol for trauma treatment at hospitals serving racetracks.

July. Death of Stella's father.

Travels to Daytona to see Peter Gregg and Hurley Haywood drive in the Paul Revere race. All three then attend race at Watkins Glen, New York.

August. Travels to Germany.

October. Accepts invitation from President Jimmy Carter to a campaign-related dinner at the White House.

Included in exhibition *Shaped Paintings* at the Visual Arts Gallery, School of Visual Arts, New York.

November. Makes design for BMW race car for Peter Gregg; goes to Daytona with Gregg for races.

1980

Completes Exotic Bird series.

February. Included in exhibition *Printed Art: A View of Two Decades* at The Museum of Modern Art, New York.

May. Exhibition *Frank Stella: Peintures 1970–1979* at Centre d'Arts Plastiques Contemporains de Bordeaux. (Catalogue)

Included in exhibition *The Fifties: Aspects of Painting in New York* at the Hirshhorn Museum and Sculpture Garden, Smithsonian Institution, Washington, D.C.

Exhibition *Frank Stella: Working Drawings/Zeichnungen 1956– 1970*, directed by Christian Geelhaar, at Kunstmuseum Basel.

(Catalogue)

Repeated visits to *Pablo Picasso: A Retrospective* at The Museum of Modern Art, New York, through September.

June. Travels to Paris.

Begins drawings and Foamcore maquettes for the Circuit series, which he later calls the "longest and most concentrated streak of work that I've ever had." The titles—e.g., *Talladega, Pergusa, Imola*—are names of international auto racetracks.

Summer. Peter Gregg and Stella survive auto crash en route to Le Mans.

August. Fabrication begins of aluminum and magnesium reliefs for Circuits, 3× and 4.75× enlargements of the maquettes. Small aluminum versions (each about 1.25×) are also produced.

Included in exhibition *Three Dimensional Painting* at the Museum of Contemporary Art, Chicago.

Exhibition of drawings for Polar Co-ordinates prints at Akira Ikeda Gallery, Nagoya, Japan.

September. At Swan Engraving Company, Bridgeport, Connecticut, to etch metal plates for Circuits reliefs. The incised parabolic pattern is derived from Polar Co-ordinates prints.

October. Begins work on Shards prints at Petersburg Press, New York. Title refers to derivation of the works' forms from scrap left over in the process of making models. Prints are published in June 1982.

December. Peter Gregg commits suicide.

Stella works with Tyler Graphics Ltd., Bedford, New York, on his first intaglio/relief prints for Circuit series, evolved from the Circuit paintings.

1981

Continues Circuit series of paintings and prints.

January. Travels to Zurich, St.-Moritz, Moscow, Leningrad, Stockholm, Paris, and London.

Included in exhibition *A New Spirit in Painting* at the Royal Academy of Arts, London.

March. Travels to Corpus Christi for bird-watching.

April. Receives Medal for Painting of the Skowhegan School for Painting and Sculpture, Skowhegan, Maine.

May. At Tyler Graphics, Bedford, New York, begins work on Swan Engravings series, named for the Swan Engraving Company and related to the patterns of saw cuts in the Circuit series reliefs; published in September 1982.

Travels to Israel; receives Honorary Fellowship from Bezalel Academy of Arts and Design, Jerusalem.

Tours Egypt.

Makes first visit to Venice.

June. Exhibition *Frank Stella: Works—Paintings, Drawings, and Maquettes* at Akira Ikeda Gallery, Nagoya, Japan.

Travels to Düsseldorf.

October. Work from Circuit series shown in exhibition *Frank Stella: Metal Reliefs* at Knoedler Gallery, New York.

November. Exhibition *Frank Stella's Polar Co-ordinates for Ronnie Peterson,* organized by The Museum of Modern Art, New York, shown at the University of Arizona Museum of Art, Tucson. Subsequently shown at The William Benton Museum of Art, University of Connecticut, Storrs; Glenbow Museum, Calgary; Art Gallery of Hamilton, Ontario; Madison Art Center, Wisconsin; and The Museum of Modern Art, New York, through January 1983.

December. Work from Circuit series shown in exhibition *Frank Stella: New Work* at Galerie Hans Strelow, Düsseldorf.

1982

Continues Circuit series of paintings and prints.

Begins Shards series of reliefs, based directly on compositions of Shards prints; series includes two giant variants: *Shards III,* 4.75× (16'11" × 15' × 40" [515.6 × 457.2 × 101.6 cm]) and *Shards IV,* 4.75× (15' × 16'11" × 40" [457.2 × 515.6 × 101.6 cm]).

From metal scrap found on factory floor, improvisationally executes high reliefs, mostly unpainted, known as South African Mines. Titles— e.g., *Blyvoors, Welkom, Western Deep*—are names of mines in South Africa.

Begins Playskool series, named for a line of children's toys; these reliefs incorporate such found, readymade objects as punctured metal strips, wire mesh, and wooden dowels.

Begins work on *Illustrations after El Lissitzky's Had Gadya,* inspired by the Russian Constructivist's imagery of 1918–19 for a Haggadah text. Aspects of morphological structure influenced by nineteenth-century treatise on stonecutting. Uses complex technique (hand-painted collage of lithographed, shaped papers) that requires two years to bring the series to completion. Published by Waddington Graphics, London, in November 1984.

February. Receives The Mayor of the City of New York's Award of Honor for Arts and Culture from Edward I. Koch.

Delivers lecture at the Walker Art Center, Minneapolis.

March. Makes print *Yellow Journal* (related to Swan Engravings), commissioned by the Howard Metzenbaum for Senate Committee, at Tyler Graphics Ltd., Bedford, New York.

Travels to Paris, Brussels, and London.

April. Included in exhibition *'60–'80: Attitudes/Concepts/Images—A Selection from Twenty Years of Visual Arts* at the Stedelijk Museum, Amsterdam.

Son Peter is born.

May. In Houston for *Stella by Starlight,* a fund-raising exhibition for The Museum of Fine Arts, Houston, of his mural designs (executed by local art students and later painted over; related to Cones and Pillars series).

Travels to London, in conjunction with an exhibition at Knoedler Gallery, and to Rome.

September. Begins Residency at American Academy of Arts and Letters, Rome (through June 1983).

Retrospective exhibition *Frank Stella: Prints 1967–1982,* directed by Richard H. Axsom, at The University of Michigan Museum of Art, Ann Arbor. Exhibition subsequently travels to Whitney Museum of American Art, New York; Huntsville Museum of Art, Alabama; Sarah Campbell Blaffer Gallery, University of Houston; Brunnier Gallery and Museum, Ames, Iowa; The Cleveland Museum of Art; Mary and Leigh Block Gallery, Northwestern University, Evanston, Illinois; Pennsylvania Academy of the Fine Arts, Philadelphia; Memorial Art Gallery, University of Rochester; Laguna Gloria Art Museum, Austin; Brooks Memorial Art Gallery, Memphis; Beaumont Art Museum, Texas; The Nelson-Atkins Museum of Art, Kansas City, Missouri; Columbus Gallery of Fine Arts, Ohio; and Los Angeles County Museum of Art, through March 1986. (Catalogue)

October. Travels to London, Berlin (where he sees the exhibition *Zeitgeist,* in which he is included), and Düsseldorf.

Exhibition *Frank Stella: From Start to Finish* at Addison Gallery of American Art, Phillips Academy, Andover, Massachusetts.

Work from South African Mine series shown at Leo Castelli Gallery, New York.

November. Visits Japan for opening of exhibition *Frank Stella: Working Drawings from the Artist's Collection* at the Kitakyushu Municipal Museum of Art. Delivers lecture at art school near Tokyo.

1983

Continues Circuit series.
Continues Playskool series.
Continues *Illustrations after El Lissitzky's Had Gadya.*
Completes Shards series.

January. Named Charles Eliot Norton Professor of Poetry at Harvard University, Cambridge, Massachusetts, first abstract painter to be so honored. Delivers six-lecture series titled "Working Space," October 1983–April 1984.

February. Exhibition *Frank Stella: Polish Wooden Synagogues— Constructions of the 1970s,* directed by Carolyn Cohen, at The Jewish Museum, New York.

Exhibition *Frank Stella: Recent Works,* directed by Bruce H. Dempsey, at the Jacksonville Art Museum.

Travels to Malta on research for Harvard lectures. The fortified architecture of Malta (where he sees Caravaggio's *Beheading of St. John the Baptist*) leads to Malta series of reliefs; most titles—e.g., *Valletta, Mellieha Bay*—refer to locations in Malta.

March. Exhibition *Resource/Response/Reservoir: Stella Survey 1959–1982,* directed by George W. Neubert, at the San Francisco Museum of Modern Art.

Travels to Tulsa, Fort Worth, and San Antonio in preparation for Harvard lectures. Delivers lecture at the San Antonio Art Institute.

April. Travels to London, Paris, Brussels, Antwerp, and Amsterdam on research.

May. Visits Raleigh, North Carolina, to attend lecture on Rubens by John Rupert Martin of Princeton University.

June. Visits Vienna and Munich on research.

Attends Nürburgring auto race.

Concludes Residency at American Academy, Rome.

Included in exhibition *Minimalism to Expressionism* at the Whitney Museum of American Art, New York.

October. Exhibition *Focus on Frank Stella: "Nasielk II," a Polish Wooden Synagogue Construction* at Skirball Museum, Hebrew Union College, Los Angeles.

November. Exhibition *Frank Stella: Fourteen Prints—with Drawings, Collages, and Working Proofs*, directed by Judith Goldman, at The Art Museum, Princeton University, Princeton, New Jersey. (Catalogue)

December. Exhibition *Frank Stella: Selected Works*, directed by Caroline Jones, at the Fogg Art Museum, Harvard University, Cambridge, Massachusetts.

1984

Continues Malta series.

Completes *Illustrations after El Lissitzky's Had Gadya*.

Completes Playskool series.

Completes Circuit series.

Begins Cones and Pillars series, large-scale painted metal reliefs using elements from his *Had Gadya* prints. Titles—e.g., *Diavolozoppo, Lo sciocco senza paura*—are from Italo Calvino's *Italian Folktales*.

May. Travels to Paris, Bologna, Florence, and Rome.

June. Receives honorary degree from Princeton University, his alma mater.

October. Exhibition *Frank Stella: The Swan Engravings* at The Fort Worth Art Museum. (Catalogue)

November. Son Patrick is born.

December. Travels to Paris, Amsterdam (to give a lecture at the Stedelijk Museum in honor of retiring director E. L. L. de Wilde), and Edinburgh (to work on tapestries—renditions of his *Had Gadya* prints—for Pepsico headquarters, Purchase, New York).

1985

Continues Cones and Pillars series.

Completes Malta series.

Makes series of ceramic reliefs; works with ceramicist Frank Bosco. Titles—e.g., *The Waxford Girl, Bonnie Bunch of Roses-O*—are traditional folk songs of New York State. The series is later expanded with cast-steel pieces made from ceramic molds and extrusions.

January. Exhibition *Frank Stella: Relief Paintings* at Knoedler Gallery, New York.

February. His article titled "On Caravaggio," related to the exhibition *The Age of Caravaggio* at The Metropolitan Museum of Art, New York, is published in the *New York Times Magazine*.

Exhibition *Frank Stella: New Prints, 1984* at the Port Washington Public Library, Port Washington, New York.

March. Exhibition at Akira Ikeda Gallery, Tokyo.

April. Gives lecture at The Art Institute of Chicago.

May. Travels to London (for openings of exhibitions) and Edinburgh (to work on tapestries).

Exhibition *Frank Stella: Ceramic Reliefs and Steel Reliefs* at Knoedler Gallery, London.

Exhibition *Frank Stella: Works and New Graphics*, directed by Declan McGonagle, at the ICA Gallery, Institute of Contemporary Arts, London, includes work from the Cones and Pillars series and *Illustrations after El Lissitzky's Had Gadya*; also shown at Douglas Hyde Gallery, Trinity College, Dublin, through August. (Catalogue)

September. Awarded honorary degree by Dartmouth College, Hanover, New Hampshire; gives convocation address.

Stella with world-champion squash player Jahangir Kahn, 1986

October. Included in exhibition *Contrasts of Form: Geometric Abstract Art 1910–1980* at The Museum of Modern Art, New York.

Receives Award of American Art from the Pennsylvania Academy of the Fine Arts, Philadelphia.

November. Included in exhibition *Carnegie International 1985*, Museum of Art, Carnegie Institute, Pittsburgh.

1986

Continues Cones and Pillars series.

Begins Wave series of large reliefs emphasizing wave-motif already present in *Had Gadya* prints. Titles of works—e.g., *Loomings, The Lamp*—are chapter titles in Herman Melville's *Moby-Dick*.

February. Included in exhibition *Directions 1986* at the Hirshhorn Mu-

seum and Sculpture Garden, Smithsonian Institution, Washington, D.C.

Spring. Designs poster and promotional materials for second annual Swan Laser Die/U.S. Pro Softball Squash Championships (held in New York, May 30–June 2).

April. Exhibition *Frank Stella: Had Gadya, after El Lissitzky—A Series of Prints, 1982–1984*, directed by Edna Moshenson, at The Tel Aviv Museum. (Catalogue)

May. Awarded honorary degree by Brandeis University, Waltham, Massachusetts.

Exhibition *Frank Stella: New Reliefs* at Akira Ikeda Gallery, Tokyo.

Summer. Begins paper maquettes for an as yet unnamed series.

October. Travels to Boston to present the Nathaniel Saltonstall Award to Dorothy C. Miller at the 50th Anniversary Dinner of the Institute of Contemporary Art.

Harvard University Press publishes Stella's Norton lectures as *Working Space.*

December. Attends auto races in England and Europe.

1987

Continues Cones and Pillars series; makes very high-relief (almost three-dimensional) versions of some works in the series.
Continues Wave series.
Continues as yet unnamed series.

April. Exhibition at Akira Ikeda Gallery, Nagoya, Japan.

May. Included in exhibition *L'Époque, la mode, la morale et la passion* at Musée National d'Art Moderne, Centre Georges Pompidou, Paris.

Exhibition at Galerie Hans Strelow, Düsseldorf.

June. Exhibition of recent work at Knoedler Gallery, London.

Stella at work in his studio, 1986

Selected Bibliography

1970–1987

Each section of the bibliography is arranged chronologically.

Writings by the Artist

"Commentaire de *Complexité simple—Ambiguïté*." In *Kandinsky: Album de l'exposition*. Paris: Musée National d'Art Moderne, Centre Georges Pompidou, 1984.

"On Caravaggio." *New York Times Magazine*, Feb. 3, 1985, pp. 38 ff.

Working Space (The Charles Eliot Norton Lectures, 1983–84). Cambridge, Mass., and London: Harvard University Press, 1986.

Lectures by the Artist

(Transcripts of most unpublished lectures are on deposit at the host institutions.)

Address in honor of William Seitz. The Art Museum, Princeton University, Princeton, N.J., Feb. 19, 1977.

"Painterly Painting Today." College Art Association Annual Convention, New York, Jan. 27, 1978.

"Ordinary Questions." Bezalel Academy of Arts and Design, Jerusalem, May 18, 1981.

Lecture in the series "Artists Talk About Their Work." Museum of Fine Arts, Boston, Feb. 17, 1982.

"Working Space," series of six lectures delivered as Charles Eliot Norton Professor of Poetry, Harvard University, Cambridge, Mass., Oct. 12, Nov. 9, Dec. 6, 1983, Feb. 6, Mar. 5, Apr. 4, 1984. Individual lectures also delivered at Walker Art Center, Minneapolis, Feb. 21, 1982; College Art Association National Convention, New York, Feb. 26, 1982; San Antonio Art Institute, Mar. 17, 1983; Musée National d'Art Moderne, Centre Georges Pompidou, Paris, May 11, 1984; Queens College, City University of New York, Oct. 1, 1984; Stedelijk Museum, Amsterdam, Dec. 14, 1984; The Metropolitan Museum of Art, New York, Mar. 3, 1985; The Art Institute of Chicago, Apr. 24, 1985. All six lectures published as *Working Space*, Cambridge, Mass., and London: Harvard University Press, 1986.

"An Artist's View of Prints." The Grolier Club, New York, Apr. 27, 1984.

Talk given at "The Frick Collection: Controversies and Personal Viewpoints" (part of a seminar on the conservation and restoration of paintings). The Frick Collection, New York, Apr. 16, 1985.

Convocation address. Dartmouth College, Hanover, N.H., Sept. 1985.

Interviews

JULIET STEYN. "Frank Stella Talks About His Recent Work." *Art Monthly* (London), May 1977, pp. 14–15.

PETER RIPPON, TERENCE MALOON, AND BEN JONES. "Frank Stella." *Artscribe* (London), July 1977, pp. 13–17.

CLAUDE GINTZ. "Entretien avec Frank Stella." *Artistes* (Paris), Apr.–May 1980, pp. 6–13.

MEIR RONNEN. "Frank Stella on Making Art." *Jerusalem Post Magazine*, May 22, 1981, p. 17.

EMILE DE ANTONIO. "Geo-Conversation: Frank Stella—A Passion for Painting." *GEO*, Mar. 1982, pp. 13–16.

PATRICIA CORBETT. "Frank Stella." *Art and Auction* (New York), Feb. 1983, pp. 59–61.

AVIS BERMAN. "Artist's Dialogue: A Conversation with Frank Stella." *Architectural Digest* (Los Angeles), Sept. 1983, pp. 70, 74, 78.

"Frank Stella Talks About. . . ." *Vanity Fair* (New York), Nov. 1983, p. 94.

JUDITH GOLDMAN. "An Interview with Frank Stella." In Goldman, *Frank Stella: Fourteen Prints—with Drawings, Collages, and Working Proofs* (exhibition catalogue). Princeton, N.J.: The Art Museum, Princeton University, 1983. Reprinted in *Frank Stella: Had Gadya, after El Lissitzky—A Series of Prints, 1982–1984* (exhibition catalogue). Tel Aviv: The Tel Aviv Museum, 1986.

CAROLINE JONES. "Spaces and the Enterprise of Painting." *Harvard Magazine* (Cambridge, Mass.), May–June 1984, pp. 44–51.

CELIA MCGEE. "Art Takes Its Chances, and Its Knocks: The *New York Newsday* Interview with Frank Stella." *Newsday* (New York), July 9, 1986.

DOUGLAS C. MCGILL. "Stella Elucidates Abstract Art's Link to Realism." *New York Times*, Dec. 7, 1986.

Books and Catalogues

WILLIAM RUBIN. *Frank Stella* (exhibition catalogue). New York: The Museum of Modern Art, 1970.

ROBERT ROSENBLUM. *Frank Stella*. Penguin New Art, 1. Harmondsworth, England, and Baltimore: Penguin Books, 1971.

Frank Stella: Neue Reliefbilder—Bilder und Graphik (exhibition catalogue). Text by Franz Meyer. Basel: Kunsthalle Basel, 1976.

BRENDA RICHARDSON. *Frank Stella: The Black Paintings* (exhibition catalogue). Baltimore: The Baltimore Museum of Art, 1976.

Frank Stella: Werke 1958–1976 (exhibition catalogue). Bielefeld: Kunsthalle Bielefeld, 1977.

PHILIP LEIDER. *Stella Since 1970* (exhibition catalogue). Fort Worth: The Fort Worth Art Museum, 1978.

Frank Stella: Peintures 1970–1979 (exhibition catalogue). Bordeaux: Centre d'Arts Plastiques Contemporains de Bordeaux, 1980.

CHRISTIAN GEELHAAR. *Frank Stella: Working Drawings/Zeichnungen 1956–1970* (exhibition catalogue). Basel: Kunstmuseum Basel, 1980.

RICHARD H. AXSOM. *The Prints of Frank Stella: A Catalogue Raisonné, 1967–1982.* New York: Hudson Hills Press in conjunction with The University of Michigan Museum of Art, Ann Arbor, 1983.

JUDITH GOLDMAN. *Frank Stella: Fourteen Prints—with Drawings, Collages, and Working Proofs* (exhibition catalogue). Princeton, N.J.: The Art Museum, Princeton University, 1983.

RICHARD MEIER. *Shards by Frank Stella.* London and New York: Petersburg Press, 1983.

Frank Stella: The Swan Engravings (exhibition catalogue). Text by Robert Hughes. Fort Worth: The Fort Worth Art Museum, 1984.

Frank Stella: Works and New Graphics (exhibition catalogue). Text by Jean Fisher. London: Institute of Contemporary Arts, 1985.

Frank Stella: Had Gadya, after El Lissitzky—A Series of Prints, 1982–1984 (exhibition catalogue). Text by Edna Moshenson. Tel Aviv: The Tel Aviv Museum, 1986.

LAWRENCE RUBIN, with an introduction by Robert Rosenblum. *Frank Stella: Paintings 1958 to 1965—A Catalogue Raisonné.* New York: Stewart, Tabori & Chang, Publishers, 1986.

Articles and Reviews

HILTON KRAMER. "Art: Two Men's Dazzling Abstractions." *New York Times,* Jan 31, 1970.

ROBERT PINCUS-WITTEN. "New York." *Artforum* (New York), Jan. 1970, pp. 66–67.

HILTON KRAMER. "Art: A Retrospective of Frank Stella." *New York Times,* Mar. 25, 1970, p. 34.

PHILIP LEIDER. "Literalism and Abstraction: Reflections on Stella Retrospective at the Modern." *Artforum* (New York), Apr. 1970, pp. 44–51. Letter in reply by William Rubin, June 1970, pp. 10–11.

LAWRENCE ALLOWAY. "Art." *The Nation* (New York), May 4, 1970, p. 540.

HAROLD ROSENBERG. "The Art World." *The New Yorker,* May 9, 1970, pp. 103–16.

ELIZABETH C. BAKER. "Frank Stella Perspectives." *Art News* (New York), May 1970, pp. 46–49, 62–64.

J. PATRICE MARANDEL. "New York Letter." *Art International* (Lugano), May 1970, p. 73.

DORE ASHTON. "New York Commentary." *Studio International* (London), June 1970, p. 275.

BERNARD DENVIR. "London Letter." *Art International* (Lugano), Nov. 1970, p. 76.

HILTON KRAMER. "Art: Two Uses of the Shaped Canvas." *New York Times,* Oct. 16, 1971, p. 25.

ELIZABETH C. BAKER. "Frank Stella, Revival and Relief." *Art News* (New York), Nov. 1971, p. 34.

CARTER RATCLIFF. "New York Letter." *Art International* (Lugano), Dec. 20, 1971, pp. 59–60.

ROSALIND KRAUSS. "Stella's New Work and the Problem of Series." *Artforum* (New York), Dec. 1971, pp. 40–44.

JOHN ELDERFIELD. "UK Commentary." *Studio International* (London), Jan. 1972, pp. 30–31.

IRVING SANDLER. "Stella at Rubin." *Art in America* (New York), Jan.–Feb. 1972, p. 33.

PETER SCHJELDAHL. "Frank Stella: The Best—and the Last—of His Breed?" *New York Times,* Jan. 21, 1973, sec. 2, p. 23.

EDMUND WHITE. "Frank Stella Explores a New Dimension." *Saturday Review* (Washington, D.C.), Mar. 3, 1973, pp. 53–54.

APRIL KINGSLEY. "New York Letter." *Art International* (Lugano), Apr. 1973, pp. 53–54.

JOSEPH MASHECK. "Frank Stella, Castelli Gallery Uptown." *Artforum* (New York), Apr. 1973, pp. 80–81.

PAUL STITELMAN. "New York Galleries: Notes on the Absorption of the Avant-Garde into the Culture." *Arts Magazine* (New York), May–June 1973, pp. 55–59.

LOUIS FINKELSTEIN. "Seeing Stella." *Artforum* (New York), June 1973, pp. 67–70.

JEREMY GILBERT-ROLFE. "Reviews: Frank Stella, Knoedler Contemporary Art." *Artforum* (New York), Feb. 1974, pp. 67–68.

DAVID BOURDON. "Frank Stella." *The Village Voice* (New York), May 19, 1975.

HAYDEN HERRERA. "Reviews: Frank Stella, Leo Castelli Gallery, Downtown." *Artforum* (New York), Sept. 1975, p. 67.

WILLIAM ZIMMER. "Frank Stella." *Arts Magazine* (New York), Sept. 1975, p. 12.

CATHERINE MILLET. "Un Peintre: Frank Stella—Histoire (ou contre-histoire) de l'espace littéral." *Art Press* (Paris), Nov.–Dec. 1975, pp. 14–15.

ROBERTA SMITH. "Frank Stella's New Paintings: The Thrill Is Back." *Art in America* (New York), Nov.–Dec. 1975, pp. 86–88.

John Russell. "Art Beyond Good and Bad Taste." *New York Times*, Oct. 8, 1976, sec. C, p. 17.

Thomas B. Hess. "Stella Means Star." *New York Magazine*, Nov. 1, 1976, p. 62.

Lawrence Alloway. "Art." *The Nation* (New York), Nov. 20, 1976, pp. 541–42.

Michael Andre. "New York Reviews." *Art News* (New York), Dec. 1976, p. 115.

Noel Frackman. "Frank Stella's Abstract Expressionist Aerie: A Reading of Stella's New Paintings." *Arts Magazine* (New York), Dec. 1976, pp. 124–26.

Budd Hopkins. "Frank Stella's New Work: A Personal Note." *Artforum* (New York), Dec. 1976, pp. 58–59.

Amy Goldin. "Frank Stella at Knoedler." *Art in America* (New York), Jan.–Feb. 1977, p. 126.

Kenneth Wahl. "On Abstract Literalist Works." *Arts Magazine* (New York), Apr. 1977, pp. 98–101.

John McEwen. "Star Struck." *The Spectator* (London), May 14, 1977, pp. 27–28.

Terence Maloon. "Frank Stella: From American Geometry to French Curves." *Artscribe* (London), July 1977, pp. 11–14.

Edward Lucie-Smith. "Stella—The Defiant Giant." *Evening Standard* (London), Dec. 21, 1977, p. 27.

John McEwen. "Pinch-Pots and Skateboards." *The Spectator* (London), Dec. 24, 1977, p. 33.

John Russell. "Stella Shows His Metal in SoHo." *New York Times*, Jan. 19, 1978, sec. C, pp. 1, 16.

Philip Leider. "Stella Since 1970." *Art in America* (New York), Mar.–Apr. 1978, pp. 120–30.

Robert Hughes. "Stella and the Painted Bird." *Time* (New York), Apr. 3, 1978, pp. 66–67.

Hilton Kramer. "Frank Stella's Vigorous Reaffirmation." *New York Times*, May 14, 1978, sec. D, p. 27.

Bill Marvel. "Stella at Fort Worth." *Horizon* (New York), May 1978, pp. 40–47.

John Ashbery. "Birds on the Wing Again." *New York Magazine*, Sept. 11, 1978, pp. 90–91.

Jeanne Siegel. "Recent Colored Reliefs." *Arts Magazine* (New York), Sept. 1978, pp. 152–54.

April Kingsley. "Frank Stella: Off the Wall." *The Village Voice* (New York), Jan. 29, 1979, p. 70.

Jane Nisselson. "Stella's Indian Birds." *Art World* (New York), Jan.–Feb. 1979, p. 8.

Kim Levin. "Frank Stella." *Arts Magazine* (New York), Mar. 1979, p. 22.

Richard Whelan. "New York Reviews: Frank Stella (Castelli)." *Art News* (New York), Mar. 1979, p. 182.

Kenneth Baker. "Stella by the Cold Light of Day: New Paintings That Holler." *Boston Phoenix*, May 22, 1979, sec. 3, p. 10.

Hilton Kramer. "Frank Stella's Brash and Lyric Flight." *Portfolio* (New York), May 1979, pp. 48–55.

Robert Hughes. "Ten Years That Buried the Avant-Garde." *Sunday Times Magazine* (London), Dec. 30, 1979, pp. 16–21, 41–47.

Hilton Kramer. "Frank Stella." *New York Times*, Nov. 6, 1981.

Kay Larson. "Art: The Odd Couple." *New York Magazine*, Nov. 23, 1981, pp. 73–77.

Roni Feinstein. "Stella's Diamonds: Frank Stella's New Work." *Arts Magazine* (New York), Jan. 14, 1982, p. C22.

Noel Frackman. "Tracking Frank Stella's Circuit Series." *Arts Magazine* (New York), Apr. 1982, pp. 134–37.

Roberta Smith. "Abstraction: Simple and Complex." *The Village Voice* (New York), Nov. 23, 1982, p. 106.

Theodore F. Wolff. "Frank Stella: As Important a Printmaker as He Is a Painter." *Christian Science Monitor* (Boston), Jan. 25, 1983, p. 19.

Jeanne Silverthorne. "Frank Stella." *Artforum* (New York), Feb. 1983. pp. 81–82.

Roberta Smith. "A Double Dose." *The Village Voice* (New York), Mar. 22, 1983, p. 106.

Roni Feinstein. "Frank Stella's Prints 1967–1982." *Arts Magazine* (New York), Mar. 1983, pp. 112–15.

Robert Rosenblum. "Stella's Third Dimension." *Vanity Fair* (New York), Nov. 1983, pp. 86–93.

Kenneth Baker. "Art: The Shape of Things to Come—Frank Stella's Past Performances." *Boston Phoenix*, Jan. 17, 1984, pp. 5, 12.

Richard Hennessy. "The Man Who Forgot How to Paint." *Art in America* (New York), Summer 1984, pp. 13–25.

Diane Solway. "Frank Stella: Speaking in the Abstract." *M* (New York), July 1984, pp. 154–57.

CALVIN TOMKINS. "Profiles (Frank Stella): The Space Around Real Things." *The New Yorker*, Sept. 10, 1984, pp. 53–97.

ROBERT ROSENBLUM. "Frank Stella." In *Art of Our Time: The Saatchi Collection,* vol. 2. London: Lund Humphries; New York: Rizzoli, 1984.

JOHN RUSSELL. "The Power of Frank Stella." *New York Times*, Feb. 1, 1985, pp. C1, C22.

CARTER RATCLIFF. "Frank Stella: Portrait of the Artist as Image Administrator." *Art in America* (New York), Feb. 1985, pp. 94–107.

ROBERT STORR. "Issues and Commentary: Frank Stella's Norton Lectures—A Response." *Art in America* (New York), Feb. 1985, pp. 11–15.

RONNY COHEN. "New York Reviews: Frank Stella." *Art News* (New York), May 1985, p. 115.

GLENN O'BRIEN. "Frank Stella, Knoedler Gallery." *Artforum* (New York), May 1985, pp. 108–09.

NORMAN TURNER. "Stella on Caravaggio." *Arts Magazine* (New York), Summer 1985, p. 91.

BRIAN FALLON. "Frank Stella Exhibition at Douglas Hyde." *Irish Times*, Aug. 15, 1985.

BERNARD CEYSSON. "'Ut pictura pictura': Frank Stella ou l'abstraction accomplie." *Artstudio* (Paris), Summer 1986, pp. 26–37.

ROBERTA SMITH. "Oh, the Pity." *Connoisseur* (New York), Aug. 1986, pp. 92–93.

HILTON KRAMER. "The Crisis in Abstract Art" (review of *Working Space*, by Frank Stella). *Atlantic Monthly* (Boston), Oct. 1986, pp. 94, 96–98.

JOHN GOLDING. "The Expansive Imagination" (review of *Working Space*, by Frank Stella). *Times Literary Supplement* (London), Mar. 27, 1987, pp. 311–12.

List of Illustrations

Dimensions are given in feet and inches, then in centimeters, height preceding width, and followed by depth. A date is enclosed in parentheses when it does not appear on the work of art. In the Brazilian, Exotic Bird, and Indian Bird series, the etching of individual metal panels within a work is not noted. Photographs (P) have been supplied by the owners or custodians of the works reproduced, unless otherwise noted.

Polish Village Series

Piaski III. (1973). Mixed media on board, 7′8″ × 7′ (233.7 × 213.4 cm). Collection Brigitte Freybe, West Vancouver, B.C. page 6

Chodorów I. (1971). Mixed media on canvas, 9′ × 8′10″ (274.4 × 269.4 cm). Collection Robert and Jane Meyerhoff, Phoenix, Maryland page 10

Chodorów II. (1971). Mixed media on canvas, 9′ × 8′10″ (274.4 × 269.4 cm). Collection Mr. and Mrs. Victor W. Ganz (P: © 1987 Steven Sloman, New York) page 11

Odelsk I. (1971). Mixed media on canvas, 7′6″ × 11′ (228.6 × 335.3 cm). Private collection (P: © Sloman) page 13

Lanckorona I. (1971). Mixed media on canvas, 9′ × 7′6″ (274.4 × 228.6 cm). Private collection page 16

Felsztyn III. (1971). Mixed media on board, 8′10″ × 7′6″ (269.4 × 228.6 cm). Collection Barbara Jakobson (P: Zindman/Fremont) page 17

Narowla II. (1971). Mixed media on canvas, 9′ × 8′8″ (274.4 × 264.2 cm). Collection Shirley and Miles Q. Fiterman (P: Bevan Davies, courtesy Leo Castelli Gallery, New York) page 19

Drawing for *Mogielnica.* (ca. 1972). Pencil, 8½ × 11″ (21.6 × 28 cm). Private collection (P: © Sloman) page 22

Drawing for *Mogielnica.* (ca. 1972). Pencil on graph paper, 11 × 16½″ (28 × 41.9 cm). Private collection (P: © Sloman) page 22

Maquette for *Mogielnica.* (ca. 1972). Oak tag with pencil, 14⅜ × 20″ (36.5 × 50.8 cm). Private collection (P: © Sloman) page 23

Maquette for *Mogielnica.* (ca. 1972). Corrugated cardboard with fabric and paint, 18 × 24⅞″ (45.8 × 63.2 cm). Private collection (P: © Sloman) page 23

Maquette for *Mogielnica.* (ca. 1972). Corrugated cardboard, 20 × 29⅞″ (50.8 × 75.9 cm). Private collection (P: © Sloman) page 23

Mogielnica I. (ca. 1972). Mixed media on board, 7′3″ × 10′ (221 × 304.8 cm). Private collection, New York (P: Kate Keller, Chief Fine Arts Photographer, The Museum of Modern Art, New York) page 24

Mogielnica II. (1972). Mixed media on board, 7′2½″ × 10′ (219.7 × 304.8 cm). Oliver-Hoffmann Family Collection (P: © 1987 Alan B. Newman, Chicago) page 25

Mogielnica III. (1972). Mixed media on board, 7′3″ × 10′5″ (221 × 317.5 cm). Private collection page 26

Mogielnica IV. (1972). Unpainted wood, 7′2½″ × 10′ (219.7 × 304.8 cm). Collection Mr. and Mrs. Paul B. Page (P: © 1987 Douglas M. Parker) page 27

Kamionka Strumiłowa III. (1972). Mixed media on board, 7′4″ × 10′4″ (223.5 × 315 cm). Private collection page 29

Kamionka Strumiłowa IV. (1972). Mixed media on board, 8′2″ × 11′6″ (248.9 × 350.6 cm). Private collection (P: Eric Pollitzer) page 30

Jabłonów I. (1972). Mixed media on canvas, 8′2″ × 9′8″ (248.9 × 294.7 cm). Private collection page 31

Nasielsk IV. (1972). Unpainted wood, 9′2″ × 7′5½″ (279.4 × 227.4 cm). The Art Institute of Chicago. Grant J. Pick Fund, 1973.334 (P: Pollitzer, courtesy The Art Institute of Chicago) page 33

Brzozdowce II. (1973). Mixed media on board, 10′ × 7′6″ (304.8 × 228.7 cm). Collection Mr. and Mrs. Bagley Wright, Seattle page 38

Targowica II. (ca. 1973). Mixed media on board, 10′2″ × 8′ (309.9 × 243.9 cm). Private collection (P: Sloman) page 39

Brazilian Series

Jardim Botânico I. (1974–75). Mixed media on aluminum, 8′ × 10′10″ (243.9 × 330.2 cm). Collection Mr. and Mrs. Bagley Wright, Seattle (P: Pollitzer) page 42

Grajaú I. (1974–75). Mixed media on aluminum, 6′10″ × 11′2″ (208.3 × 340.5 cm). Collection Philip Johnson (P: Courtesy Leo Castelli Gallery, New York) page 44

Grajaú II. (1975). Mixed media on aluminum, 6′10″ × 11′2″ (208.3 × 340.5 cm). Collection Mr. and Mrs. Victor W. Ganz (P: © Sloman) page 45

Arpoador I. (1974–75). Mixed media on aluminum, 6′6″ × 10′4″ (198.1 × 315 cm). Oeffentliche Kunstsammlung, Kunstmuseum Basel page 46

Montenegro I. (1974–75). Mixed media on aluminum, 7′6″ × 9′9″ (228.7 × 297.2 cm). Collection Gabriele Henkel (P: Pollitzer) page 47

Joatinga I. (1974–75). Mixed media on aluminum, 8′ × 11′ (243.9 × 335.3 cm). Saatchi Collection, London (P: courtesy Leo Castelli Gallery, New York) page 54

Leblon II. (1975). Mixed media on aluminum, 6′8″ × 9′8″ (203.2 × 294.7 cm). Private collection (P: © Sloman) page 55

Lapa I. (1975). Mixed media on aluminum, 6′4½″ × 10′ (194.3 × 304.8 cm). Private collection page 57

Diderot Series

Le Rêve de d'Alembert. (1974). Synthetic polymer paint on canvas, 11'10″ × 23'8″ (360.7 × 721.4 cm). Collection the artist (P: © Sloman)
page 49

Bijoux indiscrets. (1974). Synthetic polymer paint on canvas, 11'3″ × 11'3″ (343 × 343 cm). Collection Rita and Toby Schreiber page 50

Jacques le fataliste. (1974). Synthetic polymer paint on canvas, 11'3″ × 11'3″ (343 × 343 cm). Private collection (P: Jones) page 51

Sight Gag. (1974). Synthetic polymer paint on canvas, 11'3″ × 11'3″ (343 × 343 cm). Private collection (P: Bruce C. Jones) page 53

Exotic Bird Series

Eskimo curlew, 5.5×. (1976). Mixed media on aluminum, 8'3″ × 10'6½″ (251.5 × 321.4 cm). Portland Art Museum, Oregon. Purchased with funds from Howard and Jean Vollum (P: Guy Orcutt) page 58

Drawing for *Inaccessible Island rail.* (ca. 1976). Pencil on graph paper, 21⅝ × 28⅜″ (54.9 × 72.1 cm). Private collection (P: © Sloman)
page 60

Maquette for *Inaccessible Island rail.* (ca. 1976). Foamcore, 21½ × 28⅜″ (54.6 × 72.1 cm). Private collection (P: © Sloman) page 60

Inaccessible Island rail, 1×. (1976). Mixed media on aluminum, 21 × 28″ (53.3 × 71.1 cm). Private collection page 60

Inaccessible Island rail, 3×. (1976). Mixed media on aluminum, 63″ × 7' (160 × 213.4 cm). Private collection (P: Pollitzer) page 61

Inaccessible Island rail, 5.5×. (1976). Mixed media on aluminum, 9'9″ × 12'9″ (297.3 × 388.7 cm). Grinstein Family Collection (P: © Parker)
page 61

Bermuda petrel, 3×. (1976). Mixed media on aluminum, 61½″ × 6'11½″ (156.2 × 212.1 cm). Collection Mr. and Mrs. Graham Gund (P: Greg Heins) page 62

Bonin night heron, 5.5×. (1976–77). Mixed media on aluminum, 8'3″ × 10'5⅜″ (251.5 × 318.5 cm). Albright-Knox Art Gallery, Buffalo, New York. Gift of Seymour H. Knox, 1977 (P: Pollitzer) page 63

Newell's Hawaiian shearwater, 5.5×. (1976). Mixed media on aluminum, 9'4″ × 12'10″ (284.6 × 391.3 cm). Collection Ed Cauduro (P: Orcutt) page 65

Steller's albatross, 3×. (1976). Mixed media on aluminum, 65¼″ × 7'1½″ (165.8 × 217.4 cm). Collection Henry and Maria Feiwel (P: Jones) page 66

Steller's albatross, 5.5×. (1976). Mixed media on aluminum, 10' × 13'9″ (304.8 × 419.1 cm). Saatchi Collection, London page 67

Wake Island rail, 3×. (1976). Mixed media on aluminum, 54 × 69″

(137.2 × 175.3 cm). Collection Eli and Edythe L. Broad (P: Jones)
page 70

Puerto Rican blue pigeon, 5.5×. (1976). Mixed media on aluminum, 9'4⅛″ × 12'9⅝″ (284.8 × 390.2 cm). Ohio State University, Columbus. Purchased with funds from the National Endowment for the Arts, 1972.003 (P: Pollitzer) page 71

Dove of Tanna, 5.5×. (1977). Mixed media on aluminum, 12'10″ × 18'9″ (391.2 × 571.5 cm). Whitney Museum of American Art, New York. Promised and partial gift of Mr. and Mrs. Victor W. Ganz (P: Jerry L. Thompson, © Whitney Museum of American Art, New York)
page 72

New Caledonian lorikeet, 5.5×. (1977). Mixed media on aluminum, 10' × 13' (304.8 × 396.3 cm). Private collection (P: Pollitzer) page 74

Brazilian merganser, 5.5×. (1980). Mixed media on aluminum, 10' × 8' (304.8 × 243.8 cm). Collection Martin Z. Margulies, Miami
page 75

Mysterious Bird of Ulieta, 5.5×. (1977). Mixed media on aluminum, 8'4″ × 10'6″ (254 × 320.1 cm). Collection Mr. and Mrs. Graham Gund (P: Pollitzer, Strong, & Meyer) page 76

Indian Bird Series

Jungli kowwa, 5.5×. (1978). Mixed media on aluminum, metal tubing, and wire mesh, 7'2″ × 8'6″ × 38″ (218.5 × 259.1 × 96.6 cm). Collection Mr. and Mrs. Donald B. Marron (P: Courtesy Leo Castelli Gallery, New York) page 78

Drawing A for *Rām gangra.* (1977). Pencil on transparent paper, 22 × 17″ (55.9 × 43.2 cm). Private collection (P: Mali Olatunji, Fine Arts Photographer, The Museum of Modern Art, New York) page 80

Drawing B for *Rām gangra.* (1977). Pencil on transparent paper, 22 × 17″ (55.9 × 43.2 cm). Private collection (P: Olatunji) page 80

Drawing B superimposed on drawing A for *Rām gangra.* (1977). (P: Olatunji) page 80

Maquette for *Rām gangra.* (1977). Silkscreened metal and wire mesh, 20¼ × 16½ × 6½″ (51.4 × 41.9 × 16.5 cm). The Museum of Modern Art, New York. Fractional gift of the artist (P: Jones) page 80

Rām gangra, 5.5×. (1978). Mixed media on aluminum, metal tubing, and wire mesh, 9'7″ × 7'6½″ × 43½″ (292.2 × 230 × 110.6 cm). Collection Mr. and Mrs. Victor W. Ganz (P: © Sloman) page 81

Bulal-chashm, 5.5×. (1978–79). Mixed media on aluminum, metal tubing, and wire mesh, 7'10″ × 9'9″ × 45½″ (238.8 × 297.2 × 115.6 cm). Collection Robert A. Rowan (P: Neil Winokur) page 82

Khar-pidda, 5.5×. (1978). Mixed media on aluminum, metal tubing, and wire mesh, 10'2″ × 7'4″ × 35″ (309.9 × 223.5 × 88.9 cm). Collection Philip Johnson (P: Harry Shunk) page 85

Maha-lat, 5.5×. (1978–79). Mixed media on aluminum, metal tubing,

and wire mesh, 7'3¾" × 9'3" × 38½" (222.9 × 282 × 97.8 cm). Private collection, New York (P: Davies, courtesy Leo Castelli Gallery, New York) page 87

Shāma, 5.5×. (1979). Mixed media on aluminum, metal tubing, and wire mesh, 6'6" × 10'5" × 34⅝" (198.3 × 317.6 × 88 cm). Collection Diane and Steven Jacobson (P: © Sloman) page 89

Kastūra, 5.5×, two views. (1979). Mixed media on aluminum, metal tubing, and wire mesh, 9'7" × 7'8" × 30" (292 × 233.5 × 76.2 cm). The Museum of Modern Art, New York. Acquired through the Mr. and Mrs. Victor W. Ganz, Mr. and Mrs. Donald H. Peters, and Mr. and Mrs. Charles Zadok Funds (P: Keller) pages 90, 91

Circuit Series

Silverstone, 4.75×. (1981). Mixed media on aluminum and fiberglass, 8'9½" × 10' × 22" (268 × 304.8 × 56 cm). Whitney Museum of American Art, New York. Purchase, with funds from the Louis and Bessie Adler Foundation, Inc., Seymour M. Klein, President; the Sondra and Charles Gilman Jr. Foundation, Inc.; Mr. and Mrs. Robert M. Meltzer; and the Painting and Sculpture Committee, 81.26 (P: Geoffrey Clements) page 94

Drawing for *Zeltweg.* (ca. 1982). Ink on layers of acetate, 23⅝ × 27" (60 × 68.6 cm). Private collection (P: © Sloman) page 96

Maquette for *Zeltweg.* (ca. 1982). Foamcore, with pencil and ink, 23⅝ × 26⅞" × 3⅛" (60 × 68.3 × 8 cm). Private collection (P: © Sloman) page 96

Zeltweg, 3×. (1982). Mixed media on etched magnesium, 6' × 6'9" × 12⅝" (182.9 × 205.8 × 32.1 cm). Private collection (P: Jones) page 97

Zeltweg, 4.75×. (Second version, 1982). Mixed media on etched magnesium, 9'6" × 10'8" × 20" (289.6 × 325.6 × 50.8 cm). Private collection (P: © Sloman) page 97

Mosport, 4.75×. (Second version, 1982). Mixed media on etched magnesium, 9'6" × 10'6½" × 24" (289.6 × 321.4 × 61 cm). Private collection page 99

Vallelunga, 4.75×. (1981). Mixed media on aluminum, 9'4" × 10'8" × 21" (284.5 × 325.1 × 53.3 cm). Collection Robert and Jane Meyerhoff, Phoenix, Maryland page 100

Maquette for *Talladega.* (ca. 1981). Foamcore, with pencil and ink, 23⅝ × 27 × 3⅞" (60 × 68.6 × 9.9 cm). Private collection (P: © Sloman) page 102

Talladega, 4.75×. (1981). Mixed media on etched magnesium, 9' × 10'5½" × 17¼" (274.4 × 318.8 × 43.8 cm). Collection Stefan T. Edlis (P: Jones) page 103

Misano, 3×. (1982). Mixed media on etched magnesium, 67" × 6'9" × 11" (170.2 × 205.8 × 27.9 cm). Private collection page 105

Nogaro, 4.75×. (1981). Mixed media on aluminum and fiberglass, 9'7" × 10' × 24" (292.2 × 304.8 × 61 cm). Collection Mr. and Mrs. Victor W. Ganz (P: © Sloman) page 106

Nogaro, 4.75×. (Third version, 1984). Mixed media on etched magnesium, 9'7" × 10' × 22" (292.1 × 304.8 × 55.9 cm). Collection Diane and Steven Jacobson page 107

Thruxton, 3×. (1982). Mixed media on etched magnesium, 6'3" × 7'1" × 15" (190.5 × 215.9 × 38.1 cm). Shidler Collection, Honolulu (P: © Sloman) page 108

Anderstorp, 4.75×. (1981). Mixed media on etched magnesium, 9'½" × 10'3½" × 15¾" (275.7 × 313.6 × 40 cm). Private collection page 109

Norisring, 4.75×. (1982). Mixed media on aluminum, 9'7" × 8'10" × 30" (292.1 × 269.3 × 76.2 cm). Collection Mr. and Mrs. Ronald A. Pizutti (P: Ken Cohen) page 110

Jarama, 4.75×. (Second version, 1982). Mixed media on etched magnesium, 10'6" × 8'4" × 24¾" (319.9 × 253.9 × 62.8 cm). National Gallery of Art, Washington, D.C. Gift of Lila Acheson Wallace page 111

Maquette for *Pergusa,* two views. (ca. 1981). Foamcore, with pencil and ink, 20½ × 29⅝" × 5½" (52.1 × 75.3 × 14 cm). Private collection (P: © Sloman) page 112

Pergusa, 4.75×. (1981). Mixed media on etched magnesium, 8'2" × 10'5" × 28" (249 × 317.5 × 71.1 cm). Collection Holly Hunt-Tackbary (P: Jones) page 113

Zandvoort, 4.75×. (1981). Mixed media on etched magnesium, 9' × 10'4" × 20" (274.4 × 315 × 50.8 cm). Collection Donald and Barbara Zucker (P: © Sloman) page 115

Zolder, 4.75×. (Second version, 1983). Mixed media on aluminum, 10'8" × 9'4¼" × 23" (325.1 × 285.1 × 58.4 cm). Collection Bert and Marcia Blum (P: Cohen) page 116

Shards Series

Shards IV, 3×. (1982). Mixed media on aluminum, 10' × 11'2" × 27" (304.8 × 340.5 × 68.6 cm). Collection Eli and Edythe L. Broad (P: © Sloman) page 118

Shards V, 3×. (1983). Mixed media on aluminum, 10' × 11'5" × 32" (304.8 × 348 × 81.3 cm). Collection Fukutake Publishing Co., Ltd. page 121

South African Mine Series

Welkom. (1982). Unpainted honeycombed aluminum, 8'2" × 7'6" × 64" (249 × 228.7 × 162.6 cm). The Museum of Modern Art, New York. Gift of Donald B. Marron (P: Keller) page 122

Malta Series

Marsamxett Harbour. (1983). Mixed media on etched aluminum, etched magnesium, and sheet steel, 9'10″ × 9'10″ × 35¼″ (299.8 × 299.8 × 89.5 cm). Private collection (P: Jones)　　page 123

Mellieha Bay. (1983). Mixed media on fiberglass, etched aluminum, etched magnesium, and sheet steel, 11'6″ × 14'5″ × 42″ (350.6 × 439.5 × 106.7 cm). Collection Robert and Jane Meyerhoff, Phoenix, Maryland　　page 124

Marsaxlokk Bay. (1983). Mixed media on etched aluminum, etched magnesium, and sheet steel, 11'2″ × 9'11½″ × 51″ (340.4 × 303.5 × 129.5 cm). Collection Douglas S. Cramer and Douglas S. Cramer Foundation (P: © Parker)　　page 125

Zonqor Point. (1983). Mixed media on fiberglass, etched aluminum, etched magnesium, and sheet steel, 9'2″ × 10'2″ × 66″ (279.4 × 309.9 × 167.7 cm). Private collection　　page 126

St. Michael's Counterguard. (1984). Mixed media on fiberglass, etched aluminum, etched magnesium, and sheet steel, 13' × 11'3″ × 9' (396.3 × 343 × 274.3 cm). Los Angeles County Museum of Art. Gift of Anna Bing Arnold, M.84.105 (P: © 1984 Museum Associates, Los Angeles County Museum of Art. All rights reserved)　　page 127

Playskool Series

Playskool Yard. (Artist's proof, 1983). Mixed media on cast metal and wood, 32 × 28 × 9″ (81.3 × 71.2 × 22.9 cm). Private collection (P: © Sloman)　　page 129

Cones and Pillars Series

Diavolozoppo, 4×. (1984). Mixed media on canvas, etched magnesium, aluminum, and fiberglass, 11'7⅛″ × 14'1¾″ × 16⅛″ (353.4 × 431.3 × 41 cm). Collection the artist (P: © Sloman)　　page 130

Giufà, la luna, i ladri e le guardie, 3.8×. (1984). Mixed media on canvas, etched magnesium, aluminum, and fiberglass, 9'7¼″ × 16'3¼″ × 24″ (292.7 × 495.9 × 61 cm). The Museum of Modern Art, New York. Acquired through the James Thrall Soby Bequest (P: Keller)　　page 132

Giufà, la luna, i ladri e le guardie, 4×. (1985). Mixed media on canvas, etched magnesium, aluminum, and fiberglass, 10'3¾″ × 16'5″ × 27⅜″ (314.4 × 499.4 × 69.6 cm). Collection Mr. and Mrs. Harry W. Anderson　　page 133

La scienza della fiacca, 3.5×. (1984). Mixed media on canvas, etched magnesium, aluminum, and fiberglass, 10'4½″ × 10'9¼″ × 31¼″ (316.3 × 328.3 × 79.4 cm). Private collection (P: Cohen)　　page 134

Il Drago e la cavallina fatata, 3×. (1985). Mixed media on etched magnesium, aluminum, and fiberglass, 10' × 11'5¼″ × 35½″ (304.8 × 348.9 × 90.2 cm). Collection Mr. and Mrs. Victor W. Ganz (P: © Sloman)　　page 136

Gobba, zoppa e collotorto, 3×. (1985). Mixed media on etched magnesium, aluminum, and fiberglass, 11'5″ × 10'⅛″ × 34⅜″ (348 × 305.1 × 87.3 cm). The Art Institute of Chicago. Mr. and Mrs. Frank G. Logan Purchase Prize Fund and Ada Trumbull Hertle Fund, 1986.93 (P: Alan B. Newman, Staff Photographer; © 1987 The Art Institute of Chicago. All rights reserved)　　page 137

Giufà e la statua di gesso, 3.8×. (1985). Mixed media on canvas, etched magnesium, aluminum, and fiberglass, 10'2½″ × 13'3⅜″ × 26⅜″ (311.2 × 404.8 × 67 cm). Collection Mr. and Mrs. Graham Gund　　page 139

Salta nel mio sacco!, 3.8×. (1985). Mixed media on etched magnesium, aluminum, and fiberglass, 13'2⅜″ × 10'11⅞″ × 15⅞″ (402.3 × 335 × 40.3 cm). Collection Eli and Edythe L. Broad (P: Orcutt)　　page 140

Lo sciocco senza paura, 3.8×. (1985). Mixed media on etched magnesium, aluminum, and fiberglass, 10'6″ × 9'9¾″ × 20¾″ (320 × 299.1 × 52.7 cm). Kawamura Memorial Museum of Modern Art, Sakura, Japan (P: © Sloman)　　page 141

La vecchia dell'orto, 3×. (1986). Mixed media on etched magnesium, aluminum, and fiberglass, 10'7″ × 12'8¾″ × 42¼″ (322.6 × 388 × 107.3 cm). Musée National d'Art Moderne, Centre Georges Pompidou, Paris (P: Ch. Bahier, Ph. Migeat, Photographie Musée National d'Art Moderne, Centre Georges Pompidou, Paris)　　page 143

Bene come il sale, 3×. (1987). Painted aluminum, 7'5¼″ × 7'9⅝″ × 61¾″ (226.7 × 237.8 × 156.9 cm). Private collection (P: © Sloman)　　page 146

Wave Series

Loomings, 3×. (1986). Mixed media on etched magnesium and aluminum, 11'10⅛″ × 13'6½″ × 44″ (361 × 412.8 × 111.8 cm). Walker Art Center, Minneapolis. Gift of Jean and Gary Capen, 1987 (P: Glenn Halvorson, Staff Photographer, Walker Art Center)　　page 145

The Lamp, 3×. (1987). Mixed media on cast and fabricated aluminum, 8'8¼″ × 6'3½″ × 71½″ (246.8 × 191.8 × 181.7 cm). Private collection (P: © Sloman)　　page 150

Collateral Illustrations

Kasimir Malevich. *Suprematist Drawing.* (ca. 1916). Pencil, 6½ × 4⅜″ (16.5 × 11.2 cm). Private collection (from *L'Age d'homme: Malevich,* Lausanne: Éditions de l'Age d'homme, 1979, fig. 115)　　page 34

Frank Stella. *Moultonboro III.* (1966). Fluorescent alkyd and epoxy paint on canvas, 9'2″ × 10'¼″ (279.4 × 305.5 cm). Collection Mr. and Mrs. Graham Gund (P: Malcolm Varon)　　page 35

Synagogue, Piaski, Poland (destroyed 1939–45; from Maria and Kazimierz Piechotka, *Wooden Synagogues,* Warsaw: Arkady, 1959, fig. 169. P: Szymon Zajczyk, ca. 1936)　　page 40

Frank Stella. *Polar Co-ordinates V for Ronnie Peterson.* (1980). Offset lithograph and screenprint, 38 × 38½" (96.6 × 97.9 cm). Private collection (P: © Sloman)　　　page 95

Frank Stella. Drawing for *Shards V.* (ca. 1982). Felt-tip marker, 39¾ × 45¼" (101 × 115 cm). Private collection (P: © Sloman)　　　page 120

Frank Stella. *Shards V.* (Color trial proof, 1982). Mixed media on lithograph, 39¾ × 45¼" (101 × 115 cm). Private collection (P: Courtesy Petersburg Press)　　　page 120

Frank Stella. *Then Came a Stick and Beat the Dog,* Illustration no. 4 from *Illustrations after El Lissitzky's Had Gadya.* (1982–84). Hand-colored and collaged lithograph, linoleum block, and silkscreen prints, 52⅞ × 52¾" (134.3 × 134 cm). Private collection (P: © Sloman)　　　page 131

El Lissitzky. *Then Came a Stick and Beat the Dog,* Illustration no. 4 from the *Had Gadya.* 1919. Lithograph, 11 × 10¼" (28 × 26 cm). Private collection (P: © Sloman)　　　page 131

El Lissitzky. *Proun 23, No. 6.* (1919). Oil on canvas, 20½ × 30¼" (52 × 77 cm). Collection E. Estorick, London (from Sophie Lissitzky-Küppers, *El Lissitzky: Maler/Architekt/Typograf/Fotograf,* Dresden: VEB Verlag der Kunst, 1976, plate 23)　　　page 135

El Lissitzky. Drawing for *They Fly Around the Earth Back and Forth (and)* from *About Two Squares in Six Constructions: A Suprematist Story.* (1920). Watercolor and pencil on cardboard, 10⅛ × 8" (25.6 × 20.2 cm). The Museum of Modern Art, New York. The Sidney and Harriet Janis Collection (P: James Mathews)　　　page 135

Detail of *Some Penetrations of Solids* (from Louis Monduit, *Traité théorique et pratique de la stéréotomie au point de vue de la coupe des pierres,* Seine-et-Oise: Succr. de Ch. Juliot, n.d., plate 9)　　　page 142

Fernand Léger. *Mechanical Elements.* (1918–23). Oil on canvas, 6'11" × 65⅞" (211 × 167.5 cm). Oeffentliche Kunstsammlung, Kunstmuseum Basel　　　page 142

Portraits and Studio Views

Frank Stella, 1985 (P: Marina Schinz)　　　page 2

Stella at work on the Exotic Birds in his studio, 1976　　　page 68

Stella at work on an Indian Bird maquette in Ahmedabad, India, 1977 (P: Surid Sarabhai)　　　page 86

Stella at work on a Cones and Pillars piece, 1985 (P: Sanjiro Minamikawa)　　　page 138

Two views of Stella's studio, with paper maquettes for an as yet unnamed series, 1986 (P: Marina Schinz)　　　page 148

Stella, Hervé Poulin (race driver), and Jochen Neerpasch (BMW executive and former race driver) with a racing car painted with Stella's design, ca. 1976 (P: © R. R. Kröschel, Munich)　　　page 154

Stella with Harriet McGurk in Ahmedabad, India, 1977 (P: Sarabhai)　　　page 155

Stella with world-champion squash player Jahangir Kahn, 1986 (P: © 1986 Lawrence A. Armour)　　　page 158

Stella at work in his studio, 1986 (P: Brigitte Lacombe)　　　page 159

Stella with sections of a work from the Cones and Pillars series, 1985 (P: © Sloman)　　　page 169

Acknowledgments

This book could not have been written, nor the exhibition which occasioned it organized, without the patient help of Frank Stella. Over the years, he has taken time out from other activities to sit for many hours of recorded interviews with me (and has carefully gone through my text more than once to sort out any errors). Citations from the transcripts of our conversations, as edited by the artist, constitute an important part of this book.

I am particularly indebted among the writers on Stella's work to Philip Leider, whose catalogue on Stella's work of the seventies was an essential resource, and to Robert Rosenblum, whose writing on Stella in recent years was as significant for me in this book as his earlier text on Stella had been for my 1970 monograph. The extraordinarily perceptive interviews which Caroline Jones conducted with Frank Stella when she was on the staff of the Fogg Art Museum have also played an important role in the forming of my ideas. Thanks are due Ms. Jones and Ada Bortoluzzi of the Harvard University Art Museums for making the transcripts available to me.

Gathering the necessary photographic material, checking and then correcting many aspects of the chronology and bibliography were no easy tasks. In this, we were fortunate in being able to rely on the constant support of Paula Pelosi, Frank Stella's friend and assistant, who responded with alacrity, intelligence, and graciousness to what must have seemed endless inquiries on our part. M. Knoedler & Co. and the Leo Castelli Gallery, Stella's dealers, have also given unstintingly of their time and energy. At Knoedler, the weight of the responsibility fell on Carol Corey, Senior Administrator, along with Cindy Lachow and Elizabeth Seacord. At the Castelli Gallery, Dorothy Spears has been especially helpful. Photographing Stella's three-dimensional pieces is always a difficult task, and particularly in the final hours we received invaluable cooperation from Steven Sloman, who worked under great pressure to produce many of the color transparencies we needed.

Needless to say, the quality of an exhibition can only be as high as the generosity of lenders permits. In the case of *Frank Stella 1970–1987,* we have made unusually heavy demands on our lenders so as to permit the exhibition to travel to six museums in Europe and the United States. Happily, with but one exception, owners of Stella's work have risen to the occasion. Among museums, my thanks go to The Art Institute of Chicago and its Director, James N. Wood, and to its Associate Curator for Twentieth-Century Painting and Sculpture, Neal Benezra; to the Walker Art Center, Minneapolis, and its Director, Martin Friedman; and to the Kawamura Memorial Museum of Modern Art, Sakura, Japan. Among the private collectors who have deprived themselves of works by Stella in order to facilitate our exhibition, we owe thanks to Mr. and Mrs. Harry W. Anderson; Ed Cauduro; Douglas S. Cramer and the Douglas S. Cramer Foundation; Stefan T. Edlis; Henry and Maria Feiwel; Brigitte Freybe; the Fukutake Publishing Co., Ltd., of Nagoya, Japan; Mr. and Mrs. Victor W. Ganz; the Grinstein family; Holly Hunt-Tackbary; Diane and Steven Jacobson; Barbara Jakobson; Philip Johnson; Donald Kurtz; Martin Z. Margulies; Robert and Jane Meyerhoff; Rita and Toby Schreiber; and Donald and Barbara Zucker; as well as several collectors who wish to remain anonymous.

Harriet McGurk Stella has kindly provided us with essential information for our chronology, which has also profited from the help of Frank Stella's assistant Judy Epstein Gage, and Kenneth Tyler has provided a great deal of technical information. For special assistance in loans, we are indebted to the Akira Ikeda Gallery of Tokyo and Nagoya, Japan. Important help in providing photographic material for the book has come from Mr. and Mrs. Paul Hoffmann of Chicago; Linda Stouch, Curatorial Secretary of the Portland Art Museum, Oregon; Michael Floss, Curator of the Douglas S. Cramer Foundation; Michele D. De Angelus, Curator of the Eli and Edythe L. Broad Collection, Los Angeles; and Alfred Pacquement, Curator, Musée National d'Art Moderne, Paris.

The making of this book required the help of virtually everyone in the Department of Publications of the Museum, starting with William P. Edwards, the Museum's Deputy Director for Auxiliary Services. I am particularly indebted to Jim Leggio, the book's editor, from whom I have learned a lot, and who has made numerous important contributions to my text. He has made the task of bringing the book to publication an especially pleasant one. Tim McDonough has exercised his usual tremendous care and special expertise in the matter of color reproduction, and Joe del Gaudio, who handsomely designed my 1970 monograph on Stella—of which this book is, in effect, a continuation—has kindly consented to join forces with us again. Others who have been of particular help include Nancy T. Kranz and Frances Keech of the Department of Publications; Richard Tooke and Mikki Carpenter, respectively Supervisor and Archivist of Rights and Reproductions; and Kate Keller, the Museum's Chief Fine Arts Photographer.

For the organization of the exhibition itself (as well as for assistance in all stages of the book) I owe more to Diane Farynyk, Curatorial Assistant for the exhibition, than to anyone else. I have come to know Diane, with whom I've worked on other even larger exhibitions, as someone upon whom I can absolutely depend to put in long hours, and to work well beyond the call of duty, under the pressure of various deadlines. Diane and Marjorie Nathanson, who was Curatorial Assistant during the earlier stages of the exhibition's preparation, have collaborated with me and Jerome Neuner, the Museum's Production Manager, in planning the structure of the installation.

The arrangements for the American part of the exhibition's tour have been in the able hands of Richard L. Palmer, Coordinator of Exhibitions, while the negotiations for the international showings have been conducted, with his familiar professionalism, by Waldo Rasmussen, Director of the Museum's International Program, assisted by Associate Director Elizabeth Streibert. Managing all this on the purely physical level—a formidable undertaking in the case of Stella's complicated metal reliefs—has been our excellent Registrar Eloise Ricciardelli, and Assistant Registrar Janet Hawkins.

Judith Cousins, Research Curator, was of great help to me at the outset in organizing bibliographical and research material and, as

always, my secretary, Ruth Priever, has good-naturedly typed endless versions of the manuscript.

Last but far from least, I owe a deep debt of gratitude to my brother, Lawrence Rubin. As one of Stella's principal dealers for almost thirty years, first in Europe and then in New York City, Larry's familiarity with Frank Stella's work is probably second only to that of the painter himself. Through the years leading up to this exhibition, and during its organization and the making of this book, I have constantly called on him for the benefit of his knowledge and connoisseurship.

William Rubin